Memory and Emotion (Ba

Constructing Meaning from Memory

Basque politics series, No. 19

Memory and Emotion: (Basque) Women's Stories Constructing Meaning from Memory

Editors

Larraitz Ariznabarreta and Nere Lete

Center for Basque Studies
University of Nevada, Reno
2021

This book was published with generous financial support from the Basque Government.

Center for Basque Studies
University of Nevada, Reno
1664 North Virginia St,
Reno, Nevada 89557 usa
http://basque.unr.edu

Library of Congress Cataloging-in-Publication Data

Names: Ariznabarreta, Larraitz, editor. | Lete, Nere, editor.
Title: Memory and emotion : (Basque) women's stories :
 constructing meaning from memory / Larraitz Ariznabarreta,
 Nere Lete.
Description: Reno, Nevada : Center for Basque Studies Press,
 [2020] | Includes bibliographical references.
Identifiers: LCCN 2020047479 | ISBN 9781949805338 (paperback)
Subjects: LCSH: Basque literature--Women authors--History and
 criticism. | Autobiography--Basque authors. | Autobiography--
 Women authors. | American literature--Basque authors-
 -History and criticism. | Women, Basque--Ethnic identity. |
 Basque American women--Ethnic identity. | Collective
 memory and literature. | Emotions in literature. | País Vasco
 (Spain)--In literature. | West (U.S.)--In literature. Classification: LCC
PH5282 .M46 2020 | DDC 899/.92099287--
 dc23
LC record available at https://lccn.loc.gov/2020047479

Contents

Acknowledgements

The editors are appreciative to the Department of World Languages at Boise State University for its unrelenting support while editing the manuscript. We are indebted to the Center for Basque Studies Press (University of Nevada, Reno) for the opportunity to publish it.

Daring to Remember, Daring to Tell
Introduction to Memory and Emotion: (Basque) Women's Stories
Constructing Meaning from Memory

Larraitz Ariznabarreta

William A. Douglass Center for Basque Studies
University of Nevada, Reno

> The production of texts can be one way of reconfiguring what will count as the world.[1]

> We do not actually know much about what power may have meant in the hands of strong prepatriarchal women. We do have guesses, longings, myths, fantasies, analogues. We know far more about how, under patriarchy, female possibility has been literally massacred.[2]

It was not until the mid-1970s that the social sciences embarked on the systematic study of emotions, their symbolic significance, and their practical consequences. Up until then, and with rare exceptions, the

1 Butler 1993, 19
2 Rich 2018, 81

dichotomy between notions such as rational and irrational had run parallel to the binary opposition of male and female: while rational thinkingwaslargelyconsideredamasculinequality,womenwerebelieved to be more prone to feebleness, irrationality, and emotional reaction.

Similarly,thelong-heldnegativestancetowardfemaleemotionality was portrayed in archetypical cultural figures that accounted for a big part of our (Western) symbolic world. Discourses based on an essentialist approach to womanhood not only romanticized women's roles as angel-like mothers or homemakers, but they also depicted women's psychology and emotional realm as a "dark-continent".[3] Other parallel,gender-driven,dichotomoustensionshaveexistedfortheterms culture/nurture, mind/body, head/heart, active/passive, public/private, and the opposition between the political and the personal. Until very recently, these dichotomies were pervasive in the all-encompassing cult of domesticity that permeated popular culture and the everyday life of Western women. Indeed, as Adrienne Rich (2018, 99)[4] shrewdly asserts: "The asexual Victorian angel-wife and the Victorian prostitute were institutions created by this double thinking, which had nothing to do with women's actual sensuality and everything to do with the male's subjective experience of women."

Albeit whimsically regarded as matriarchal until recently, Basque culture has been far from foreign to these gender-driven binary oppositions. As Margaret Bullen, one of the contributors to this volume, emphasizes in her groundbreaking book Basque Gender Studies:[5]

> The nature-culture dichotomy is found to be at the
> heart of the separation between the private and the

3 Gilligan 1982, 313
4 2018, 99
5 Bullen 2003, 30

public arena that is crucial to explaining the gender divisions and stratifications in society. Women are associated with nature, with reproduction, with child-raising, with family relations, and ultimately with particularistic or socially fragmenting concerns in the private, domestic domain (Moore, 1998:15). Men are associated with culture, with artificial means of creation, with the extra-domestic, public, and political domains identified with social life and the public interest.

The masculinizing ethics of traditional Basque nationalism—which cajoled and constrained women to play the role of affective, selfless mothers who raise their children and act as cultural transmitters while men acted as the political pawns of the nationalist endeavor—is yet another emblematic and historic metaphor of the gender division Bullen touches on. Much like what happens with other groups in a struggle for political/cultural recognition, Basque nationalism has traditionally regarded community rights as more central than individual rights for the survival of the group. The obvious paradox lay in that Basque nationalism traditionally also signaled the socially stirring notion of a matriarchal past as a central element for the Basque particularity. This contradiction in terms and symbols was divulged by feminist forerunners in the Basque Country during the 1980s.

Nonetheless, similar to what has been the case with other Western societal structures in recent years, Basques have witnessed an increasing equality for women and men in different walks of private and public life, and the sphere of Basque nationalism and its political factions has been no exception to that transformation. To put it differently, even

when many Basques still regard the nation as shared memory,[6] awareness of the fallacy of irreconcilable differences between the sexes and their social roles has permeated our collective social ethos.

Feminist practice (and theory) and post-structuralism are to be commonly credited for the demystifying of such antagonistic positions in the Western world. Today we have come to understand that the complex cognitive web of affects, emotions, and their various expressions are social constructs which are molded by cultures, as well as societal and political structures. Indeed, gender and culture—as social paradigms exerting an influence on individual identities and affects—do shape our emotions, but this whittle is never accomplished through a universal essentialist binary equivalence. As Jo Labanyi posits,[7] the new critical scenario for the study of emotions "means paying attention to feelings as well as ideas, and viewing feelings, not as properties of the self, but as produced through the interaction between self and world."

The study of the relationship between emotion, gender, and memory is a growing field in the broader framework of cultural studies. This late date is emphatically remarkable since emotions have infused practically every aspect of human experience and all social relations since the dawn of time: it is emotions that make social structures and systems of cultural symbols sustainable, emotions that generate allegiances to large-scale social and cultural structures. Conversely, and equally interesting as a framework for study, emotions are what can drive people to contest—and even tear down—social structures, and to challenge cultural traditions and canonical narratives. "Emotions," as

6 Renan 1992
7 2010, 233

Sara Ahmed[8] highlights, "do things, and they align individuals with communities."

In that sense, both cultural studies and the recent affect theories suggest that no signifying system is completely steady or unproblematic. Post-structuralism's skeptical perspectives and feminist critique facilitated the subversion of the symbolic assumptions of Western thought: reality is now viewed as fragmented, diverse, and culture-specific, and, therefore, memory and emotion are also contingent and changeable. Cultural practices and the role of language in the construction of our emotions are deemed central, and, as a result, greater attention is given to specific stories and to local contextualization. In turn, memory is viewed as the process through which we revisit and reassess those personal and local stories. However, as Llona[9] stresses, it is important to note that resorting to memory does not necessarily imply misrepresentation or falsification of reality. Much to the contrary, Llona believes that:

> The fact that memory is a process of continual evaluation does not imply that all the meanings and resonances of the past are distorted. In my experience, I have observed that there are certain types of accounts in memory that, even if not immune to the intersubjective character of the interview and to the passage of time, have a deep emotional charge. This charge enables the account to remain quite faithful to the experience and the emotions felt in the past that provoked the memory in the first place. My purpose is to demonstrate that in human

8 2004, 19
9 2016, 77

experience, emotions are intertwined with discourses
and comprise a significant component of memory.

The principles of the social study of emotions and affect theory
originate from the tradition of psychoanalysis, often via its radical revision
from theorists such as Jacques Lacan, Gilles Deleuze or Judith Butler.
However, affect theorists have also drawn extensively from outside of
psychology, principally from post-structuralists, such as Michel Foucault
and Jacques Derrida who were central in the application of the so-called
"philosophy of skepticism". Affect studies consider that it is through
socialization that we receive the emotional culture of a society, and, thus,
we learn to play appropriate roles in different situations. Similarly, class
and gender positions are of paramount importance in the quality of
emotions and in the acceptance and approval of their management. It
is a result of these social positions—all strongly associated with power
relations—that humans develop some emotions and atrophy others.
Thus, culture fundamentally conditions the social and personal structure
of identity. We swim in culture, and we drink from it even when we are
not fully aware of it. There is no identity constituent that is not affected
by culture. Indeed, as Adrienne Rich[10] maintains: "On the other side
of silence women have enormous differences of experience." Cultural
idiosyncrasies account for a large part of the differences of experience
Rich alludes to.

Memory and Emotion: (Basque) Women's Stories is a multidisciplinary
quest for the individual and social dimensions of memory and gender
through the exploration of the relationship between discourse, emotion,
and (cultural) identity. The book includes contributions by researchers
who deal with emotions at the core of their scholarly queries. These

10　331

scholars' articles address topics such as conflict and memory, emotion and adaptation, memory and exile, collective memory, cultural identity, cultural trauma, emotions and censorship, repressed memory, and autobiography (and other forms of personal narratives) as means to retell stories. The Basque backdrop acts as a significant presence in all the articles (except one), but frequent intercultural and transnational references are made throughout every contribution.

Memory and Emotion: (Basque) Women's Stories denounces the silence to which women—particularly those who withdraw from adopting a male-dominated discourse—have been subject. This is a book about women whose stories were long silenced or disregarded: diasporic and exiled women, activists, militant scholars, avant-garde writers, forerunners of women's rights. The researchers and contributors to this volume have dared to remember and retell the stories of those women who blazed a trail in unchartered territory—women whose contributions have been overlooked and ignored. In that sense, each contribution to Memory and Emotion: (Basque) Women's Stories could be deemed as a metatextual process of memory construction—a process of meaning-making from past experiences, knowledge, and identity. The chapters focus on such relevant questions as: Does emotion help us remember? How do emotions affect the ability to recall memories? Does memory contribute to adaptation? Does restoring one's self—individually or collectively—mean daring to remember? Is oblivion necessary for survival?

Tellingly, as Garbiñe Iztueta, one of the contributors to the collection, maintains in her chapter: "Memory is a process of meaning-making from past experiences, knowledge, and identity, in which

individuality intersects with a dominant collective process....Subjectivity, multiplicity, process, and transference are inherent categories to memory."

The publication of this volume has constituted a meaning-making emotional process which has bridged the personal and the academic domains for the two editors of the volume, Larraitz Ariznabarreta and Nere Lete. The result of a long journey that took over two years to become reality, it began with the organization of the First International Conference on Cultural Studies which took place at Boise State University in March of 2018. The inaugural conference, organized by the university's Department of World Languages, sought to address the issues of emotion, memory, and gender from the perspective of cultural studies. Participants from around the world were invited to reflect on the link between gender, memory, and emotion in disciplines such as literature, language, sociology, history, philosophy, ethics, global studies, and the visual arts. The objective of the conference was to bring together scholars and community partners, particularly individuals and groups who had relied on memory to survive emigration or forced displacement and had found a home in the city of Boise. A panel of migrant and refugee women discussed the relevance of memory and emotion in their adaptation. A special panel considered the role played by women in the Basque diaspora. The conference was a true sisterhood of cultures that provoked intense personal emotions in the participants. Often, emotions trigger memories, and memories provoke strong emotions which, in turn, make personal memories last. Certainly, that was the affective happenstance that initiated the publication of this volume.

In short, Memory and Emotion: (Basque) Women's Stories analyzes women's memories and emotions—their individual and collective constituents—through an interdisciplinary and intercultural lens. The

interdisciplinary spirit of this work is not commonplace in the realm of Basque and Iberian studies and its editors hope the publication offers a pathway to more cultural studies-oriented works, particularly given the transnational approach the chapters take.

Mari Jose Olaziregi—a beacon of Basque memory studies and one of the contributors to this book—maintains that "the formal differences between the literary production of men and women are striking." Olaziregi continues:

> When the author is a woman, narratives on the conflict [over the issue of Basque nationalism and ETA's armed struggle] do not fictionalize their protagonists as "women writers" on the conflict. ... Put another way, novels penned by men demonstrate metafictional structures that would denote the active role male writers want to play in the face of the conflict, while women's narratives talk about the Basque conflict based on structures resembling different autobiographical moods.

Indeed, women's autobiographical writing and other personal narratives are often dependent on emotions and intimate memories. The large number of female authors turning to personal narratives is precisely telling of the alleged literary trend. Early feminist criticism long expressed an interest in women's autobiographical writing, diaries, and memoirs, which, according to many, "have been pivotal for revising concepts of women's life issues".[11] In the case of women authors, these seemingly individualistic accounts often tell a story that supersedes singular

11 Smith and Watson 2010, 5

narratives and acquire a broader social significance by underscoring the political position of the private realm. Women's personal stories provide female authors a voice and agency when brought out of the shadows.

Personal narratives are a thread across many of the chapters of this book. Monika Madinabeitia employs vivid, oral-like storytelling to tell the story of Petra Amoroto Egaña, a historic character that is a synecdoche for the many Basque women who left their homeland and headed to the American West. Petra's story recreates a general tendency for Basque Americans: it was common for second-generation Basques to consciously reject and refuse their ethnic roots. Petra was acclaimed-US-writer Frank Bergon's Basque grandmother. Frank Bergon, who is now strongly attached to his Basque identity, claims that "it's our Basque grandmother who connects us—to our past, yes, but also to each other in the present." It was through experiences of affective and sensorial engagement that Petra provided and triggered, that Bergon became aware of his Basque heritage later in life. Through the story of Petra Amoroto Egaña, Monika Madinabeitia inquires into the wide-ranging notions of memory construction, as well as intergenerational and intercultural transmission.

Emigrant Basque women have made an important contribution to building a new community in their host countries while still preserving and passing on elements of the old. However, due to male migrants' prominence and the romanticized image of the lone sheepherder in western mythology, the focus on Basque migration in the American West has been on sheepherding. Edurne Arostegui's article, "Basque Women in the West: Bringing Migrant Women out of the Shadows," deepens the scholarly understanding of Basque diasporic communities while addressing the existing historiography and theoretical frameworks

for the study of Basque gendered migration. By focusing on Basque labor and migration in the American West, Arostegui highlights the paradox that although Basque females were among the first migrants to the West, their experience has been relegated to the shadows of men. Their lack of visibility, Arostegui maintains, was the result of their social positions in host societies and their labor within the domestic sphere. Arostegui's contribution stresses the need for an intersectional perspective; by connecting women's intimate and labor lives, the chapter brings to life the intersections between gender, class, and ethnicity specific to migration.

David Río also emphasizes the underrepresentation of Basque women in the American diaspora while he censures the neglect of Basque women immigrants and the affairs of the second and third generation. The interaction of memory, emotion, and gender in the immigration process is illustrated through the analysis of Monique Laxalt Urza's semi-autobiographical novel, The Deep Blue Memory,[12] a major novelty in American writing on the Basques because it meant an important shift in both a generational and a gender perspective. Laxalt Urza's novel may be regarded as a powerful account of the tensions between loyalty to the family group and the individual's natural process of searching for their identity, with a particular emphasis on the emotions produced during this conflict. Río chooses a novel which departs from nostalgic approaches to the homeland and focuses on the new generations of female characters, addressing the ways in which a Basque family deals with the tensions between loyalty to their ethnic roots and assimilation into American society. Time, identity, and memory appear intertwined in the three dimensions of the personal, the social, and the cultural. In fact, while exploring the contradictory influences acting on the Basque-

12 1994

American family depicted in the novel—illustrated by recurrent images of both the new and old worlds—Laxalt Urza addresses the impact of such emotions as grief, attachment, shame, and guilt in the family. Additionally, the power of these emotions and their connection with memory are examined from a female perspective, and female characters belonging to different generations play a prominent role in the novel. According to Río, Laxalt Urza's book stands out as a major portrait of the experience of Basque-American women, breaking with the archetypal literary treatment of the Basques as herders, and providing awareness of the interference of the private domain in women's public matters.

Ziortza Gandarias' chapter, "Basque Women in Exile," highlights the masculinizing ethics of traditional Basque nationalism and the neglect undergone by many female Basque nationalist writers and activists who were pivotal in the cultural movement under the dictatorial regime of Francisco Franco (1939-1975) underwent. Although there were female writers prior, it was not until the beginning of the 20th century that women became relevant and began to have a place in the Basque cultural and political arena. Gandarias' contribution delves into the literary works of female writers in the cultural magazine Euzko Gogoa, a magazine rooted in traditional Basque nationalist ideology. Through the representation of the archetypical Basque woman, Euzko Gogoa emphasized women's role in motherhood and its centrality in the conception of an idealized Basque family. During times of censorship, forced exile, and cultural persecution, Basque resistance—women and men alike—operated in the shadows and abroad to maintain and develop a culture on the verge of annihilation. However, while living in exile, women also contributed by acting as selfless community workers, helping new immigrants find housing, providing childcare, promoting religious services, among other charitable works. The cultural and political responsibilities of these

Basque nationalist women in exile conflicted with the feminization of labor and gendered roles assigned to them in the domestic sphere

It could be argued that the purported discord underscores the complexity of Basque nationalist discourses in the 1920s and 30s.

> The eternal nature of this type of conception situates the present as part of a long past and transforms ordinary cultural elements into "roots," that is, into elements of significance. Thus, the very elements that previously formed the basis of stigma acquire new meaning in light of this new truth. From the point of view of emotions, this change is important in that it makes it possible to perceive the effect of this process in healing past humiliations. This narrative, then, reveals the capacity of nationalist discourses to restore dignity. (Llona 2016, 87)

Several of the articles in the book are marked by the political and social struggles of the recent past. One of the most polemical feminist struggles currently underway in the Basque Country is the fight for women's right to take part in militia-like parades called Alardes, which are celebrated annually in the neighboring towns of Irun and Hondarribia in the Peninsular Basque Country. In "What we have learned on the way," Margaret Bullen looks back on the disputed participation of women in these Alardes. Just over twenty years ago, a conflict arose over the proposed participation of women in the hitherto almost exclusively all-male marches that are central to the annual festivals in these border towns of Gipuzkoa. Bullen's article examines different aspects of the

conflict through the relationships between gender, festive ritual, and social schemes. According to Bullen, the Alarde is a particularly emotional conflict which stirs up strong feelings and has caused much hurt on both an individual and collective scale. Emotions are used to justify positions either for an egalitarian parade in which women can participate freely in any role in the parade, or in favor of keeping the traditional format of men only with the exception of the emblematic figure of the cantinera, elected on a once-in-a-lifetime basis. There are multiple factors at play in the polemic, involving social and cultural identities, the interpretation and performance of history and tradition, family and local hierarchies and networks, and of course notions of femininity and masculinity combined with a desire to maintain or challenge the gender system. Bullen's chapter looks back on the passions provoked by the Basque parades through the eyes of some of the participants.

Some of the chapters in the collection deal with emotion in the aftermath of politically motivated violence. The Basque Country again is the backdrop that allows for a meaningful scrutiny. Marina Pérez de Mendiola-Arizmendi's contribution is—as the author contends—a "disturbance of memory." The chapter, which contains clear psychological undertones, pays homage to Begoña Aretxaga, a Basque anthropologist who dedicated her short life to the indefatigable study of cultural politics and state violence in Northern Ireland and the Basque Country, often concentrating on women's roles and gender in the formation of political subjectivities. A young scholar who moved to the United States to pursue a scholarly career, Aretxaga constantly resorts to her fresh memory of her coming-of-age as a disenfranchised queer, feminist, Basque intellectual, and activist during a most repressive state dictatorship. According to Pérez de Mendiola-Arizmendi, these memories left indisputable traces in Aretxaga's academic production. The chapter explores how Aretxaga's

being physically away from the Basque Country conditioned her academic approach to emotional states such as anxiety, fear, irritation, anger, and patriotism. Pérez de Mendiola delves into personal and collective memory through the narrative of a profoundly emotional encounter between Pérez de Mendiola and Aretxaga, at the time two noticeably young academics who had fled a violent Basque Country to engage in academic life in the United States.

Xenia Srebrianski Harwel's chapter deals with trauma, emotion, and memory as depicted in the works of Russian-Austrian author Alja Rachmanowa (pen name of Galina Djurjagina) who recorded her life's events in diary form throughout her life. These diaries were eventually the basis for Rachmanowa's literary works in which she highlights the ways she—as mother-narrator—negotiates motherhood through traumatic liminal space. Rachmanowa reworked her personal diaries into literary texts, using traditional literary devices, shaping the narrative with specifically selected themes, events, and characters. Thus, the four works examined may be considered representative of the genre of autofiction—a mixture of autobiography and fiction—and in her case, presented within a diary structure. Eloquently, Rachmanowa reworked the materials of her diaries not once, but twice, from different points of view—which underscores the truly catastrophic impact of the events she experienced. According to Srebrianski Harwel, Rachmanowa's autobiographical works reveal that the liminal periods, although supposedly transitional in nature, can be of long duration, possibly lasting a lifetime.

On a related theme, Garbiñe Iztueta connects inter-cultural perspectives through the study of three authors and the ways in which they problematize the transmission of cultural memory in the 1900s. The significant emotional component that all the authors meaningfully

focus on are experiences of loss in intimate spaces of motherhood during situations of political conflicts and violence. Iztueta's chapter suggests that in the all the works under scrutiny motherhood ties together emotions, memory, and creativity. The concern for the child and the protective response of the mother in the face of the traumatic events leads to a creative process: writing. As writing becomes the outlet for harnessing and containing emotion through a daily, almost scientific observation and recording of the child's development, it, in turn—and simultaneously—acts to preserve memory. The transnational perspective Iztueta's article opts for, opens new possibilities for future studies on the role of contemporary literature in the critical awareness-raising production of cultural memory. Maternity as trope remains a central thread throughout many references in the volume.

Indeed, maternity is one of the most recurring motifs in current Basque literature by women authors. In her chapter "Beyond the Motherland: Memory and Emotion in Contemporary Basque Women's Fiction," Mari Jose Olaziregi highlights that mothers make up the core image of women as projected by Basque nationalism. Through the critical analysis of several novels that present motherhood as a central theme, Olaziregi underscores the importance of examining the representation of political violence in Basque narratives written by women. Throughout the chapter, Olaziregi critically reflects on gender identities and roles encouraged by Basque nationalism and the way in which gender differences are polarized in armed conflicts. In that sense, Olaziregi believes that Basque literature has contributed to dialogue and understanding through its capacity to constitute itself a part of cultural memory.

Memory and Emotion: (Basque) Women's Stories wishes to contribute to that very dialogue by framing the debate via the intersection

of memory, gender, and affect theories. The editors of the volume remain determined to challenge the separation between the personal and the political, expose long-held myths, demystify other gender-driven, antagonistic positions, and bind together the literary and cultural narratives of diverse female voices. We are grateful for the support we have encountered along the way and look forward to new contributions that help us dare to remember, dare to tell, while we do our share to reconfigure what will count as the world.

WORKS CITED

Ahmed, Sara. "Affective Economies." Social Text (79) (2004): 117-139.

—. The Cultural Politics of Emotions. Edinburgh: Edinburg University Press, 2004.

Bullen, Margaret. Basque Gender Studies. Reno: Center for Basque Studies Press, 2003.

Butler, Judith. Bodies that Matter. On the Discursive Limits of Sex. New York: Routledge, 1993.

—. Gender Trouble Feminism and the Subversion of Identity. New York: Routledge, 1990.

Gilligan, Carol. In a Different Voice Psychological Theory and Women's Development. Cambridge: Harvard University Press, 1982.

Labanyi, Jo. "Doing Things: Emotion, Affect, and Materiality." Journal of Spanish Cultural Studies (2010): 223-233.

Labanyi, Jo. "Memory and Modernity in Democratic Spain> The Difficulty of Coming to Terms with the Spanish Civil War." Poetics Today 28 (1) (2007): 89-115.

Llona, Miren. "The Healing Effect of Discourses: Body, Emotions, and Gender Subjectivity in Basque Nationalism." In Memory, Subjectivities,andRepresentation.ApproachestoOralHistory in Latin America, Portugal, and Spain, by Rina Benmayor, María Eugenia Cardenal De la Nuez and Pilar Domínguez Prats. New York: Palgrave McMillan, 2016.

Renan, Ernest. "What is a Nation?" In Quést-ce une nation, by Ernest Renan. Paris: Presses Pocket, 1992.

Rich, Adrienne. Culture, Politics, and the Art of Poetry. Essential Essays. New York: Norton, 2018.

Smith, Sidonie, and Julia Watson. Reading Autobiography: A Guide for Interpreting Life Narratives. 2. Minneapolis: University of Minnesota Press, 2010.

Petra: The Legacy of a Basque Grandmother in the American West

Monika Madinabeitia

Mondragon Unibertsitatea

Let me tell you a story – the story of Petra Amoroto Egaña. In truth, it could be the story of many of the Basque women that left their homeland and headed to the American West. In fact, it could the story of any emigrant woman. The little story of Petra indeed represents the big history of Basque emigration, especially that of Basque women: Women who established the foundations and repositories of Basqueness for their grandchildren, who subsequently embraced their Basque ethnicity safely and with pride.

Petra was born in 1887 in Markina, in the Basque province of Bizkaia, to José Evaristo Amoroto and Manuela Francisca Egaña. It is still unclear what happened to her parents, for some of the evidence points to them passing away when Petra was very young, while other pieces of information contradict this version. In any case, for one reason or another, Petra's parents were no longer around when she was a young girl, a neskatila. Her uncle Jose Mari adopted her in his family. Jose Mari Amoroto was the brother of Petra's father. He was married and had children of his own. Nonetheless, Petra became like a daughter to him and to his wife. Petra was actually so close to her uncle's family that she ended up being like a sister to her cousin Raimunda.

Petra once received a letter. Its postmark was oddly unfamiliar to Petra. Before excitedly opening the envelope, she checked the postmark more thoroughly. She could not figure out what it said exactly, but she understood that the letter came from the United States of America – Ameriketatik, she thought. The letter was signed by someone named Esteban Mendive, also unknown to Petra. Petra must have been in her late teens/early twenties when she got this letter.

Esteban Mendive was born in Ajangiz, also in the province of Bizkaia. Like many other Basque men at the time, Esteban left the Basque Country to look for opportunities in the United States; he wanted to hacer las Américas and leave behind the poverty and the lack of opportunities in the Euskal Herria of the time. Though not for very long, Esteban initially worked with sheep in Nevada, in the American West. Sheepherding was one of the most frequent job options open to Basques in the West. Nonetheless, after working in the mines and other odd jobs, he was eventually able to run a store in Nevada – the Mendive Store. Esteban established himself in Battle Mountain, Lander County, in northern Nevada.

As Petra's family in Markina tells the story, another Basque in the West received a letter from his girlfriend in the Basque Country. With the letter was enclosed a photograph. This Basque's girlfriend appeared in the photograph, along with eleven other girls. They all worked for the same family in Markina. At one point the family had taken a photograph of all the maids. This is the picture that the Basque girl had sent her boyfriend in America. Esteban must have been around, for he saw the photograph. He paid special attention to one of the girls in it. Without Petra's knowing it, someone's heart in Nevada, on the other side of the world, started pounding much faster. Esteban asked

his Basque friend to get information about the girl that had captured his attention. He learned that her name was Petra and that she was from Markina. Esteban wanted to write to her. He eventually obtained Petra's address with the help of this Basque friend in Nevada and his girlfriend in Markina.

Petra had attended school and knew her three "R"s. She used to read the newspaper frequently. She was not a farmer – a baserritarra, but an urban girl – a kaletarra. The Markina of the time, although isolated from the world, was not rural, but more like a small city. Petra's family was not wealthy, but they were fairly well-off. They had fine houses and lived comfortably. The family today remembers the Amoroto women as being modern and self-determined. They liked travelling and education was of high significance to them all. They took every opportunity to learn and educate themselves. Petra fit into this family profile, as her family in Markina still recalls.

It is not clear how long they corresponded with each other through letters. One day, though, Petra received a special letter from Esteban. Esteban asked Petra to marry him and go to America, to Nevada, where he was. Although Esteban was from Ajangiz and Petra from Markina, just nine miles apart, they had never seen each other. Had Esteban not left for America, they probably would not have met each other either, for back then communication and transportation between towns and villages was not as easy and quick as nowadays. Going all the way to the American West must have been not only expensive, but also extremely exhausting and even unsafe. This is what Petra's uncle and aunt told her when she gave them the news. Jose Mari and his wife did not approve of Petra's marrying Esteban, whom they had never met. The family remembers Raimunda being furious with

Petra. Petra is remembered as being pretty, so her family in Markina thought of her as having plenty of opportunities to marry well. No one really knows why, and we can merely speculate with the information we have, but Petra was determined to go to America. Whether it was the promising news that came from America, or whether it was the thrill of adventure, no one will ever know for certain.

Eventually, Petra's family agreed to her going to America, but only on one condition. She had to leave the Basque Country a married woman. They arranged the wedding to take place in Markina, in 1908. Petra got ready to be married, but instead of Esteban appearing for the wedding, his father, Juan José de Mendive,[1] took his son's place. At the time, Esteban was thirty-one years old and Petra twenty-one. The marriage took place on December 12, 1908, in Markina. Juan José had been provided with the power of attorney on November 2nd of the same year to replace his son in the wedding. Jose Mari Amoroto was one of the witnesses who also signed the wedding minute. Esteban's father signed "Juan José Mendibe," spelled the Basque way with a "b" rather than with the "v" that fits the Spanish spelling and was later used by the Mendives in the United States. Basque was not an official language in the Basque Country yet – although it was used in daily life more than it is nowadays – which is why the Spanish spellings of names were the official spellings at the time.

After getting married by proxy in Markina, Petra still had a long journey ahead to reach Esteban. The Ellis Island records show that she got to New York on January 14, 1909. She left Southampton on the Teutonic and crossed the Atlantic Ocean. The family does not know how Petra got to Southampton, in the United Kingdom, from

1 Name officially used in the marriage register in Markina, December 12, 1908.

the Basque Country. What they do know is that she travelled second-class and that it took her at least a couple of weeks to get to New York from the UK. Once in Ellis Island, as was routine at the time upon arrival, Petra had to go through many immigration tests to approve her entrance into the country. The family remembers that she was described as five feet seven, in good health, with dark brown hair and brown eyes. She had ten dollars with her. The immigration records registered Petra as Petra Mendive. As is customary in the Anglo-Saxon culture, Petra was officially dispossessed of her own surnames, Amoroto Egaña, and received that of her husband.

There is no information on how Petra managed in New York but bearing in mind the experiences of many other Basques, it is safe to assume that she had some support from the Basque community in the East. Many Basques remained in New York, but there were many more who travelled to the west coast than those who stayed. Juan Cruz and Josefa Aguirre helped numerous Basques obtain employment and travel information. Similarly, Casa Vizcaína (a hotel), their Valentín Aguirre's Travel Agency, and their Jai-Alai Restaurant were the results of the assistance they provided to many of the Basques that were planning to travel further west. In the early 1900s, Ogden, Utah, was the last railway stop for direct travelling from New York to the north and west of the US.[2] Petra's destination was pinned on her coat. That is where she was to meet Esteban, her husband.

Petra was fluent both in Euskara (Basque) and Spanish, but she could not speak a word of English. We may imagine the difficulties for the numerous Basque migrants and other people from all over the world in understanding and being understood when getting to America.

2 Gloria Totoricagüena, The Basques of New York: A Cosmopolitan Experience (Reno: Center for Basque Studies, 2005), 70-76.

On the train, Petra found a way to communicate her requests in the dining car. She used two four-syllable Spanish words, which she made sure to articulate clearly and slowly. She broke them into syllables to be understood: en–sa–la–da; cho–co–la–te.

Before the long journey, Esteban had sent Petra a brooch to show his love for her. It is not certain whether the brooch was posted or sent via another Basque; either way, they decided that Petra would wear the brooch when she got off the train in Ogden, Utah, so that Esteban would know who she was. No one knows what they said to each other or what he or she must have felt when husband and wife met for the very first time. Only Petra and Esteban will ever know. Once in the United States, they married for the second time; on this occasion both Petra and Esteban were physically there. According to La Historia de Los Vascongados en el Oeste de Los Estados Unidos,[3] Señorita Petra Morato (surname misspelled in the original source) and Señor Esteban were officially united in the holy bonds of matrimony in Ogden, Utah. That was right after Petra's arrival in Utah and before they left for Battle Mountain, Nevada. After the usual difficulties of any other migrant in the US, Esteban had been able to buy a small store in Battle Mountain in 1907 – the E.S. Mendive's Cash Store and General Merchandise. Six years later, once Petra was already with him, they built a second story on top of their store. That became the Mendive Hotel. La Historia de Los Vascongados en el Oeste de Los Estados Unidos was written in 1917, at the time when the store and the hotel were still being run. The experience of the Mendives is depicted as a story of success. The information gathered also justifies the belief that the Mendives accomplished the American Dream.

3 Sol Silen, La Historia de Los Vascongados en el Oeste de Los Estados Unidos (New York: Las Novedades Inc., 1917), 322.

Both the store and the hotel were later renamed as the Midway Store and Hotel for their strategical location halfway across the state. In the store, they stocked bacalao, salted cod, and freshly ground coffee. They used a big hand-crank coffee grinder for it. Many of the customers in Battle Mountain were Basques that worked in the desert. To them, eating bacalao must have been a treat and a way to feel a sensation of home. Similarly, the fact that it was salted must have made it easier for them to take it to the desert without it going bad. There were also non-Basque customers, many of whom were immigrants from other countries. The Mendives served them all. Considering the location of Battle Mountain, and the number of Basques in the American West, mainly working as herders, we may surmise that many of the people that found supplies and accommodation at the Mendive's were Basque.

Basques, as is customary in migration communities, gathered at informal venues. Basque hotels, otherwise known as Basque boardinghouses, became important gathering locations for the Basques in the West; they were usually the closest thing to the Basque home in the Old Country – it was their "home away from home."[4] Back then boardinghouses did not only signify accommodation but were the means for first-generation Basques to receive assistance when needing to visit a doctor or requiring other help due to their limited English. To some of the Basque shepherds – in particular, those who never married – boarding houses became their new home. This was the place where they could feel at home, and at ease, speaking their own mother tongue and communicating with other Basques. This was indeed the place where they were able to create a sense of home and establish a connection with the places they had left behind.[5] Many nurtured the idea of returning

4 Jeronima Echeverria, Home Away from Home: A History of Basque Boardinghouses (Reno: University of Nevada Press, 1999).
5 Jayani Bonnerjee, Alison Blunt, Cathy McIlwaine, and Clifford Pereira, "Connected

home, but only a few were able to do so; countless first-generation Basques remained in the West and this space became their new home. Nevertheless, both "homing desire" and "nostalgia for a homeland"[6] mingled in Basque hotels. Above all, these meeting places were a means to establish a sense of belonging, a sense of connection. These "home-making practices"[7] enabled "re-membering"[8] routines by re/creating a community where intergroup members were identified. Overall, as research demonstrates, family, home, and community create a sense of belonging. In fact, the community is vital in "generating people's sense of belonging."[9] Diverse sociological and anthropological studies show how community organizations and a shared perception of identity play a significant role in the construction of a sense of belonging.[10]

Petra settled down in Battle Mountain. She arrived in 1909 and had her first child, Maria Carmen, in 1910. The next child was also a girl, Lina Rose, born in 1911, only one year later. To Frank Bergon, Petra's grandson, 1911 became important not only because that is when his mother was born, but also because of the tragic events that took place not far from Battle Mountain. These tragic events, as explained later, then evolved into Frank Bergon's first novel, Shoshone Mike, published in 1987.[11] Petra subsequently gave birth to six other children: Julia Petra (1913), Pedro Rufino (1915), Elissa Antonia (1918),

Communities: Diaspora and Transnationality" (http://www.geog.qmul.ac.uk/media/geography/images/staff/Connected-Communities–Diaspora-and-Transnationality.pdf, 2012), 23 - retrieved September 10, 2018.

6 Avtar Brah, Cartographies of Diaspora: Contesting Identities (London: Routledge, 1996), 180.

7 Bonnerjee, "Connected," 23.

8 Anne Marie, Fortier, "Re-membering Places and the Performance of Belonging(s)" in Theory, Culture and Society, 16 (1999, 41-64).

9 Graham Crow and Allan Graham, Community Life: An Introduction to Local Social Relations (Hemel Hempstead: Harverster Wehatsheaf, 1994), 6.

10 Anne Marie Fortier, "Community, Belonging and Intimate Ethnicity" in Modern Italy (11 (1), 63-77); Peter Block, Community: The Structure of Belonging (San Francisco: Berrett-Koehler Publishers, 2008).

11 Frank Bergon, Shoshone Mike (New York: Viking Press, 1987).

Angela Victoria (1920), Neva Teresa (1922), and Louis Steven (1925). The young Petra who had left Markina had become a wife and then a mother. On top of all this, she continued to actively work in both the store and the hotel.[12]

Petra then became a grandmother. Frank Bergon was one of her grandchildren. He was born in Ely, Nevada, in 1943. At about the age of five, his family moved to California. They established themselves in Madera, in the Central Valley, where Bergon's paternal grandfather owned a ranch. Once Bergon worked out where his new home was, he learned that California was the West and that he himself was a Westerner. He lived on a ranch that had sheep, horses, and cattle; it also had cotton and alfalfa. As Bergon recalls, nobody back then used the word farm. Both his father and paternal grandfather were ranchers. They were Westerners. They lived on a ranch in the San Joaquin Valley, California. His father, mother, sisters, brother, grandfather, aunt, and himself were all Westerners. They spoke fluent English; English was, in fact, their mother tongue. They rode horses and wore outfits that were habitual in the West, like cowboy hats that would protect them from the scorching California sun. This scenario had little to do with that of the high desert of Nevada, where his grandmother Petra lived. Bergon felt that his maternal grandmother was oddly disconnected from who they were. She did speak English, but she had a strong foreign accent. She rolled her r's and would also utter dis, dat, and japi, while she meant this, that, and happy. There were some other difficult sounds for her to make in English, like distinguishing her v's and b's. To Frank, his grandmother was not like the other grandmothers. Her dresses were shapeless and buttoned down the front; in Frank's eyes,

12 See Echeverria Home Away, chapter "Etxeko Amak, Second Mothers" to learn more about women's role in boardinghouses and Basque hotels.

she was old-fashioned. Frank knew that she had been born in Europe, in Spain, but back then he did not know that she was actually from the Basque Country and that that made her different from Spaniards.

Petra's family remembers her as full of ausardia and indarra, courage and strength. She did well in America, but there were also many hard times she had to endure. When Esteban died, in 1944, Petra did not stop working. She continued hauling soiled sheets down the narrow, steep hotel stairs to the house. She washed them in an old squeeze-roll wringer-washer and then hung them on the clothesline. She was still doing that in her eighties; in fact, she never stopped working until death found her in 1975. There are many stories about Petra's hard work, even when she was elderly, like the time she was eighty-seven and crawled through a window onto the hotel's roof to help one of her sons repair it. Although her family believes she must have had a lot on her plate, she never showed it. She was a devout Catholic and followed many of the Basque religious traditions she had inherited. One of them was praying with her rosary in her hands. She attended mass every morning. Her rosary and prayer book are still lovingly kept by her relatives in Elko, Nevada. Her rocking chair, too, as well as much of the crochet work she was still doing in her older years.

Crocheting was one of the connections between Petra and her grandson Bergon. Petra tried to show the young Bergon the intricacies of crocheting. She also taught him some words in Euskara. Lina Rose spoke English, or occasionally Spanish, to her children. Bergon and his siblings did not learn any Basque from their mother Lina. Petra's little Euskara lessons triggered Bergon's senses to learn more about the Basque world, its language included. Back then he did not know anything about Euskal Herria or Euskara; it was later, through research and visits

to the homeland, when he learned about his Basque ancestry and the Basque world. Petra likely did not know as much about her old place as did Bergon years later. Petra was a Basque, she spoke the language of the Basques, but, as was often the case back then, she possibly did not know that she spoke one of the oldest languages in Europe or that Euskara is a pre-Indo-European isolate language. Vince Juaristi's Back to Bizkaia[13] recreates how both the father, Joe, and the son, Vince, are both Basque in different ways and fashions. Joe, like Petra and many other first-generation Basques, speaks fluent Euskara. Their children do not. However, when both Joe and Vince visit the Basque Country in 2008, it is the son who instructs the father about the latter's own homeland. Although Joe and Petra were both born in the Basque Country and grew up there, they did not learn about their homeland in a formal way, which is usual for first generation migrants of the time. In the case of the Juaristis, for example, Vince explains that – dissimilar to the ways of the US – businesses do not open on Sundays. He tells his father Joe about the cooperatives nestled in Arrasate,[14] the Civil War and the Bombing of Gernika,[15] and Franco's time.[16] When Joe tells his son about Euskara, Joe knows that it is the oldest language in Europe but thinks that "It survive 'cause it pass from grandpa to daddy to boy. Dey don' write it down."[17] Vince corrects him and says that it is written down. Joe and Vince personify how the elders have the first-hand Basque experience, while their offspring have the knowledge and information. The same pattern is followed by Petra and many other immigrant families. The elderly do not have the formal or academic knowledge, but the vivid experience.

13 Vince Juaristi, Back to Bizkaia: A Basque-American Memoir (Reno: University of Nevada Press, 2011).
14 Juaristi, Back to Bizkaia, 115.
15 Juaristi, Back to Bizkaia, 28-30; 32-37.
16 Juaristi, Back to Bizkaia, 46-51.
17 Juaristi, Back to Bizkaia, 56.

This first-hand vivid experience was almost always one of the main sources of diasporic Basques' ethnic awareness, especially once it became fashionable to be from somewhere else. Petra's story recreates a general tendency within Basque Americans. Second-generation Basques consciously rejected and denied their ethnic roots. Bergon's maternal grandparents spoke Basque amongst themselves, but their children did not continue either these linguistic or cultural practices Many second-generation Basques were downgraded, scorned, and despised for their foreign roots. Bergon claims: "My parents' generation wanted to put the European past behind them. Neither my father nor mother ever visited Europe. They wanted to be Americans, and they wanted me to be an American."[18] Ethnic awareness in these cases is thanks to grandparents, notably grandmothers; in fact, they have been crucial in the ethnic awareness and transmission of Basque identity.[19] Bergon goes on to say, "My grandmother, however, was very Basque, and she taught me some words in Spanish and in Euskara when I was a child."[20] Identically, Martin Etchart's "Amatxi" recalls his personal memories of his own childhood with his grandmother. His fiction resonates with the generational transition from immigrant to American-born.[21] Another example is the name that a music band from Boise, Idaho, gives themselves: Amuma Says No. Some of the band members explain: "My Amuma used to work at Dan's Amuma's boarding house and restaurant in Sun Valley back in the 1930's. We also found out that Jill's Amuma was close friends with my Amuma."[22] As they were

18 Monika Madinabeitia, "Getting to Know Frank Bergon: The Legacy of the Basque Indarra," in Journal of the Society of Basque Studies in America 28 (2008), 71.
19 Linda White and Cameron Watson, Amatxi, Amuma, Amona: Writings in Honor of Basque Women (Reno: Center for Basque Studies, 2003).
20 Madinabeitia, Getting to Know, 71.
21 Martin Etchart, "Amatxi" in Amatxi, Amuma, Amona: Writings in Honor of Basque Women (edited by Linda White and Cameron Watson, Reno: Center for Basque Studies, 2017 [2003]), 21-34.
22 "Frontoitik kalera': Basque-American band Amuma Says No hits the streets with its debut album" (http://www.euskalkultura.com/english/news/frontoitik-kalera-basque-american-

debating on the name, the band members realized that they often said, "My amuma would say no," to this or that. The ultimate result was Amuma Says No (ASN).[23] Trisha Clausen Zubizarreta, another Idahoan from Boise, opens her book Chorizos, Beans, and Other Things[24] with a special tribute to her grandmother, Amuma Candida. Zubizarreta explains, "The feelings I have for my grandmother can't be put onto paper in a way that would do her justice. There are so many things I remember about her." When she was eighty-four, "Amuma was every bit the woman she was at twenty-five, when she first came to this country... Amuma was a country girl who chose to travel thousands of miles away from home to the New World to begin a new life. A life that would bring marriage, thirteen children, twenty-eight grandchildren, and fourteen great-grandchildren." Like Petra, Amuma Candida "grew from a young girl into a woman. She was a strong woman, or perhaps the years made her strong." Candida's "children have gone on to build successful lives for themselves, as well as her grandchildren. I'm proud to have had a grandmother like her." Similarly, Zubizarreta claims she is "sure Amuma would be proud to know that her granddaughter has written a book about the Basques," and hopes that "after reading it, those unfamiliar with our culture will have a better understanding of the Basque people. For those of you who are Basque, I hope you will recognize a bit of yourself or family in the poems and will appreciate your heritage even more."[25]

band-amuma-says-no-hits-the-streets-with-its-debut-album, 12/19/2008), retrieved September 14, 2018

23 "Basque Musical Traditions Updated in Idaho" (https://www.voanews.com/a/basque-musical-traditions-updated-in-idaho-121793974/164953.html,05/12/2011),retrieved September 14, 2008.

24 TrischaClausenZubizarreta,Chorizos,Beans,andOtherThings:APoeticLookattheBasque Culture (Boise: Lagun Txiki Press, 1987).

25 Zubizarreta, Chorizos, Beans, n.p.

Contrary to the second generation, third-generation Basques profited from the good reputation Basques had earned thanks to their work ethic, perseverance, and financial success. Bergon is certainly an example of the sociologist Marcus Lee Hansen's (1937) "third-generation return hypothesis." The first generation, the immigrant generation, established spaces and venues that operated as ethnic organizations and institutions. While second-generation children wanted to blend in and be like their peers, the grandchildren, who already fit in the mainstream, felt the need to belong to something and somewhere else. They hence fostered voluntary conscious ethnic affiliation. That is why many grandchildren wished to remember what their parents had tried to forget.[26] Bergon depicts this ethnic awakening and awareness in his third novel, Wild Game (1995),[27] through the Basque-American protagonist Jack Irigaray. Bergon's last novel, Jesse's Ghost (2011)[28], also provides an insight into the Basque-American ways in the American West. Similarly, his first novel, Shoshone Mike, recreates the rejection of Basque identity and the urge to assimilate to the mainstream solely as American. Bergon's first novel, which recreates the Last Indian Battle, also known as The Last Indian Massacre,[29] highlights the difficulties of many immigrants upon arrival in a foreign country. The need to claim one's Americanness is underscored through the second-generation character, Jean Erramouspe, who stresses he is "as American as anyone else."[30] The tragic events took place in 1911, when, as previously pointed out, Bergon's mother was born. At that time, Basques were derisively called

26 Marcus Lee Hansen, "Who Shall Inherit America?" in American Immigrants and Their Generations: Studies and Commentaries on the Hansen Thesis after Fifty Years (edited by Peter Kivisto and Dag Blanck. Urbana: University of Illinois Press, 1990 [1937]).
27 Frank Bergon, Wild Game (Reno: University of Nevada Press, 1995).
28 Frank Bergon, Jesse's Ghost (Berkeley: Heyday, 2011).
29 Depending on the perspective, "massacre" can be understood in one way or another: while some see the Indians as committing the massacre, others view the posse as the perpetrators of the massacre when killing the Shoshone.
30 Bergon, Shoshone Mike, 46.

Basco. Many of the second-generation Basques were raised Basque at home but were American outside. Their private family environment was Basque, but numerous Basques wanted to be seen as simply American and be acknowledged as so. Oftentimes, "Their inability to speak English made them targets of other children's cruelty. ... They were branded as 'black Bascos' or 'garlic snappers,' words used earlier by cowboys arguing with sheepherders over grazing land. They got into more than a few fistfights on the playgrounds."[31] This type of approach and attitude resulted in dissuading many from speaking Basque and from feeling Basque. Mainly due to conflicts over range rights, Basques themselves "were prone to downplay their ethnic uniqueness."[32] These ethnic dis/connection relationships and affiliation representations proliferate in Bergon's academic and fieldwork research, as well as in his experience as a first-hand Basque American himself.

As did numerous immigrant parents, Petra and Esteban worked hard in order to provide their children with more possibilities than those they had been given in their homeland. They tried to instill in them good habits and values. They wanted their children to be successful in America by climbing the ladder, without having to do the jobs that no one else wanted – like herding, for example, as explained in Shoshone Mike. There are countless stories of success within the Basque experience. In fact, the economic success achieved by many Basques, plus their parents' endurance, hard work, and perseverance, paved the way for the American Dream of many. This success translated into Basques becoming an integral part of the American community; Basques became visible in the eyes of the mainstream. Jack Irigaray points out in Wild Game

31 John Bieter and Mark Bieter, An Enduring Legacy: The Story of Basques in Idaho (Reno: University of Nevada Press, 2000), 77.
32 Richard H. Lane and William A. Douglass, Basque Sheep Herders of the American West (Reno: University of Nevada Press, 1985), 32.

that "Laxalt, Arrizabalaga, Ybarguengoitia were familiar names around Reno, but no longer of sheepherders. The solitary Basque herders of previous generations – those tough 'Black Bascos' as they were derisively called – had pretty much vanished. … Most of the Basques … sold cars, taught school, ran banks."[33] The novel also highlights how the term "Basco" had become positively used in recent years.[34]

Although many Basque men worked as sheepherders, at least for a while, and usually upon their arrival, many others were employed in other jobs. This is the case of Esteban Mendive, Bergon's Basque grandfather, who worked in the mines before opening the Mendive Store in Battle Mountain. Sadly, there are not many records about women in the American West. As in Petra's case, they were dispossessed of their maiden names when married, which makes it more difficult to trace back the experiences of the many Basque women who left their homeland. Similarly, women were often positioned in weak supporting roles, often justifying their existence so as to define men. Basque women were not only forgotten in the metanarrative of the history of the American West but have also been neglected within Basque Diaspora and Migration Studies. For most of the twentieth century, sociological research on international migration only focused on men. Before the 1980s, scholars largely regarded immigrant women as simply following their husbands; women were thus considered of little or no importance to understanding immigration. Consequently, for almost a whole century, women were largely invisible in the field.[35] In other words, compared to male Basque emigrants, who were also out of the picture in the official narrative of the West, Basque women have been

33 Bergon, Wild Game, 2-3.
34 Bergon, Wild Game, 2.
35 Rita J. Simon and Caroline B. Brettel, "Immigrant Women: An Introduction" in International Migration: The Female Experience (edited by Rita J. Simon and Caroline B. Brettel, New Jersey: Rowman and Allanheld, 1986), 3-20.

ignored twice. Therefore, it is difficult, if not impossible, to know as much about Basque female migrants.

In the 1970s, "The invisibility of women was first questioned … as feminist perspectives emerged in various humanities and social science disciplines. … At the time, scholars in women's studies asked a simple question: 'Where are the women?'"[36] As a result, memory is key when trying to recuperate the story of these women. Much of the information gathered for this article is in fact the result of the memories of the Amoroto and Mendive families, both in the Basque Country as well as in the American West. If a family produces and maintains its memory together, its cohesion and continuity are bound to occur. The family's shared narrative, which crisscrosses generations, reproduces family traditions and unique sentiments that are jointly co-memorized.[37] Recalling memories is a strategy to encode personal and collective experiences and is "an act of remembering that can create new understandings of both the past and the present. Memories are an active process by which meaning is created"[38] and play a role when individuals construct both their social and personal identities.

Often, people's memory of home or homeland includes food. To be more precise, it is food that triggers these memories. In fact, "food represents a particularly strong form of anchorage in the past, its strength deriving in part from the familial relationship in which the serving and preparing of foods are located. … Food, then, serves as one of the links between historical, individual time and household time."[39] Certainly,

36 Chien-Juh Gu, "The Gendering of Immigration Studies in the United States" in At the Center: Feminism, Social Science and Knowledge (edited by Vasilikie Demos and Marcia Texler Segal, Bingley: Emerald Group Publishing Limited, 2015 [1997]), 271.
37 Michael Billig, "Collective Memory, Ideology and the British Royal Family" in Collective Remembering (edited by David Middleton and Derek Edwards, London: Sage, 1990).
38 Vijay Agnew, "Introduction" in Diaspora, Memory, and Identity: A Search for Home (edited by Vijay Agnew, Toronto: University of Toronto Press, 2005), 8.
39 David H.J. Morgan, Family Connection: An Introduction to Family Studies (Cambridge:

food is regarded as an enduring and tangible link to one's heritage; what we eat expresses our beliefs, cultural and social background, and personal experiences. Food is thus a means to transfer consciousness and it facilitates the shaping, articulation, and acknowledgment of a particular ethnic identity. Food shapes emotional ties between oneself and the community. It can also serve to internalize an ethnic affiliation and diasporic consciousness. Food serves as sensorial engagement and, because of its multisensory nature, food and its associate practices – like shopping, preparing, and eating – "evoke a multifaceted experience of place,"[40] recreating sensory landscapes of home.[41] Food is widely recognized as one of the cultural and material practices most connected to the expression, maintenance, and re/construction of identity groups;[42] it is sensorial and triggers memories, which are similarly testimonies of re/connection with one's past; food memories shorten and connect time and distance while providing a way to tell stories and histories, to remember them, to form identities, and to imagine communities.[43] The sensorial capacity of food can unleash many memories – frequently, memories stored in our subconscious. Food is one of the main practices within Basque diaspora communities in the American West. Certainly, food – along with boarding houses – has been vital in creating a sense of home and connection amongst Basque migrants. The "visceral experience of food" shapes "emotional and affective relations with place

Polity Press, 1996).

40 Lisa Law, "Home Cooking: Filipino Women and Geographies of the Senses in Hong Kong" in Ecumene 8 (2001, 264-283), 267.

41 C. Nadia Seremetakis, The Senses Still: Perception and Memory as Material Culture in Modernity (edited by C. Nadia Seremetakis, Chicago: The University of Chicago Press, 1994).

42 Nir Avieli, "Roasted Pigs and Bao Dumplings: Festive Food and Imagined Transnational Identity in Chinese-Vietnamese Festivals" in Asian Pacific View Point, 46 (2005, 281-294); Krishnendu Ray, The Migrant's Table: Meals and Memories in Bengali-American (Philadelphia: Temple University Press, 2004); Moya Kneafsey and Rosie Cox, "Food, Gender and Irishness – How Irish Women in Coventry Make Home" in Irish Geography 35 (2002, 6-15).

43 Seremetakis, The Senses Still.

and create a sense of home."[44] Food is undoubtedly an ongoing home-
making practice in the contemporary Basque-American community.
Basque restaurants, picnics, and festivals all over the West devote an
important role to traditional Basque food. Similarly, places like the
Basque Market in Boise (Idaho) are not only practices of homemaking,
but also of "re-membering"[45] and "re-memory."[46]

Bergon's memories of Petra include the smells drifting from his
grandmother's wood-fired kitchen stove. These distinctive, rich smells
became part of Bergon's memory of his Basque childhood, and in turn
– along with other memories – an integral ingredient of the legacy
Bergon inherited from his grandmother. These memories helped him
understand and construct his own ethnic identity. In the mornings,
Petra would fill Bergon's heavy white bowl with chunks of homemade
bread, soaked in hot coffee and milk, plus lots of sugar. Bergon did not
know it back then, but that breakfast was what we know as sopesniak
in the Basque Country – the traditional Basque breakfast of the old
times. Presumably, that is what Petra used to have for breakfast back at
home and then continued with the tradition in her home in Nevada.

By emulating homeland cooking and eating rituals, many
immigrants produce a taste of home. This taste may also be the outcome
of the imagination and the memories of the home left behind. In any
case, this relational constitution of particular tastes conveys a specific

44 Robin Longhurst, Lynda Johnston, and Elsie Ho, "A Visceral Approach: Cooking 'at
 Home' with migrant women in Hamilton, New Zealand" in Transactions of the Institute of
 British Geographers 34 (2009, 333-345), 333.
45 Fortier, "Re-membering Places."
46 "Re-memory is memory that is encountered in the everyday, but is not always a recall or
 reflection of actual experience. It is separate to memories that are stored as site-specific
 signs linked to experienced events. Re-memory can be the memories of others as told to
 you by parents, friends, and absorbed through day-to-day living, that are about a sense of
 self beyond a linear narrative of events, encounters and biographical experiences" (Divya,
 Tolia-Kelly, "Locating Processes of Identification: Studying the Precipitates of Re-memory
 through Artifacts in the British Asian Home" in Transactions of the Institute of British
 Geographers (34, 2009, 314-329), 316.

context of displacement and relocation, enunciated in the aesthetics and expressions of the everyday. Petra is remembered as being a good cook. However, as is the case for other immigrants, Petra had to adapt much of her cooking to the American way. This adaptation evolved into what we now know as Basque-American cooking and food. Mary Ancho Davis, in Chorizos in an Iron Skillet: Memories and Recipes from an American Basque Daughter,[47] gathers this change and adaptation in the Basque culinary tradition. In the early 1900s, Basque immigrants brought with them a basic cuisine, identified as traditional Basque cooking. This cuisine, almost always simple and unelaborate, was the cooking of ordinary people. Its main purpose was to feed the family members, workers, and sheepherders in boarding houses. In other words, rather than seeking perfection and elaboration, hearty and easy meals were often preferred. Besides, it was usually difficult and/ or expensive to get the ingredients used back home. Other times the taste of the ingredients differed, which made a palatal difference in the final outcome. Similarly, boarding houses also served other ethnic groups, which meant that they had to adapt some of the ingredients and cooking styles to please others. That was the case of garlic, for example. All these factors gave way to Basque-American cooking and eating – a process that took place principally in boarding houses, but also in smaller private and family spheres. The boarding houses gradually became open gathering places for Basques and non-Basques. The sheep industry declined, which directly affected "the institution of the Basque boarding house. Many of these establishments, however, adapted and became restaurants." The "food and the form in which it [was] served naturally reflect[ed] their Basque-American origins rather than homeland cuisine." While in the past it was "a dining room full

47 Mary Ancho Davis, Chorizos in an Iron Skillet: Memories and Recipes from an American Basque Daughter (Reno: University of Nevada Press, 2002).

of hungry sheepherders at long tables, today's restaurants serve up generous amounts of hearty food family-style."[48] Initially, "the long communal tables at Basque hotels began as a rooming-house custom for boarders. ... In other words, family style was invented for men without families, mostly unmarried Basque sheepherders." Basque hotels were simultaneously "both cultural havens and transitional zones of assimilation for immigrants. ... The concept of 'family' expanded as Basques began to invite friends for dinner. ... Eventually the hotels opened up their boarders' tables to the public."[49] One may typically find "soup; green salad; beans; vegetables; stew; lamb, beef, chicken or fish; bread; red wine; ice cream and coffee. Sweetbreads, beef tongue, and salt cod are often offered. Red and green peppers, tomato, onion and garlic are the underpinnings of most dishes."[50]

Bergon enjoys the now so-called Basque family-style restaurants. As he portrays through the Basque-American character in his novel Jesse's Ghost, Mitch Etcheverry likes going to such restaurants with his friends and family. That is, in fact, one of the ways to be and feel Basque in America. For Bergon, "Sunday afternoons in the 1950s ... often meant going to the Basque Hotel or the Santa Fe Hotel in Fresno. [His] family lived on a ranch twenty-five miles away. ... Both hotels offered a child's vision of ... families hooked up with relatives and friends."[51] To Bergon, and many other Basque Americans, Basque eateries were, and still are, a means to articulate their ethnic belonging and identity, a device to connect their past and present. Indeed, bodily impressions through familiar sensorial reminders activate memories, which are "the glue

48 "Basque Folklife" (ONE, Online Nevada Encyclopedia, http://www.onlinenevada.org/articles/basque-folklife) – Retrieved September 19, 2018.
49 Frank Bergon, "Family Style" in Gastronomica (November 4, 2001, https://gastronomica.org/2001/11/04/family-style/).
50 http://www.onlinenevada.org/articles/basque-folklife
51 Bergon, "Family Style."

that holds the past and present together."[52] Food and its effects can be analyzed from a visceral viewpoint –"visceral"understood as"sensations, moods and ways of being that emerge from our sensory engagement with the material and discursive environments in which we live. Paying attention to the visceral means paying attention to the senses – sight, sound, touch, smell and taste – which are a mechanism for visceral arousal."[53] Food has the power to trigger visceral reactions. It is a"home-making practice"[54] that enables"re-membering"[55] routines by recreating a community where intergroup members are identified. Food invites a sense of collectivity, a sense of community and belonging, and it offers an intense sense of both self and others. Similarly,"memory, perception, cognitive thinking, historical experience, and other material relations, and immaterial forces all intersect with individuals'sensory grasp of the world."[56] This sensory threshold allows diaspora members to go "back home,"[57] wherever or whatever this home may be, both individually and collectively. The ambience re/created in the Basque family-style restaurants generates a strong sense of "affective communication," which is identically received with an enhanced feeling of "affective engagement."[58] Certainly, food is one of the most accented identity markers of individuals and communities.[59] The Basque-American West is an example of how "the descendants of the diasporic movements ...

52 Vijay Agnew,"Diaspora and Memory"in Diaspora, Memory, and Identity: A Search for Home (edited by Vijay Agnew, Toronto: University of Toronto Press, 2005), 19.
53 Longhurst, Johnston, and Ho, "A Visceral Approach," 334.
54 Bonnerjee, "Connected," 23.
55 Fortier, "Re-membering Places."
56 Allison Hayes-Conroy and Jessica Hayes-Conroy,"Taking back taste: feminism, food and visceral politics"in Gender, Place and Culture: A Journal of Feminist Geography (15, 2008, 461-473), 465.
57 Longhurst, Johnston, and Ho, "A Visceral Approach," 339.
58 Steven R. Livingstone and William Forde Thompson,"The Emergence of Music from the Theory of Mind" in Musicae Scientiae (Special Issue, 2009-2010, 83-115), 87; 85.
59 John Baily and Michael Collyer,"Introduction: Music and Migration"in Journal of Ethnic and Migration Studies 32(2) (2006, 167-182), 173.

have developed their own distinctive cultures which both preserve and often extend and develop their originary cultures."[60]

As explained previously, numerous biographies show that second-generation Basques felt detached from their ethnic heritage. As a result, many third-generation Basques were not aware of their Basqueness until much later. This is the case of Bergon too. Bergon felt that at home they were Americans first and Westerners second. When pressed for his heritage, he would say that he was "half French, half Spanish," or even "mostly French," so as to make a long story short and hence explain the region where his surname came from. As many other young third-generation Basques, once Bergon became aware of his ethnic roots, in great part thanks to his grandmother, this new conscious identity and connection to the Basque community became an important part of his life. As a matter of fact, he explains, "The first story I ever published in a high school literary magazine, when I was seventeen years old, was titled 'The Flood,' and it was about a Basque sheepherder in California named Fermin Erro."[61] The affective connection Bergon felt toward his grandmother, which had been made primarily through food and the practices around it, activated and enhanced Bergon's interest in his ethnic heritage. He asserts, "It's clear that from the beginning of my writing career, I was curious about my Basque heritage. Later I began to attend Basque festivals and to learn something about Basque history, both in Europe and America."[62]

The third and subsequent generations have primarily been able to benefit from the possibility to publicly manifest their Basqueness without coming into conflict with their American identity. As a matter

60 Bill Aschroft, Gareth Griffiths, and Helen Tiffin, Key Concepts in Post-Colonial Studies (London: Routledge, 1998), 57.
61 Madinabeitia, Getting to Know Frank Bergon, 71.
62 Madinabeitia, Getting to Know Frank Bergon, 71.

of fact, "the third generation, the ethnic generation, developed during a period of immense change in the US. During the 1960s and afterward, it became less fashionable to be simply American – living in what many considered to be a bland, vanilla culture – and increasingly popular to be from somewhere, to have an identity that set one apart." This was possible because "in many ways, third-generation Basques had the best of both worlds; they could claim to be unique in the larger American society, yet still feel the security of a community."[63] Indeed, the community has played, and still plays, an important role in the construction of Basque identity; "the idea of community is related to the search for belonging in the insecure conditions,"[64] and the Basque diaspora is no exception. In truth, home and family were the first valuable constituents of this community.

Before it became trendy and safe to publicly manifest that one was from somewhere else, in addition to American, families provided the ethnic transmission that would then become something to be proud of. As already explained, since second-generation Basques grew up in a context where being Basque was not yet secure, it was grandparents, in particular grandmothers, who became the primary transmitters of Basque identity. This transmission was almost always unconscious and unaware. Grandmothers, on most occasions, left their homeland while still very young. They became wives, mothers, and grandmothers in a foreign country that had then become their home too. They grew old and watched their faces and hands wrinkle in a country far away from their own ancestors and families. Although Basque immigrant women went through many difficulties that arose from their immigrant and womanhood status – such as raising children in a foreign language,

63 Bieter and Bieter, An Enduring Legacy, 5.
64 Gerard Delanty, Community (New York: Routledge, 2010 [2003]), x-xi.

adapting to new ways and styles, having limited and slow communication with their families in the homeland, and working hard in numerous jobs – they were in general strong women. Or, as Zubizarreta[65] claims, maybe life and the years made them strong. Whatever the case, and whether or not they were aware, they kept many of the identity markers from the homeland. As opposed to their children, they were the full transmitters of the homeland identity. Their ways of dressing (like the old-fashioned dresses that Petra wore), their strong accent, their religious devotion, their Basque words, their stories, their cooking, all became an important bond with their grandchildren.

Through Basque cooking and eating, participants are able to not only express themselves as Basques but also to feel Basque and to display this feeling of belonging. In private family gatherings, family-style restaurants, picnics, and festivals, peer encouragement is a means to hold onto one's identity or even consolidate one's awareness. This awareness is inter-generational, both vertical and horizontal, and it provides Basques of different generations with the space to share unique experiences and ways of being and feeling Basque. Indeed, Petra's practices at home, in her private kitchen, like the many private connections and stories that other Petras wove with their own grandchildren, have become part of the public manifestations of ethnic pride nowadays. The smells and tastes that drifted from the kitchens of Basque amamas have served as a foundation for sensorial and affective narratives, landscapes of homes that connect both the past and the present. Sensorial memories are triggered and activated; they are viscerally experienced and encoded. They operate as private and public accounts and are "constantly made and remade as people try to make sense of the past."[66] The process of

65 Zubizarreta, Chorizos, Beans, n.p.
66 Agnew, "Introduction," 9.

remembering happens at a cognitive, emotional, and physical level. It can be voluntary or involuntary[67] and reminds one of "who they are and where they come from."[68] No doubt, food geographies are a significant grammar for the migrant and diasporic self; food practices create a sacred connection, as well as a particular ambience and ethos. Food connects oneself to one's ancestry and has material, symbolic, and emotional value.

Grandmothers have certainly cultivated and reinforced the foundation for the transmission of ethnic identity. Petra, through her sopesniak, for example, instigated Bergon's Basque identity. She furnished him with the groundwork for a positive sense of belonging; without her knowing it, Petra promoted resources that Bergon would then contest, negotiate, and re/construct to become the Basque-American scholar and writer he has become today. Thanks to Petra, when Bergon first visited the Basque Country and his Basque family, he recognized many of the smells and tastes from his grandmother's kitchen. This visceral and sensorial experience allowed Bergon to engage with his past and his present, to re/connect with his childhood memories and to come to terms with his ethnic identity. Since then, Bergon's experience as a Basque American has enabled him to express, maintain, and engage in emotional and affective communication. Thanks to Bergon and his memories, he has given visibility to many of the narratives of the Basque West. Bergon points out that "it's not necessarily the right way, but it's our way."[69] This "our way" is, without a doubt, as valid as any other way. It is the way that evolved from the many Petras, who certainly convey the history of Euskal Herria – both now and then. Through the

67 David E. Sutton, Remembrance of Repasts: An Anthropology of Food and Memory (Oxford: Berg Publishers, 2001), 37.
68 David J. Parkin, "Mementoes as Transitional Objects in Human Displacement" in Journal of Material Culture 4 (3) (1999, 303-320), 313.
69 Bergon, "Family Style."

memories of grandchildren and further generations, we can recuperate some of the biographies, at least partly, about the many women that left the Basque Country and made a fine home for those who came after them.

WORKS CITED

Agnew, Vijay. "Diaspora and Memory." In Diaspora, Memory, and Identity: A Search for Home, de Vijay Agnew, 19-21. Toronto: University of Toronto Press, 2005.

Agnew, Vijay. "Introduction." In Diaspora, Memory, and Identity: A Search for Home, de Vijay Agnew, 3-18. Toronto: University of Toronto Press, 2005.

Aschroft, Bill, Gareth Griffiths, and Helen Tiffin. Key Concepts in Post-Colonial Studies. London: Routledge, 1998.

Avieli, Nir. "Roasted Pigs and Bao Dumplings: Festive Food and Imagined Transnational Identity in Chinese-Vietnamese Festivals." Asian Pacific View Point 46 (2005): 281-294.

Baily, John and Michael Collyer. "Introduction: Music and Migration." Journal of Ethnic and Migration Studies 32(2) (2006): 167-182.

Bergon, Frank. Gastronomica. https://gastronomica.org/2001/11/04/family-style/ November 4, 2001.

—. Jesse's Ghost. Berkeley: Heyday, 2011.

—. Shoshone Mike. New York: Viking, 1987.

—. Wild Game. Reno: University of Nevada Press, 1995.

Bieter, John and Mark Bieter. An Enduring Legacy: The Story of Basques in Idaho. Reno: University of Nevada Press, 2000.

Billig, Michael. "Collective Memory, Ideology and the British Royal Family." In Collective Remembering, by David and Derek Edwards Middleton, 60-80. London: Sage, 1990.

Block, Peter. Community: The Structure of Belonging. San Francisco: Berrett-Koehler Publishers, 2008.

Bonnerjeee, J., Blunt A., McIlwaine, C., and Pereira, C. Connected Communities: Diaspora and Transnationality, 2012.

http://www.geog.qmul.ac.uk/media/geography/images/staff/Connected-Communities--Diaspora-and-Transnationality.pdf.

Brah, Avtar. Cartographies of Diaspora: Contesting Identities. London: Routledge, 1996.

Chien-Juh, Gu. "The Gendering of Immigration Studies in the United States." In At the Center: Feminism, Social Science and Knowledge, de Vasilikie and Marcia Texler Segal Demos, 269-290. Bingley: Emeral Group Publishing Limited, 2015 [1997].

Crow, Graham and Allan Graham. Community Life: An Introduction to Local Social Relations. Hemel Hempstead: Harvester Wheatsheaf, 1994.

Davis, Mari Ancho. Chorizos in an Iron Skillet: Memories and Recipes from an American Basque Daughter. Reno: University of Nevada Press, 2002.

Delanty, Gerard. Community. New York: Routledge, 2010 [2003].

Echeverria, Jeronima. Home Away from Home: A History of Basque Boardinghouses. Reno: University of Nevada Press, 1999.

Encyclopedia, ONE - Online Nevada. n.d. Basque Folklife. http://www.onlinenevada.org/articles/basque-folklife.

euskalkultura.com. http://www.euskalkultura.com/english/news/frontoitik-kalera-basque-american-band-amuma-says-no-hits-the-streets-with-its-debut-album, 2008.

Fortier, Anne Marie. "Community, Belonging and Intimate Ethnicity." Modern Italy (11 (1)): 41-64, 2006.

Fortier, Anne Marie. "Re-membering Places and the Performance of Belonging(s)."Theory, Culture and Society 16: 41-64, 1999.

Hayes-Conroy, Allison and Jessica Hayes-Conroy. "Taking Back Taste: Feminism, Food and Visceral Poliitics." Gender, Place and Culture (2008): 461-473.

Juaristi, Vince. Back to Bizkaia: A Basque-American Memoir. Reno: University of Nevada Press, 2011.

Kneafsey, Maya and Rosie Cox. "Food, Gender and Irishness - How Irish Women in Coventry Make Home." Irish Geography 35 (2002): 6-15.

Law, Lisa. "Home Cooking: Filipino Women and Geographies of the Sense in Hong Kong." Ecumene 8 (2001): 264-283.

Livingstone, Steven R. and William F. Thompson. "The Emergence of Music from the Theory of Mind." Musicae Scientia (2009-2010): 83-115.

Longhurst, Robin, Lynda Johnston, and Elsie Ho. "A Visceral Approach: Cooking 'at Home' with migratn women in Hamilton, New Zealand." Transactions of the Institute of British Geographers 34 (2009): 333-345.

Madinabeitia, Monika. "Getting to Know Frank Bergon: The Legacy of the Basque Indarra." Journal of the Society of Basque Studies in America, 28 (2008): 69-75.

Morgan, David H. J. Family Connections: An Introduction to Family Studies. Cambridge: Polity Press, 1996.

Parkin, David J. "Mementoes as Transitional Objects in Human Displacement." Journal of Material Culture 4(3) (1999): 303-320.

Ray, Krishnendu. The Migrant's Table: Meals and Memories in Bengali-American Households. Philadelphia: Temple University Press, 2004.

Seremetakis, C. Nadia (ed.). The Senses Still: Perception and Memory as Material Culture in Modernity. Chicago: The University of Chicago Press, 1994.

Silen, Sol. La Historia de los Vascongados en el Oeste de los Estados Unidos. New York: Las Novedades Inc, 1917.

Simon, J. Rita and Caroline B. Brettel. "Immigrant Women: An Introduction." In International Migration: The Female Experi-

ence, de J. Rita and Caroline B. Brettel Simon, 3-20. New Jersey: Rowman and Allanheld, 1986.

Tolia-Kelly, Divya. "Locating Processes of Identification: Studying the Precipitates of Re-memory through Artifacts in the British Asian Home."Transactions of the Institute of British Geographers 34 (2004): 314-329.

Totoricagüena, Gloria. The Basques of New York: A Cosmopolitan Experience. Reno: Center for Basque Studies, 2005.

VOA. https://www.voanews.com/a/basque-musical-traditions-updated-in-idaho-121793974/164953.html, December 5, 2011.

White, Linda and Cameron Watson. Amatxi, Amuma, Amona: Writings in Honor of Basque Women. Reno: Center for Basque Studies, 2003.

Zubizarreta, Trisha Clausen. Chorizos, Beans, and Other Things: A Poetic Look at the Basque Culture. Boise: Lagun Txiki Press, 1987.

Basque Women in the West: Bringing Migrant Women out of the Shadows

Edurne Arostegui

Ph.D. Candidate, William A. Douglass
Center for Basque Studies
University of Nevada, Reno
University of the Basque Country

Introduction

Recent contemporary literature on women's migration focuses on the disproportionate rate at which women from developing countries immigrate to shoulder the care and domestic work of the developed world.[1] As Pardis Mahdavi has noted, "the increasing feminization of migration has productively led to calls for understanding gendered migratory patterns and the commodification of intimacy and intimate labor."[2] Intimacy and intimate labor, in this sense, are used to understand

1 For more on the literature and theory dealing with gender and migration through intersectionality, see: Arjun Appadurai, Modernity at Large: Cultural Dimensions of Globalization (Minneapolis: U of Minnesota P, 1996); Nicole Constable, "The Commodification of Intimacy: Marriage, Sex, and Reproductive Labor," Annual Review of Anthropology 38 (2009): 49-64; Barbara Ehrenreich and Arlie Russell Hochschild, eds., Global Woman: Nannies, Maids, and Sex Workers in the New Economy (New York: Holt Paperbacks, 2002); Pardis Mahdavi, Crossing the Gulf: Love and Family in Migrant Lives (Stanford: Stanford UP, 2016).
2 Mahdavi, Crossing the Gulf, 43.

the intersection between gender, race, and class within structures of power that contextualize the broad category of domestic work. It is "intimate" in the sense of the "personal"—care, sympathy, and even love—often relegated to the periphery of the market economy. "Women's work" sustains societies and is most often unpaid, rendering it a cause for the misunderstanding of intimate labor and its effects on women's agency in the economic sphere.

Although the geographical trends in migration are a relatively new phenomenon that is often tied to globalization,[3] the displacement of women has been ongoing for centuries, and Basque women are no exception. The focus of Basque labor and migration in the American West has been on sheepherding, due to male migrants' visibility in terms of this market and the romanticized image of the lone sheepherder in western mythology.[4] Still, Basque women were among the first migrants to the West, at times alongside their husbands and families and others on their own journeys. Women's experience, nevertheless, has often been relegated to the shadows of men. Their lack of visibility was due to their social positions in host societies and their labor within the domestic sphere, whether in boardinghouses, sheep camps, or in their own homes. Nevertheless, women were a part of Basque migratory societies. By uncovering both their economic and cultural roles, new perspectives into this group's particularities and similitudes with respect to other uprooted migrants will enliven and deepen our understanding of Basque diasporic communities.

3 See: Deborah A. Boehm, Intimate Migrations: Gender, Family, and Illegality among Transnational Mexicans (New York: New York UP, 2012); Denise Brennan, What's Love Got to Do with It?: Transnational Desires and Sex Tourism in the Dominican Republic (Durham: Duke UP, 2004); Rhacel Salazar Parreñas, Servants of Globalization: Women, Migration, and Domestic Work (Stanford: Stanford UP, 2001).
4 See: Iker Saitua, "The Best Sheepherder. The Racial Stereotype of Basque Immigrants in the American West between the end of the nineteenth and the beginning of the twentieth centuries," Historia Contemporánea 56 (2017): 81-119.

The mass waves of migration at the end of the nineteenth century to the United States, referred to as the "uprooted huddled masses"[5] by historian Oscar Handlin, brought migrants from the world over, transforming both society and migrants. History has incorporated a from-the-ground-up focus throughout the cultural turn in academia, and subsequent work has brought women into the picture with its own gendered perspectives. As Donna Gabaccia observed, "immigrant women did not act as women in one context and as ethnics in another,"[6] calling for an intersectional analysis of gender, class, and ethnicity which connects women's intimate and labor lives. Intersectionality further addresses women's responses and agency within—and specific to—migratory contexts and history. However, these intersections in the case of Basque women's migration to the United States have yet to be confronted.

Gabaccia has compared different European immigrant women's "cultural diversity and shared economic positions," while pointing toward the fact that "histories of immigrants in the United States begin with the experiences of migratory men disguised as genderless humans."[7] Women also came to the United States to work, initially leaving their homeland for economic and social mobility, whether forced due to familial circumstances or on their own accord. In that sense, Basque women also came for a better future, and to a certain extent, adventure. In order to understand their particularities, migrant women's desires, responsibilities, deterrents, and cultural changes must be grappled with, drawing

5 OscarHandlin,TheUprooted:TheEpicStoryoftheGreatmigrationsthatMadetheAmerican People, 2nd ed. (New York: Little, Brown, and Co., 1973), 4.
6 Donna Gabaccia, From the Other Side: Women, Gender, and Immigrant Life in the U.S., 1820-1990 (Bloomington: Indiana UP, 1994), 130.
7 Gabaccia, From the Other Side, xiv & xi.

upon previous studies but also going beyond them to expand the field of Basque studies and migration history overall.

Taking the debates from Basque historiography into account, this article will provide a brief review of academic literature dealing with Basque women's migration to the U.S., while also exploring different theoretical models outside of Basque studies that aid in presenting gendered analyses of migration. The aim is to give voice to women migrants and their role within the Basque-American community, both as workers and as transmitters of culture and identity. Women renegotiated definitions of Basqueness in the American West as well as their own identities as mothers, wives, daughters, and workers in a new world, which they made their own in time.

Basque Migration(s)

Basques have migrated disproportionally to the relative size of their homeland. The Basque Country is comprised of seven provinces in both Spain and France and spans a little over eight thousand square miles, which is about the size of Clark County, Nevada. Clark County accounts for just over seven percent of Nevada's area, just to put it into perspective. Although there are no definitive statistics, especially with regard to women, Gloria Totoricagüena notes that "Spanish official statistics give 1,042,775 emigrants leaving Spain between 1882 and 1930," although many more migrants may not have been counted since they departed from French ports or left through other means.[8] It must also be stated that these numbers represent all migrants from Spain,

8 Gloria P. Totoricagüena, Identity, Culture, and Politics in the Basque Diaspora (Reno: University of Nevada Press, 2004), 61.

not just the Basques, and that records in receiving states point toward many more immigrants. Whatever the case, a migratory phenomenon has existed in Basque society for centuries and was especially poignant beginning in the nineteenth and throughout the following century.

Many factors have contributed to Basques' migratory experience when analyzed through an economic push-pull model. Although economic interests do in fact inform decisions to migrate, they obscure and simplify migrants, neatly categorizing the movement of groups instead of individuals. Nevertheless, the Basque Country's proximity to the ocean made for good fishing, causing men to travel across the Atlantic to hunt whales and catch cod, as well as leading to a shipbuilding industry. During the Spanish colonial period, Basque men "hicieron la Carrera de Indias," in other words, tried their luck abroad as part of the imperial project.[9] After Latin American colonial independence, Basque men, once again, began to migrate for economic reasons, establishing families and businesses abroad. Wars must also be mentioned as a push factor, including the Carlist Wars (1833-1839 and 1846-1849) and the Spanish Civil War (1936-1939), which produced the exile of both Basque politicians and civilians throughout the world. In all of these cases, women also migrated, both as wives and as laborers, yet, as Gabaccia notes, the use of "migrants" in literature seems to present genderless agents, when in fact gender shapes experience and opportunity.

A common and repeated cause for migration in Basque historiography has been the analysis of the impartible inheritance

9 Because of their status as hidalgos, or nobles, due to the Fueros, or Foral Rights, Basques had the opportunity to advance their careers in the New World. Once established, they created kinship networks that expanded migration. Many of these Basques remained, creating a prominent Basque presence throughout Central and South America, as well as in the Philippines. Their visibility is still present as seen in the high numbers of Basque surnames throughout the continent as well as ethnic institutions. For more on Basque diasporic institutions see: Totoricagüena, Identity, Culture and Politics.

system. Farmhouses and their land provided the economic unit to sustain a family and little more. Due to property size, Basque inheritance laws limited the distribution of land, allowing for one sole inheritor. Although primogeniture was the law in some areas, this was not always the case,[10] and the remaining sons and daughters often received a dowry and were forced to make tough decisions. If they chose to stay in the household, they were to remain celibate and work for the family. Another option was to marry an heir or heiress of another household, or even a returnee from the Americas.[11] Some went down religious paths, while for others, migration was a chance to start a new life. It was an option for those who did not inherit, especially since migration networks had already been established. Due to the history and social imaginary surrounding Basque migration, Pierre Lhande, already in 1910, wrote: "To be an authentic Basque there are three requisites: carry a sonorous name which states its origin, speak the language of the sons of Aitor, and . . . have an uncle in America."[12] Migration is part of Basque collective identity, and has been for centuries.

This analysis of inheritance, however, is limited at best. As the work of Amaia Iraizoz Cia demonstrates, many heads of households and designated heirs also migrated to the New World, among them women.[13] Migration networks and news of fortunes motivated many

10 Bizkaia followed male primogeniture, while in areas of Navarre and Iparralde (the Basque Country in France, translated as "the Northern side"), parents chose the most suitable heir according to their work ethic and dedication to the land, regardless of sex.
11 Margaret Bullen, Basque Gender Studies (Reno: Center For Basque Studies - UNR, 2003), 85: "Marriage to an émigré who had returned home was considered especially desirable in terms of economic and social status."
12 Pierre Lhande, L'Emigration Basque: histoire, économie, psychologie (Paris: Nouvelle Librairie Nationale, 1910). Translation in: William A. Douglass and Jon Bilbao, Amerikanuak: Basques in the New World (Reno: U of Nevada P, 2005), vi.
13 Amaia Iraizoz Cia, "Homeward Bound: The Influence of Emigration and Return on Aezkoa Valley and its surrounding Rural Communities in Northern Navarre at the turn of the nineteenth century," (PhD diss., University of Nevada, Reno, 2017), ProQuest

to try their luck abroad.[14] Her research also shows that the number of women who migrated from certain villages was oftentimes on par with that of men, travelling before marriage as single women. As she puts it, "Women escaped a patriarchal society and abroad could handle their own money having much more freedom."[15] Although inheritance laws may have induced some migration patterns, individual stories lead to a more nuanced view of the Basque diaspora, especially with regard to gender. What can be generalized, perhaps, is that migration was in large part due to a wish for both economic and social mobility, both in the case of men and also of women.

But how does this relate to migration to the United States? With the discovery of gold in California in 1848, news spread throughout the world. The first Basques to arrive came from Latin America alongside their wives and families—a form of secondary migration. For instance, Martina Aguirre and her husband, José, were among the first to arrive. Together, the Aguirres opened the first Basque hotel in San Francisco, the Hotel Vasco.[16] Many other men, women, and families appear on the passenger lists, embarking to California from Valparaíso, Chile, in 1849, or throughout the 1850s from Buenos Aires, Argentina.[17] The names of six forty-niners,

(2013337871). Her work deals with the influence of return migration to Navarre and the subsequent industrialization of the area, with an emphasis on transnational practices.

14 The Indiano myth ("Indiano" coming from the fact that Spanish colonizers in Latin America believed they had reached the Indies), later used almost interchangeably with Amerikanuak, is similar to the collective imagery of Gold Mountain by Chinese immigrants. The Amerikanuak were those who made it rich abroad and had returned to their homelands. This caused many migrants to believe it was simple to gain success abroad, or at least that there were opportunities.

15 Patricia Carballo, "Una tesis estudia la influencia de la emigración en la Aezkoa del siglo XIX," Noticias de Navarra, February 19, 2018, http://www.noticiasdenavarra.com/2018/02/19/vecinos/sangesapirineos/una-tesis-estudia-la-influencia-de-la-emigracion-en-la-aezkoa-del-siglo-xix.

16 Ibid., 427.

17 Douglass and Bilbao, Amerikanuak, Appendixes 2-3.

including the Aguirres, appear in a description of a banquet in the Basque language newspaper California'ko Eskual Herria.[18] It was held in their honor in 1893, complete with champagne toasts. Sadly, the story also notes that Martina died the next day, at the age of 77, survived by her husband of 80. However, other women appear among the list of attendees, including two who had adopted the English honorific titles "Mrs." and "Miss," symbolically identifying as Americans.

The Aguirre story reflects that of many other migrants who first traveled to South America—in this case to Montevideo, Uruguay, to escape the Carlist wars—only to embark on a secondary migration to the States. These cases of migration were familial in nature, once again disrupting the image of the single male Basque migrant. Although the Aguirres did begin the tradition of Basque boardinghouses in the West, José was never engaged in ranching or herding, disentangling associations between Basques and sheep in the American experience.[19] Other Basques did travel to California to try their luck in mining, and many remained after their fortunes had not been secured, or to start a new life. Some had experience in the South American cattle industry, and the terrain in areas such as the Argentinian Pampas has much more in common with large expanses in West than the Basque Country's rugged landscape does. These Basques were those who began the longstanding connection between Basques and sheep, although

18 J.P. Goytino, "Papurrak: San Francisco-ko Berriak," California'ko Eskual Herria, September 7, 1893. Escualdun Gazeta (1885-1886) and California'ko Eskual Herria (1893-1897) were the only newspapers published in Basque in the United States during the nineteenth century. They offer a view into what life was like for Basques in California, but also provide news about Basques in other parts of the West and in the Basque Country. For information about the periodicals, see: Javier Díaz Noci, "Historia de la prensa en lengua vasca de los Estados Unidos: Dos Semanarios de Los Ángeles en el siglo XIX," Zer: Revista de Estudios de Comunicacíon 10 (2001): 1-10.
19 Douglass and Bilbao, Amerikanuak, 376 & 427.

other stereotypes are present in other parts of the United States.[20] Although rooted in reality, the many stories and scholarly works on Basque sheepherding obscure both other professions and the role and presence of Basque women in the diaspora.

Basque Gender and Migration

The traditional emphasis by Basque scholars has been to connect Basque women migrants to the ostatuak, or Basque boardinghouses that spread throughout the Great Basin and larger American West. Although there are no statistics as to how many women migrated in order to work in these hotels, most of the cases found on Basque women begin in boardinghouses. These sites were of central importance to the maintenance of Basque culture and the emergence of diasporic Basque communities. However, the limited focus on women exclusively in this labor sphere obscures the many other opportunities they had in the United States. Furthermore, since hotel work is closely associated with "women's work," female migrants' economic activity is often associated with their role as mothers, wives, or daughters, rather than labor within the marketplace.

William A. Douglass and Jon Bilbao's 1975 publication of Amerikanuak: Basques in the New World ushered in the beginning of U.S. studies on Basque migration.[21] As a comprehensive study of Basque

20 For example, California Basques are often associated with gardening and bakeries. See: Pedro J. Oiarzabal, Gardeners of Identity: Basques in the San Francisco Bay Area. Ed. Lisa M. Corcostegui (Reno: Center for Basque Studies - UNR, 2009).
21 For a great historiographical essay on the works published before 1970, see: Grant McCall, "American Anthropological Interest and Prospects in Basque Studies," Current Anthropology 11, no. 2 (April 1970): 161-164.

migration from the colonial period onward, it traces the movements of Basques from their homeland to the Americas and into the West. The authors identify the importance of the Basque hotel as "a network of ethnic establishments along which Basque immigrants could enter and move about the United States with a maximum of protection and a minimum of culture shock."[22] Once again, Basque immigrants are presented as genderless characters, when in fact, the authors are referring to male migrants in particular. As ethnic establishments, these sites of commensality and cohabitation helped seasonal workers—men—find "a home away from home."

However, Douglass and Bilbao also bring attention to female migrant workers in these operations: "The hotels themselves were the greatest source of single Basque girls ... employment in the hotels, with the related possibility of employment as domestics within private homes, was the major channel along which young Basque women arrived in the United States."[23] Their initial description of women migrants "as a source of single Basque girls" commodifies women as objects. It is understood that they were a "source" for single Basque sheepherders who stayed in these hotels, applying a patriarchal lens to link women migrants directly to the needs of men.

Furthermore, Douglass and Bilbao speak of the high turn-over of women, "the majority of whom married within a few months after reaching the American West."[24] Many did in fact find their future husbands at work in the hotels, and the statistics are staggering: "Eighty-five percent of the Basques had met their spouses in the boardinghouses."[25] Many of these women's journeys were sponsored

22 Douglass and Bilbao, Amerikanuak, 370.
23 Ibid., 377.
24 Ibid.
25 Jeronima Echeverria, Home Away from Home: A History of Basque Boardinghouses

by their future employers, which were then paid off in a type of debt bondage.26 Marriage was an option for some to escape the labor demands imposed by their employers. For instance, Anastasia Arriandiaga Gamecho Arteaga travelled to the U.S. in 1907 at the age of 14. Before migrating, an agreement was made with Benito Arego, a hotel owner in Boise, to pay off the voyage in exchange for her work as a maid. Since the working conditions were so poor, her case ended up in the courts. She eventually paid the amount owed in exchange for leaving her job, marrying just a year later.27 As one resident of the ostatuak recalled, women "working in the hotels were virtually slaves, performing every variety of task needed to keep the enterprise going."28 Literature on the matter has focused on the after instead of the before. By continuing to center the analysis of women's migration on marriage, their labor and work conditions become relegated to a thing of the past. Basques in the West did in fact partake in endogamic marriage patterns, but more work should be done to understand the choices these women made to come to the West and their experiences before and during marriage.

Other authors, such as Joxe Mallea-Olaetxe in the translator's introduction to Basques in the United States, assume that women initially traveled to find marriage partners: "When Basque villages became empty of young men, many of the young women left behind chased the men all the way to the US. For them the American West provided a practical and enticing venue to find a mate and raise a family."29 The

(Reno: U of Nevada P, 1999), 227.

26 Echeverria, Home Away from Home, 227.

27 Koldo San Sebastián, "Arriandiaga Gamecho Arteaga, Anastasia," in Basques in the United States: A Biographical Encyclopedia of First-Generation Immigrants, trans. Joxe Mallea-Olaetxe, 1st ed., vol. 1, (Center for Basque Studies - UNR, 2015), 158.

28 Echeverria, Home Away from Home, 224.

29 Joxe Mallea-Olaetxe, "Translator's Introduction," in Basques in the United States, 14.

"practicality" of crossing the Atlantic, then taking a train across the United States to end up in a place like Winnemucca, far from home and family, just to get married, seems like quite the effort, if not a bit desperate. The language used, in this case "to find a mate," makes it seem as though women's role in society is to procreate and "raise a family." Mallea-Olaetxe is right to comment on the disproportionate number of men who "migrated emptying villages," but women must have had other opportunities to find marriage prospects or even job opportunities closer to home.[30] Although they may have intended to eventually marry and settle in the United States, it is difficult to believe that their main motivation was just to find a man. Whatever the case, the index of Amerikanuak does not have entries for either "women" or "gender," although its publication date may help to explain this absence. Nevertheless, in the descriptions by Douglass, Bilbao, and Mallea-Olaetxe, it seems that these women arrived in the West and were soon married off, disappearing into their roles as mothers and caretakers in the domestic sphere. By relegating Basque women's place to the home and domestic "bliss," other aspects of their migratory lives are forgotten.

Margaret Bullen's work on Basque Gender Studies looks at relations of power in the Basque Country and its society, stating that "by magnifying motherhood and placing women firmly in the domestic space, their activity beyond the home is silenced, ignored or undervalued."[31] These values traveled with migrants to the New World, reproducing family structures and the division of labor. Bullen, in her chapter on women's migration, focuses on women's "contribution to the consolidation of the Basque communities of the diaspora and to the maintenance of Basque

30 For example, opportunities for work were available just over the border in Iparralde. The director Jon Abril came out with a documentary in 2016 entitled Neskatoak (female servants) dealing with such women migrants.

31 Bullen, Basque Gender Studies, 182.

values and traditions."[32] Although this is a key role played by women (and also by men), it undervalues the labor performed outside of the community sphere, perpetuating the same gender norms associated with Basque women in transnational contexts.

Jeronima Echeverria's Home Away from Home: A History of Basque Boardinghouses documents the many Basque hotels in the United States and contains descriptions of the essential role played by women in these establishments.[33] Her focus, however, is on the hoteleras, or female hotel keepers, who became etxeko amak, or mothers of the house, for many sheepherders.[34] However, although the hoteleras were co-owners and visible faces at the boardinghouses, the domestic staff, as mentioned before, often came from abroad and were in debt. These young women, sometimes just fifteen years old, worked hard and were at times exploited by their own family members in the U.S. The few descriptions of female workers in the book show that working conditions were tough, with no days off and no free time. As a home away from home for men, these boardinghouses were in fact sites of labor for many women. Although Echeverria's work brings much more attention to women in the American West, it still falls short when it comes to women's personal experiences and their decisions to emigrate. Behind every hotelera, there was a staff of women, and it is their stories that comprise the experience of the majority of Basque women in the West.

32 Ibid., 215.
33 It is interesting to note that this book not only explains the particularities of Basque boardinghouses but is also among the few books that deal with boardinghouse culture in general in the United States. Wendy Gamber, in her "Essay on Sources" included in The Boardinghouse in Nineteenth-Century America (Baltimore: The Johns Hopkins UP, 2007), 200, cites Echeverria's work among three exclusively dedicated to boardinghouses.
34 Echeverria, Home Away from Home, 218-219.

Jacqueline Thursby's dissertation, completed in the same year as Home Away from Home (1994), looks at Basque-American women through an anthropological and folkloric lens, and was later published as Mother's Table, Father's Chair: Cultural Narratives of Basque American Women in 1999.[35] Parting from the basis that "women were powerful preservers of their cultural heritage and had no intention of being 'just Americans,'" Thursby's ethnographic interviews collect the stories of Basque women across generations. When Thursby embarked on her research, she encountered a Basque man who said there was little to write about women: "What? The women? What have they done to contribute anything to this culture? The men have done it all."[36] This did not stop Thursby, but goes to show how little attention has been brought to women's experiences, even from Basques themselves. Thursby's work, according to my own research, is the only one solely dedicated to Basque-American women.

Throughout the oral histories collected by Thursby, women's migratory lives are shaped by work and relationships. Women such as Louise Etcheverry, over eighty years old in the 1990s, exclaimed: "Of course I work. Who else is going to do it? I've worked all my life, so why should it be any different now?"[37] This is not an exceptional case: most women interviewed eventually married, but work did not end after the celebration. Thursby found that "after marriage, Basque women often stayed at home and raised the children, but that was not usually all that was expected of a young wife. Many women became directly involved in the sheep business, the rooming

35 Jacqueline S. Thursby, Mother's Table, Father's Chair: Cultural Narratives of Basque American Women (Salt Lake City: Utah University Press, 1999); Thursby, "Basque Women of the American West," PhD diss., Bowling Green State University, 1994.
36 Thursby, Mother's Table, 3.
37 Ibid., 72.

house or hotel business, or both."[38] Marrying a sheepherder came with a new set of tasks, and many women lived their first years of married life on ranches and sheep camps: "For many a Basque woman, a sheepwagon was the first home she shared with her new husband."[39] Their labor not only included rearing children but preparing and serving meals to the sheepherders as well as cleaning and washing. Although domestic labor is often expected to be the role of women, it is labor nonetheless, and should be recognized as such, even when unpaid. Once these couples made enough money to move into town, however, the work continued, and many women went on to open their own boardinghouses, take on sewing work, or labor in the private homes of others.

For instance, there is the extraordinary case of Juanita Mendiola Gabiola, the woman sheepherder.[40] After marrying in the Basque Country, she moved to the United States with her husband, who had already had a brief stint abroad. Instead of simply caring for the sheep camp, Juanita worked alongside the men, eventually starting her own company with her husband in 1927. It was not until her children reached school age that she moved to town. However, she never quite stopped working with sheep. Juanita's story shows a different side of immigrant women, and more research might reveal other colorful stories such as hers. Although Thursby provides narratives and rich oral histories, collected at a time when many of the second wave of Basque migrants were still alive, her work should be expanded

38 Ibid., 65.
39 Nancy Weidel, Sheepwagon: Home on the Range (Glendo, WY: High Plains Press, 2001), 104. Nancy Weidel's book includes a chapter on the Basques as well as one on "Women in Sheepwagons." Although the association between Basques and sheep has been ingrained into the mythology of the West, more comparative work between Basques and other groups would be fruitful, especially looking at the ways different women experienced their home on the range.
40 San Sebastián, Basques in the United States, Vol. 1, 337.

upon not just to illuminate the lives of Basque women, but also to locate them within a larger narrative of gendered migration. Thanks to her collection of oral histories, alongside those of Begoña Pecharromán,[41] these women's stories are ripe for further research.

Gloria Totoricagüena's comparative study, Identity, Culture, and Politics in the Basque Diaspora, acknowledges the omission of women in Basque migration studies, pointing out that "females are generally perceived as amendments to the men who migrate, nonthinking, nonemotional appendages with no choices, comparable to the valuable things packed in traveling trunks."[42] In what begins as a promising section on "migration experiences,"[43] Totoricagüena delves into women's role in ethnicity maintenance and solidarity with other Basque migrants. However, besides pointing out that migrant women "have more in common with each other in different countries than we do with other women equivalent to ourselves in this country," and that "homeland conditions as females have much to do with the decision to migrate," [44] Totoricagüena adhers to the common trope of women migrating as wives, mothers, and daughters. She does little to explore women's agency in other forms. She does not expand upon these commonalities, homeland conditions, or decisions. Once again, she focuses on ethnicity maintenance in diasporic communities, leaving labor aside as well as her own critique of women as "appendages."

41 Although she is cited by both Bullen (218) and Camus-Etchecopar (The North American Basque Organizations (NABO), Incorporated 1973-2007. Vitoria-Gasteiz: Servico Central de Publicaciones del Gobierno Vasco, 2007: 198), Pecharromán has not published her research and collection of oral histories, archived in Boise's Basque Museum and in the Northeastern Nevada Museum in Elko.

42 Totoricagüena, Identity, Culture, and Politics, 142.

43 Ibid., 142-146.

44 Totoricagüena, Identity, Culture, and Politics, 144 & 145. Totoricagüena is the daughter of Basque migrants from Bizkaia who settled in Boise, Idaho.

However, Totoricagüena's work on gender and ethnicity in Basque Diaspora: Migration and Transnational Identity goes into somewhat more depth, or at least contextualizes her claims. Here she states that "women also migrated to escape the various forms of oppression that are unique to their gender status."[45] However, this statement lacks an elaboration of this gendered oppression. Although she does not cite her sources regarding the following claim, she states that "in some instances . . . such as in the United States, female migrants outnumber male migrants."[46] If this in fact is true, Basque migration studies would have to rethink some previously held assumptions, but her lack of citation or sources for these statements leaves the researcher wondering, or perhaps prompts him or her to confirm them, changing the way we look at women in the diaspora.

What stands out in Basque historiography is how women are cast and what role they play in these accounts. Although the literature does not completely lack women migrants, further work on their depictions and agency within the diaspora would question and reshape the view of the male-driven labor migration often at the center of academic discourse. In this case, women migrants from this period share many qualities and experiences with current women in the new economy of globalization. In the case of Basque women, it is difficult to determine what women did once they arrived in the United States. Having at times adopted the American custom of taking their husbands' surnames, the information on their initial lives becomes lost in the archives.[47] However, by adding to the existing work and poring over

45 Gloria Totoricagüena, Basque Diaspora: Migration and Transnational Identity (Reno: Center for Basque Studies – UNR, 2004), 466.
46 Totoricagüena, Basque Diaspora, 471.
47 For example, when searching for Louise Etcheverry, mentioned above, in Basques in the United States, I realized that she had taken her husband's name, therefore

the archives, it is possible to reconstruct migrant women's experiences in the West and the integral labor they provided with their stories at the center of the narrative.

Theorizing Basque Gendered Migration

The essays collected in Global Woman: Nannies, Maids, and Sex Workers in the New Economy, edited by Barbara Ehrenreich and Arlie Russel Hochschild, explore the feminization of labor and migration, providing a gendered analysis of the movement from the developing to the developed world within the globalized economy. The "new economy" they refer to deals with intimate aspects of labor, such as caregiving, often invisible in migration history. Networks of chain migration both "push and pull" migrants across borders. Although the essays deal with contemporary migration, connections and continuities with the past can be found. As the editors note in the introduction, "the presence of immigrant nannies does not enable affluent women to enter the workforce; it enables affluent men to continue avoiding the second shift."[48] Although Basque women did not migrate as nannies per se, and few Basque men were ever affluent, women's work made the establishment of Basque communities across the West possible. Their husbands or brothers may have been sheepherding on the range—a job once degraded by society—but women also worked hard and were the backbone of Basque society in the United States. However, women's labor largely remains invisible, while their role in cultural maintenance is glorified. Women did much more than bear children and keep house. These activities

making it impossible to find her entry. Furthermore, because she was an American-born Basque, I was unable to find her family or background.

48 Ehrenreich and Hochschild, eds., Global Woman, 9.

were part of traditional female roles, but women renegotiated their identities through their migratory experiences and the struggles they encountered in their new homes.

Begoña Pecharromán has proposed that migration "was not an individual endeavor but rather a family undertaking that involved the women who stayed behind as well as the men who left."[49] Mahdavi, in relation to migration to Dubai, proposes insights into the intertwined nature of migrants' relationships with family, the state, and place, as well as their intimate subjectivities as reasons for migration:

> A focus on the intimate lives of laborers and their kin reveals the interconnections between movements, emotions, and destinations. Migrants become both mobilized and immobilized because of their family and the bonds of love they share across borders. And just as mobility or migration can lead to immobilities, immobilities or immobilizations can lead to mobility. Mobility and immobility are mutually reinforcing and mutually constitutive forces impacting the intimate lives of migrants and their loved ones.[50]

Her focus on agency and the interconnectedness of mobility and immobility shape the narrative of her theory. For Mahdavi, im/mobilities are intertwined, explaining migrants' flexibility (agency) to move as well as their position in a liminal space between receiving and sending countries. By focusing on the intimate lives of migrants, Mahdavi argues that migration can shape subjectivity as well as the other way round, broadening our understanding of decision-making processes.

49 quoted in Bullen, Basque Gender Studies, 218.
50 Mahdavi, Crossing the Gulf, 13-14.

Although economic reasons for migration abound, Mahdavi also looks at the way migration can lead women to a sense of liberation, leaving behind obligations and the binds family members can impose, while maintaining social contracts.[51] By giving migrants a voice, Mahdavi lets women's intimate lives shape her theory and analysis, instead of applying it from above.

Drawing from Neha Vora and Filippo and Caroline Osella, Mahdavi looks at the construction of "new (stronger) senses of identity"[52] during migration processes and applies it to intimate mobility. By focusing on intimate lives, she builds upon Anthony Giddens' idea of "the realm of the intimate as a space wherein individuals can navigate and negotiate agency."[53] Layers of relationships and personal emotions come together in the migration process, "crafting a new sense of self and home."[54] Together, these experiences show how identity is shaped by migration, where mobility and immobility coincide in liminal spaces and where agency takes the form of individuals' many decisions. Basque women empowered themselves in their communities and homes. Although the traditional division of labor was reinforced in the United States, women were able to work outside of the home, creating new notions of community and society. By leaving behind immobilizing ties to family and kin, migrants, both men and women, get the chance to re-craft their identities, both in the way they represent themselves and the ways they are recognized, by host societies or by other fellow migrants.

By comparing Basque women's migratory experiences to those present in the globalized economy, we can come to understand the way

51 Ibid., 97.
52 Mahdavi, Crossing the Gulf, 98.
53 Ibid., 30.
54 Ibid., 117.

migration has shaped the globe and continues doing so. The invisibility of feminized labor is not a new phenomenon. As Maxine Seller noted in 1975, "It is my opinion that the relative lack of material about immigrant women is not the result of a lack of activity on the part of these women."[55] It is not the aim of this article to explain the reasons for the scarcity of studies on Basque women migrants, but instead to present what has been done in order to expand and enrich diaspora studies through an intersectional approach that questions what has been taken as a given for too long.

Conclusion

As many Basque scholars have pointed out, a gendered analysis of migration is lacking, especially in the case of Basque migration to the United States. Although this statement most often precludes a generalized description of women migrants, the call is out there. The work of oral historians and folklorists has helped to bring women out of the shadows, but an in-depth analysis of migratory patterns, labor relations, and community foundations would bring about a more nuanced understanding of Basque women in the West. Their role as cultural transmitters and keepers of tradition is pivotal in the creation of Basque-American identity, but this often overshadows women's agency and intimate lives.

Women were essential in this transformation of identity and representation and by bringing their stories to light, new perspectives on immigration history and diaspora will not only reflect gendered

55 Maxine S. Seller, "Beyond the Stereotype: A New Look at the Immigrant Woman, 1880-1924." Journal of Ethnic Studies 3 (1975): 59.

analyses, but the intersections between ethnicity, class, and labor present in migrants' lives. Within United States history, we cannot remove the fact that both African men and women were enslaved for their labor in agriculture and the domestic sphere. Moving further along, the influx of Irish immigrants in the nineteenth century was not always a familial move. Women made the jump across the pond to fill in labor shortages both in industry and as domestic servants. In the case of Mexican women, many of whom lived in areas once a part of Mexico, their labor contributed to agriculture and food processing, right up to the present. These examples, not meant to encompass all migrations to the United States, prove that the globalization of women's labor is not a recent phenomenon, but has taken place for centuries, and although Basque women statistically did not reach the levels of representation as the women mentioned above, they too labored and filled in voids in the market economy.

We often hear of the exceptions—ground-breaking women who are the "firsts" in their field. What about the women who come next, the ones that continue to live in a gendered world that is informed by its past? By understanding the women who chose or were forced to emigrate from their homelands, we will further understand not only the gendered aspects of this migration but also the intersectional facets of migratory agency.

WORKS CITED

Appadurai, Arjun. Modernity at Large: Cultural Dimensions of Globalization. Minneapolis: University of Minnesota P, 1996.

Boehm, Deborah A. Intimate Migrations: Gender, Family, and Illegality among Transnational Mexicans. New York: New York University Press, 2012.

Brennan, Denise. What's Love Got to Do with It?: Transnational Desires and Sex Tourism in the Dominican Republic. Durham: Duke University Press, 2004.

Bullen, Margaret. Basque Gender Studies. Reno: Center For Basque Studies Press - UNR, 2003.

Camus-Etchecopar, Argitxu. The North American Basque Organizations (NABO), Incorporated 1973-2007. Vitoria-Gasteiz: Servicio Central de Publicaciones del Gobierno Vasco, 2007.

Carballo, Patricia. "Una tesis estudia la influencia de la emigración en la Aezkoa del siglo XIX." Noticias de Navarra, February 19, 2018. http://www.noticiasdenavarra.com/2018/02/19/vecinos/sangesapirineos/una-tesis-estudia-la-influencia-de-la-emigracion-en-la-aezkoa-del-siglo-xix.

Constable, Nicole. "The Commodification of Intimacy: Marriage, Sex, and Reproductive Labor." Annual Review of Anthropology 38 (2009): 49-64.

del Valle, Teresa, director. Mujer Vasca: Imagen y Realidad. Barcelona: Anthropos, 1985.

Díaz Noci, Javier. "Historia de la prensa en lengua vasca de los Estados Unidos: Dos Semanarios de Los Ángeles en el siglo XIX." Zer: Revista de Estudios de Comunicacíon 10 (2001): 1-10.

Douglass, William A., and Jon Bilbao. Amerikanuak: Basques in the New World. 1975. Reno: University of Nevada Press, 2005.

Echeverria, Jeronima. Home Away from Home: A History of Basque Boardinghouses. Reno: University of Nevada Press, 1999.

Ehrenreich, Barbara, and Arlie Russell Hochschild, eds. Global Woman: Nannies, Maids, and Sex Workers in the New Economy. New York: Holt Paperbacks, 2002.

Gabaccia, Donna. From the Other Side: Women, Gender, and Immigrant Life in the U.S., 1820-1990. Bloomington: Indiana University Press, 1994.

Gamber, Wendy. The Boardinghouse in Nineteenth-Century America. Baltimore: The Johns Hopkins University Press, 2007.

Goytino, J.P. "Papurrak: San Francisco-ko Berriak." California'ko Eskual Herria, September 7, 1893.

Handlin, Oscar. The Uprooted: The Epic Story of the Great migrations that Made the American People. 2nd ed. New York: Little, Brown, and Co., 1973.

Iraizoz Cia, Amaia. "Homeward Bound: The Influence of Emigration and Return on Aezkoa Valley and its surrounding Rural Communities in Northern Navarre at the turn of the nineteenth century." PhD diss., University of Nevada, Reno, 2017. ProQuest (2013337871).

Lhande, Pierre. L'Emigration Basque: histoire, économie, psychologie. Paris: Nouvelle Librairie Nationale, 1910.

Mahdavi, Pardis. Crossing the Gulf: Love and Family in Migrant Lives. Stanford: Stanford University Press 2016.

McCall, Grant. "American Anthropological Interest and Prospects in Basque Studies." Current Anthropology 11, no. 2 (April 1970): 161-164.

Oiarzabal, Pedro J. Gardeners of Identity: Basques in the San Francisco Bay Area. Edited by Lisa M. Corcostegui. Reno: Center for Basque Studies Press, 2009.

Parreñas, Rhacel Salazar. Servants of Globalization: Women, Migration, and Domestic Work. Stanford: Stanford University Press, 2001.

Saitua, Iker. "The Best Sheepherder. The Racial Stereotype of Basque Immigrants in the American West between the end of the nineteenth and the beginning of the twentieth centuries." Historia Contemporánea 56 (2017): 81-119.

San Sebastian, Koldo. Basques in the United States: A Biographical Encyclopedia of First-Generation Immigrants. Translated by Joxe Mallea-Olaetxe. Reno: Center for Basque Studies Press, 2015.

Seller, Maxine S. "Beyond the Stereotype: A New Look at the Immigrant Woman, 1880-1924." Journal of Ethnic Studies 3 (1975): 59-70.

Thursby, Jacqueline S. Mother's Table, Father's Chair: Cultural Narratives of Basque American Women. Salt Lake City: Utah University Press, 1999.

-----. "Basque Women of the American West." PhD diss., Bowling Green State University, 1994.

Totoricagüena, Gloria P. Identity, Culture, and Politics in the Basque Diaspora. Reno: University of Nevada Press, 2004.

-----. Basque Diaspora: Migration and Transnational Identity. Reno: Center for Basque Studies Press, 2004.

Weidel, Nancy. Sheepwagon: Home on the Range. Glendo, WY: High Plains Press, 2001.

Exploring Basque Heritage in America at the End of the Twentieth Century: Monique Laxalt Urza's The Deep Blue Memory

David Río

Euskal Herriko Unibertsitatea-Universidad del País Vasco[1]

Monique Laxalt Urza's semi-autobiographical novel, The Deep Blue Memory, published in 1994, was a major novelty in American writing on the Basques because it reflected an important shift in both a generational and a gender perspective. Until then, most fiction and non-fiction stories, including her father's masterpiece Sweet Promised Land (1957), had focused on the experiences of first-generation Basque immigrants in America, with an emphasis on the figure of the sheepherder and his struggle for success in the New World. In fact, one of the most prominent scholars on Basque immigration in the American West, Richard W. Etulain, already claimed in 1977 that this overemphasis on the herder had provoked not only the neglect of those Basque immigrants who went into other occupations, but also of "the experiences of Basque women and urbanites and the affairs of the second and the third generation."[2]

1 I am indebted to the Basque Government (IT 1026-16), the Spanish Ministry of Economy and Competitiveness (FFI2014-5278-P), and the Spanish Ministry of Education, Culture and Sports (PGC2018-094659-B-C21, FEDER) for funding the research carried out for this essay.
2 "The Basques in Western American Literature," in Anglo-American Contributions to Basque Studies: Essays in Honor to Jon Bilbao, ed. William A. Douglass, Richard W. Etulain, and William H. Jacobsen, Jr. (Reno: Desert Research Institute Publications on the Social Sciences, 1977), 16.

He specifically mentioned the need to pay literary attention to Basque women "who came to work in Basque hotels and restaurants, or who lived in towns and cities like Winnemucca, Reno, and San Francisco."[3] The truth is that Basque women were underrepresented in American literature during most of the twentieth century, with a few exceptions, such as Mirim Isasi's Basque Girl (1940), Robert Laxalt's Child of the Holy Ghost (1992), or Gregory Martin's Mountain City (2000). Of these works, only Basque Girl, a semi-autobiographical and nostalgic novel about the protagonist's life as a girl in the Basque Country, employs a female perspective. Urza's novel, on the other hand, departs from nostalgic approaches to the homeland, to focus on the new generations and on female characters, addressing the ways in which a Basque family deals with the tensions between loyalty to their ethnic roots and assimilation into American society. Monique Urza's main aim in her novel is to explore the role of memory in this conflict and the emotions produced in this process, revealing the complexity of ethnic identity at different generational levels.

Although The Deep Blue Memory is largely based on the experiences of the author and her family, the deliberate use of a fictional narrator distances the book enough from the real life of the author for it not to be a memoir. Certainly, Monique Urza's account navigates the territory between fact and fiction, but in choosing to leave her narrator nameless rather than claiming the story as her own lived experience, she deliberately distances herself from her private memories. As Laura Beard states, "The question of which stories can and cannot be told within a family history or within an autobiography again raises the problematic nature of autobiography, always teetering between the classifications of fiction and nonfiction."[4] Monique Urza herself has

3 Ibid.
4 Acts of Narrative Resistance: Women's Autobiographical Writing in the Americas (Charlottesville:

admitted to the blending of memoir and fiction in the book, but she has also insisted on the novelistic condition of her account: "I didn't want the book to be like a biography of the Laxalt family. [. . .] I didn't use the Laxalt name at all in the book, even in my name. Definitely an important part of the book is autobiographical. However, I fictionalize certain things. [. . .] I would describe the book as psychologically autobiographic."[5] Regardless of the similarities between the narrator's memories about her family and the author's own family story, the truth is that the whole book, as suggested even in the title, focuses on memory and heritage as key elements in the configuration of one's identity. In fact, it may be argued that another of the primary aims of the book is to capture the stories of a family to preserve them on paper for future generations. In The Deep Blue Memory, preserving memory is a process that is not exclusively related to the old country or to the first-generation immigrant experience; memory preservation is extended to the other generations too, exploring the impact of Americanization on the younger generations. In Urza's own words, "I tried to write the book in a circular way: progressing forward, but at the same time a constant remembering and understanding the past."[6]

The Deep Blue Memory is told from the point of view of the granddaughter of Basque immigrants and daughter of a successful Basque-American first-generation family whose surname is never revealed. The unnamed narrator who, like the author, is a lawyer from Reno, reconstructs the story of her family both in the Basque Country and in America through a wide array of memories belonging to different generations. Time, identity, and memory appear intertwined in the

University of Virginia Press, 2009), 83.
5 See David Río, "The Miraculous Blend: An Interview with Monique Urza," Journal of the Society of Basque Studies in America vol. XVI (1996): 5–6.
6 Ibid., 5.

three dimensions of the personal, the social, and the cultural, and the whole book may be regarded as a selective reconstruction of the experiences of a child growing up in an immigrant family through a series of images, moments, and places. This idea of selection should be emphasized because, as Ruth M. Van Dyke and Susan E. Alcock claim, "memories are not ready-made reflections of the past, but eclectic, selective reconstructions. People remember or forget according to the needs of the present, and social memory is an active and ongoing process."[7] Similarly, Jan Assmann underscores the role of reconstruction in cultural memory: "No memory can preserve the past. [...] Cultural memory works by reconstructing, that is, always relates its knowledge to an actual and contemporary situation."[8] In her novel, Urza carefully selects the settings and images she wants to juxtapose in order to represent the complexity of family relationships and the conflict between ancient values and modern American life. These settings and images, such as the citadel in the Basque Country, the sheep ranch in Lake Tahoe, the family table in Carson City, and the deep blue book dealing with the story of the narrator's grandfather and her heritage, are united by a common link—"the creature called family,"[9]—creating an illusion of continuity. At times these locations and images seem to be conflicting, but the different generations of this immigrant family are able to integrate them. In fact, it is possible to find important connections between some images belonging to the Basque Country and others related to America, as may be noticed, for example, when the citadel of Saint-Jean-Pied-de-Port is juxtaposed with the family table in Carson City. As Monique Urza herself explained, "There are really tight connections between the two with their similar underneath (the reality that you cannot see) and their

7 Archaeologies of Memory (London: Blackwell, 2003), 3.
8 "Collective Memory and Cultural Identity," New German Critique 65 (1995): 130.
9 Monique Urza, The Deep Blue Memory (Reno: University of Nevada Press, 1993), 27 et al.

similar top (the reality that you can see)."[10] In fact, most of the images and settings are somehow related to each other, creating a network of connections that symbolize the complex and often precarious balance between assimilation and affirmation of ethnic heritage, or to use Werner Sollors's terms, between consent relations and descent relations.[11]

In Urza's reconstruction of the experiences of the narrator and her Basque family, material objects play a fundamental role and become central in the process of exploration of the characters' social, cultural, and personal identities. After all, memory has important roots in the material world, and material culture and identity are usually interconnected because, as Ian Hodder points out, objects are relevant in negotiating one's identity.[12] Additionally, as scholars such as Igor Kopytoff[13] or Katina Lillios[14] note, objects have their own life-histories and these may be traced to increase our knowledge about the different constructions of memory. Similarly, Michael Rowlands reminds us that "objects are culturally constructed to connote and consolidate the possession of past events associated with their use or ownership."[15] Finally, it is also worth mentioning that objects contribute to revealing a particular identity only through the actions of individuals and groups. As Emma Blake states, "Memory and tradition alone do not preserve an object's identity; it is the ongoing incorporations of that object into routinized practice that generates meaning."[16] In Urza's book, objects

10 David Rio, "The Miraculous Blend: An Interview with Monique Urza," 8.
11 Beyond Ethnicity: Consent and Descent in American Culture (New York: Oxford University Press, 1986).
12 Symbols in Action: Ethnoarchaeological Studies of Material Culture (Cambridge: Cambridge University Press, 1982).
13 "The Cultural Biography of Things: Commoditization as Process," in The Social Life of Things, ed. Arjun Appadurai (Cambridge: Cambridge University Press, 1986), 64–91.
14 "Objects of Memory: The Ethnography and Archaeology of Heirlooms," Journal of Archaeological Method and Theory 6.3 (1999): 235–262.
15 The Role of Memory in the Transmission of Culture," World Archaeology 25.2 (1993): 144.
16 Quoted in Ian Kuijt, "The Regeneration of Life. Neothilic Structures of Symbolic Remembering and Forgetting," Current Anthropology 49.2 (2008): 173.

actively participate in negotiating an identity based on ethnicity, age, and gender, and they become particularly meaningful in both preserving the Basque heritage of the family and in maintaining its unity.

Certain specific objects, such as photographs, have been traditionally linked to the construction of both individual and collective memory because they provide graphic access to the past that can be kept in circulation for several generations. In Urza's book, almost from the beginning of the story, the reader becomes aware of the fundamental role played by "a brown-and-white photograph on the mantel,"[17] showing Grandma and Grandpa and their five children. The family picture symbolizes the immigrant story and it has dominion in the grandparents' dining room "where family was everywhere."[18] In fact, the narrator explicitly acknowledges that this family picture outweighs all the other pictures in the house and captures the attention of the younger generations: "We ignored our own photographs, which were in color and were too recent, too familiar to have significance."[19] The picture embodies not only the past of the family, but also a symbolic connection of lives and stories across two continents and several generations, emphasizing the family roots and creating an image of continuity. Besides, as Marianne Hirsch affirms, "Photographs, as the only material traces of an irrecoverable past, derive their power and their important cultural role from their embeddedness in the fundamental rites of family life."[20] In Urza's novel, the brown-and-white family photograph works as a source of emotions, activating positive feelings related to the immigrant story of the family—such as love, attachment, pride, devotion, and determination. Although each generation assumes these memories and

17 The Deep Blue Memory, 9.
18 Ibid., 8.
19 Ibid., 8–9.
20 Family Frames: Photography, Narrative, and Postmemory (Cambridge: Harvard University Press, 1997), 5.

the emotions attached to them as their own, we know that the brown-and-white picture does not really represent all their genuine, individual past experiences. After all, a family photograph cannot be regarded as the testimony of a single truth about the past, and may be subject to multiple interpretations because "family photography can operate at this junction between personal memory and social history, between public myth and personal unconscious."[21] Or, as Victoria Bañales observes, "A subject looking at a photograph constructs a fantastic past, just like the 'memory' of this family's immigrant story is only a version of a real life, tainted by the contributions from other 'narrators' and their transformations of the story over time."[22] Similarly, Michael Fischer affirms that ethnicity is "something reinvented and reinterpreted in each generation by each individual."[23]

The brown-and-white picture is placed in the grandparents' house not too far away from an old round dining room table, another major symbol of the family's immigrant story. The table epitomizes a common and ancient bond that both reveals the uniqueness of the family and stresses its cohesion. It is "the table where early on the children of immigrants had formed a circle that protected them, that strengthened them, that over time had become a place of privilege, where only family was allowed."[24] The table certainly works as a symbol of unity and continuity, contributing to reinforce the image of sameness between different generations due to a common ethnic and family heritage. As the narrator of the book states, "It was the sameness that prevailed over the difference, because we felt the same in each of their laps. It

21 Laura Beard, Acts of Narrative Resistance, 13.
22 "Literary Portraits of Basque–American Women: From Shadow to Presence" (PhD dissertation, UPV/EHU, 2015), 195.
23 "Ethnicity and the Post-modern Arts of Memory," in Writing Cultures: The Poetics and Politics of Ethnography, ed. James Clifford and George E. Marcus (Berkeley: University of California Press, 1997), 195.
24 The Deep Blue Memory, 13.

was a sense of something that went far back, long before our existence, somehow connected with the old country, with green hills and dark earth."[25] Certainly, the novel may be interpreted as a vindication of family ties and family loyalty in a culture that has traditionally promoted individualism as one of the key traits of American identity. However, Urza's book also exposes the risks of an overemphasis on devotion to family unity and bonds, particularly when the individual is willing to sacrifice his or her own identity to promote a family image that may be unrealistic or too distanced from the goals or needs of some of its members. Marianne Hirsch, for example, explains that some specific family symbols, such as photographs, can create "images that real families cannot uphold."[26] The conflict between the myth of the ideal united family and the lived reality of family life is also suggested by the narrator of the book when she claims that "the stronger the family, the more valuable it is, the more vulnerable it is, the more needful of protection."[27] The novel discloses the inability of some members of the family to live up to the group's expectations, revealing some of the negative emotions that this self-imposed discipline of duty to the family group may create, such as fear, grief, despair, guilt, or helplessness. These negative emotions become more noticeable in the novel after the grandparents' death and are related to the overexposure of the family to the media due to the political success of one of its members, Uncle Luke. The entire family's efforts have contributed to a large extent to his rise in American politics "against [others'] money and connections that went three generations back."[28] However, the political rewards of family solidarity may not compensate for the invasion of the private lives of its members as they rise into public prominence. Traditional boundaries

25 Ibid., 17.
26 Family Frames, 7.
27 The Deep Blue Memory, 113.
28 Ibid., 65.

between public and private spaces are disrupted by politics, and the price to be paid for political success becomes really painful, as illustrated by the serious allegation "that was black in color"[29] made against the family, first by a political rival and later by a newspaper. Uncle Luke's lawsuit to defend the family name brings the family together, but it also has tragic consequences. The novel shows that loyalty to one's family and an overemphasis on the public recognition and respectability of the family name, may not only destroy the individual's personal identity, but also endanger his emotional stability, generating negative emotions. In some cases, commitment to family and the inability to live up to the group's expectations may even have tragic consequences, as exemplified in the book by the suicide of one of the characters, Aunt Sondra, a relative by law who, in fact, "had no duty to them or to the name."[30]

One of the key elements in the construction and transmission of memory in the narrator's family is the deep blue book written by her father. It is the story of the grandfather's life in the Nevada desert and of his return trip to the Basque Country with the narrator's father. This book evokes the family's immigrant past, their fight for success and assimilation in America, and the search for their roots in the old country. It is obviously a thinly disguised reference to Robert Laxalt's iconic work Sweet Promised Land. The deep blue book becomes, for the second generation of the family, a major symbol of their ethnic and family identity. As the narrator claims, this book was "that which each of us, if ever a fire had struck our house, would have taken first."[31] The deep blue book works as a point of cohesion, sameness, and continuity, as an instrument with the emotional power to transmit family memories to the new generations. In a way, this book resembles the brown-and-

29 Ibid., 92.
30 Ibid., 131.
31 The Deep Blue Memory, 14.

white picture because family photography and autobiography perform similar roles in terms of preserving memories. As Marianne Hirsch states, "Both operate at the interstices of memory and imagination."[32] Or, to use Victoria Bañales's words, "Just like photographs may serve as the family's main instrument of self-knowledge and representation, an object that holds the emotional power to perpetuate and pass on family memories to future generations, the act of writing itself is also an act of retrieving memory, an act of remembering."[33] In Urza's novel, the genuine meaning of the deep blue book as the immigrant sheepherder story becomes corrupted when it is politically marketed to help Uncle Luke to win a seat in the United States Senate. Again, the connection with Sweet Promised Land and its use as campaign propaganda seems obvious. In 1974, Robert Laxalt's memoir was massively distributed in Nevada in a special edition that contained an epilogue where the author detailed his brother Paul Laxalt's career. In a way, this campaign edition established a parallelism between the candidate's integrity and that of his immigrant father. According to Sally Denton and William Morris, the political marketing of the immigrant family story displeased Monique Urza because it meant "the prostitution of his father's work of art and [...] the beginning of the haunting of the family."[34] In fact, in Urza's novel, the success of the deep blue book as political propaganda marks the beginning of inner family conflicts and dissension: "It was done then [...] the day the deep blue book was given up, although we did not know it, we could not see it."[35] Uncle Luke's rise to power not only means vanishing privacy, but an increasing artificiality because the unique features of the narrator's family, particularly those connected

32 Family Frames, 84.
33 Literary Portraits of Basque–American Women, 195.
34 The Money and the Power: The Making of Las Vegas and Its Hold on America, 1947–2000 (New York: Knopf, 2001), 265.
35 The Deep Blue Memory, 99.

withthesheepherderstory,aresubordinatedtothefamily'spublicimage
and to success and recognition in America.[36]

Afterthemythofthedeepbluebookisbrokenandherfather
has died, the narrator needs new references to reinforce the idea of
samenessandcontinuity,"themiraculousblend"[37]thatmakesitpossi-
bleforthisimmigrantfamilytointegrateloyaltytotheirBasqueheri-
tageandAmericansuccess.Additionally,sheseemstofindinherson's
birthaunifyingeventabletoreplacethedeepbluebookandreinforce
the family legacy and identity:"He was like the deep blue book. He
wastobethedeepbluebook.Hewouldcomedark-eyedandgood-
skinned bearing the beauty of the green hills. [...] He would be the
untarnishedlink."[38]Thebirthofhersonisregardedbythenarratornot
onlyasatestimonyoffamilyloyaltyandduty,asexemplifiedbyher
emphasis on such terms as"entrustment"[39] or"fiduciary,"[40] but also
asawaytopayhomagetohergrandmother,transmittingherlegacy
to the fourth generation:"The baby boy, my baby boy, was for you,
Grandma, although you never saw him, held him, knew him."[41] In
fact,thewholenovelvindicatesthefigureoftheBasquegrandmother,
traditionallyrelegatedtoasecondaryroleinBasque-Americanstories
duetotheoveremphasisontheimmigrantsheepherderlife.InUrza's
novel,thenarrator'sgrandmotherbecomesakeyfigureinthefamily
becausesheplaysadoubleroleinthebook:asymbolofloyaltytothe
BasqueheritageandanexampleoftheneedtoassimilateAmerican
values.Thus,ontheonehand,thegrandmotherillustratesthetrans-

36 See also David Rio, "Monique Laxalt: A Literary Interpreter for the New Generations of Basque Americans,"in Amatxi,Amuma,Amoma:WritingsinHonorofBasqueWomen,ed. Linda White & Cameron Watson (Reno: Center for Basque Studies Press, University of Nevada, Reno, 2003), 94–95.
37 The Deep Blue Memory, 67.
38 Ibid., 101.
39 Ibid.
40 Ibid., 102.
41 Ibid., 100.

missionoffundamentalfeaturesoftheirBasqueheritage,suchasfamily roots or the Catholic religion, but on the other hand, she is also awareoftheneedtoadjusttoAmericanways,asexemplifiedbyher insistenceontheimportanceofeducationforthenewgenerations, her commitment to speak only English to her children, or her decisiontosendthemto"roamintheroomwhereNevada'ssenatorsand judges drank and talked business over hot meals."[42]

The prominence ofthe grandmother in the novel, together withtheuseofafemalenarrator,servesUrzatoaddressseveralidentity issuesrelatedtotheintroductionofagenderedviewoftheexperiences ofBasquesinAmerica.AsIhavearguedelsewhere,thenovelmaybe regardedasanexampleof"thepowerofautobiographicalwritingto exploresuchissuesasgrowingupfemale,motherhood,andfemale subjectivity."[43] As scholars such as Sidonie Smith and Julia Watson claim,"Iffeminismhasrevolutionizedliteraryandsocialtheory,the textsandtheoryofwomen'sautobiographyhavebeenpivotalforrevisingourconceptsofwomen'slifeissues."[44]Urza'snovelstresses,in particular,theuniquefemaleandintergenerationalbondestablished betweenthegrandmotherandthenarrator.Gendercertainlyshapes the emotional connection between them, but this relationship is not just one and static, as it intersects with other signifying net of practicesdictatedbyconceptssuchasfamilyorage.Afterall,gender identityisacomplexconstructinfluencedbyeverydaypractices,oras LynnMeskellstates,itis"aprocessofbecomingratherthanastateof being."[45]

42 Ibid., 11.
43 "Autobiographical Writing on Politics in the Sin State: Latina and Basque American Perspectives,"inSelvesinDialogue:ATransethnicApproachtoAmericanLifeWriting,ed. Begoña Simal (Amsterdam: Rodopi, 2011), 166.
44 Women,Autobiography,andTheory:AReader(Madison:TheUniversityofWisconsinPress, 1998), 5.
45 "ArchaeologiesofIdentity,"inTheArchaeologyofIdentities:AReader,ed.TimothyInsoll

In Urza's novel, the gender bond between the grandmother and the narrator has an obvious physical dimension, as illustrated, for example, by the references to "the warm good scent"[46] of the grandmother or to the narrator's reaction after bathing her: "As she turned and laid her old weary body down I climbed onto the bed and stretched out beside her, my young sun-darkened limbs next to her."[47] However, the closeness between both characters is mainly portrayed as a cultural and spiritual process where the narrator, as the granddaughter of immigrants, is fully integrated into American society and yearns for the Basque heritage embodied by her grandmother, a legacy she is afraid of losing due to Americanization. As Monique Urza herself observes, "The more integrated we're supposed to be, the more desperately we're reaching back to some kind of heritage to try to give to our own kids because we feel that our roots have been lost."[48] In a way, the bond between the narrator and her grandmother serves Urza to recreate in her novel the classical principle of third-generation interest developed by Marcus Lee Hansen in 1938 in his well-known essay "The Problem of the Third Generation Immigrant."[49] According to Hansen, while second-generation immigrants are eager to assimilate the cultural norms and values of the host country, third-generation immigrants are eager to retain and reaffirm those of their grandparents' generation, asserting their difference from mainstream culture and clinging to iconic images of a remembered past. In the novel, the narrator directly addresses her grandmother, telling her about her determination to be faithful to the family legacy, even if this means shielding herself—and the next generation, represented by her son—from the

(London: Routledge, 2007), 30.
46 The Deep Blue Memory, 80.
47 Ibid.
48 David Rio, "The Miraculous Blend: An Interview with Monique Urza," 7.
49 Published by the Augustana Historical Society (Rock Island, IL), 5–20.

pressure of American mainstream values. Maternity is understood as a way to perpetuate Basque ancestral roots and identity in newer generations, holding in trust the memories of the previous generations. In fact, the narrator explicitly admits that her son was conceived for her grandmother with the idea of the entrustment of a valuable but vulnerable heritage: "The image of entrustment, the image of a thing of value, and the handing of it, the entrusting of it, to another. [...] And flowing from the strength of the one and the vulnerability of the other the recognition of duty, duty of a special nature, of an exalted nature, running from him who holds control to him who is powerless, to preserve and protect the valuable thing."[50]

Despite the emphasis on ancient, blood-deep imperatives, as exemplified by the bond between the narrator and her grandmother, the end of Urza's novel also illustrates the increasing psychological separation from the family of the new generations. Although they are proud of the family heritage and are aware of their Basque-American hybrid identity, remaining loyal to a series of rituals and motifs, they will give priority to their own personal sense of reality and individuality over collective memories. The narrator herself realizes that her own children, the fourth generation, search for a sense of the self that goes beyond ethnic labels. They are active agents, creating their own social reality, without the help of the images of sameness that have been so influential on other generations of their family. This process of realizing one's aloneness is illustrated by the narrator's new awareness of her twelve-year-old son's face: "I looked at the young face and suddenly I knew that I had never looked at it before, the face that bore nothing of the dark earth, the face that was as open, as unrestrained,

50 The Deep Blue Memory, 102.

as free as these desert hills."[51] Significantly enough, the character who was supposed to symbolize the family's ever-lasting connection with the Old World seems to epitomize the diminishing influence of the descent relations and the natural desire to choose one's own destiny. Additionally, the narrator introduces the figure of her grandmother once again to explain that the vanishing of the traditional relevance of the old ways is not just an issue related to the new generations. In fact, the narrator realizes, it is a common process in immigrant families, something that her grandmother had both anticipated and willed. Her grandmother had indeed taught her children about the need to adjust to the demands of the present and to assimilate the American ways. As the narrator states at the end of the book, "You knew it long ago, you knew it raven-haired, gold-earringed, you knew it before leaving the green hills. You willed it. You kicked it over. It was no accident."[52] Monique Urza herself has claimed that the new generations of Basque-Americans "are aware of their Basque heritage and they are proud of being Basque, but it does not seem so psychologically important or central to them. It's not like a frantic need searching back for some kind of identity."[53]

In general, The Deep Blue Memory may be regarded as an insightful account of the tensions between loyalty to the family heritage and the process of realizing one's aloneness, revealing the emotions produced during this conflict. The novel addresses issues such as self-representation, the preservation of a collective past, and the tensions between the immigrant heritage and the reality of modern-day America. In fact, Urza's book may be defined as a masterful exploration of the multiple interactions between identity and memories, and the role

51 Ibid., 156.
52 The Deep Blue Memory, 157.
53 David Rio, "The Miraculous Blend: An Interview with Monique Urza," 11.

memory plays in identity formation and self-representation. Her story shows that the construction of an identity is often connected to the different registers in which a human being responds to individual and collective memories. Her novel should be praised for its approach to the border space between immigrant identity and mainstream American culture, with its emphasis on the interaction between the ancestral unity of the Basque family and the traditional American devotion to the individual's personal characteristics. The book also stands out for presenting a dynamic model of ethnicity because it deals with the way in which several generations of the same immigrant family deal with their ethnic heritage, with particular attention to the female bond between the first and the third generations. Overall, Urza's novel illustrates the complexities of exploring one's identity, a process where progress toward the future often coexists with loyalty to one's heritage and celebration of common memories. In this sense, it is worth remembering the epigraph by T. S. Eliot that is placed at the beginning of the novel:

We shall not cease from exploration

And the end of all our exploring

Will be to arrive where we started

And know the place for the first time.

"Little Gidding"

WORKS CITED

Assman, Jan. "Collective Memory and Cultural Identity." New German Critique 65 (1995): 125–133. Translated by John Czaplicka. This text was originally published in Kultur und Gedachtnis, edited by Jan Assmann and Tonio Holscher, 9–19. Frankfurt/Main: Suhrkamp, 1988.

Bañales, Victoria. "Portraits of Basque–American Women: From Shadow to Presence" (PhD dissertation, UPV/EHU, 2015).

Beard, Laura. Acts of Narrative Resistance: Women's Autobiographical Writing in the Americas. Charlottesville: University of Virginia Press, 2009.

Denton, Sally and William Morris. The Money and the Power: The Making of Las Vegas and Its Hold on America, 1947–2000. New York: Knopf, 2001.

Etulain, Richard W. "The Basques in Western American Literature." In Anglo-American Contributions to Basque Studies: Essays in Honor to Jon Bilbao, edited by William A. Douglass, Richard W. Etulain, and William H. Jacobsen, Jr., 7–18. Reno: Desert Research Institute Publications on the Social Sciences, 1977.

Fischer, Michael. "Ethnicity and the Post-modern Arts of Memory." In Writing Cultures: The Poetics and Politics of Ethnography, edited by James Clifford and George E. Marcus, 194–233. Berkeley: University of California Press, 1997.

Hansen, Marcus Lee. "The Problem of the Third Generation Immigrant." Rock Island, IL: The Augustana Historical Society (1938), 5–20.

Hirsch, Marianne. Family Frames: Photography, Narrative, and Postmemory. Cambridge: Harvard University Press, 1997.

Hodder, Ian. Symbols in Action: Ethnoarchaeological Studies of Material Culture. Cambridge: Cambridge University Press, 1982.

Isasi, Mirim. Basque Girl. Glendale: Griffin-Patterson Publishing, 1940.

Kopytoff, Igor. "The Cultural Biography of Things: Commoditization as Process." In The Social Life of Things, edited by Arjun Appadurai, 64–91. Cambridge: Cambridge University Press, 1986.

Kuijt, Ian. "The Regeneration of Life. Neolithic Structures of Symbolic Remembering and Forgetting." Current Anthropology 49.2 (2008): 171–197.

Laxalt, Robert. Sweet Promised Land. New York: Harper & Row, 1957.

Lillios, Katina. "Objects of Memory: The Ethnography and Archaeology of Heirlooms." Journal of Archaeological Method and Theory 6.3 (1999): 235–262.

Martin, Gregory. Mountain City. New York: North Point Press, 2000.

Meskell, Lynn. "Archaeologies of Identity." In The Archaeology of Identities: A Reader, edited by Timothy Insoll, 37–57. London: Routledge, 2007.

Río, David. "Autobiographical Writing on Politics in the Sin State: Latina and Basque American Perspectives." In Selves in Dialogue:

A Transethnic Approach to American Life Writing, edited by Begoña Simal, 159–180. Amsterdam: Rodopi, 2011.

Río, David. "The Miraculous Blend: An Interview with Monique Urza." Journal of the Society of Basque Studies in America vol. XVI (1996): 1–14.

Río, David. "Monique Laxalt: A Literary Interpreter for the New Generations of Basque Americans." In Amatxi, Amuma, Amona: Writings in Honor of Basque Women, edited by Linda White & Cameron Watson, 86–98. Reno: Center for Basque Studies Press, University of Nevada, Reno, 2003.

Rowlands, Michael. "The Role of Memory in the Transmission of Culture." World Archaeology 25. 2 (1993): 141–151.

Smith, Sidonie and Julia Watson. Women, Autobiography, and Theory: A Reader. Madison: The University of Wisconsin Press, 1998.

Sollors, Werner. Beyond Ethnicity: Consent and Descent in American Culture. New York: Oxford University Press, 1986.

Urza, Monique (Laxalt). The Deep Blue Memory. Reno: University of Nevada Press, 1993.

Van Dyke, Ruth M. and Susan E. Alcock. Archaeologies of Memory. London: Blackwell, 2003.

Basque Women in Exile: Remembering Their Voices and Impact in Literature through the Cultural Magazine Euzko-Gogoa

Ziortza Gandarias Beldarrain

Boise State University

Following the War of 1936,[1] many Basque individuals, families, politicians, artists, and intellectuals left the Basque Country and went into exile. According to José Angel Ascunce, the tragedy suffered by those exiled is revealed by two principles: the geographical breakdown and the breaking of one's identity.[2] For Basque women specifically, exile brought renewed self-definitions of purpose and identity, as well as expectations imposed upon them by men. This essay will discuss how Basque female writers addressed the tragedy undergone and the roles they took on,

1 The term "War of 1936" will be used instead of "Spanish Civil War." As the scholar Xabier Irujo states in Gernika 1937, The Market Day Massacre (Reno: University of Nevada Press, 2015), 225: "Most historians use the term Spanish Civil War to describe the conflict. However, Narcissus Bassols and Isidro Fabela, representatives of the Mexican Government at the League of Nations, criticized the categorization of the war as 'civil' conflict. US ambassador Claude G. Bowers stated that the war was neither Spanish nor civil but a prologue to the World War II, and Congressman Jerry J. O'Connell offered a similar critique by saying that the bombing of Gernika was the work of German planes, German bombs, and German pilots. O'Connell asked Secretary of State Cordell Hull 'to take official notice of what is common knowledge, namely, that Germany and Italy are in fact belligerents in the war of invasion now going on in Spain' Congressional Record: Appendix of the First Session of the 75th Congress of U.S.A., vol.81, pt.9, January 5–May 19, 1937 (Washington, DC: US Government Printing Office, 1937)."
2 José Angel Ascunce, El exilio: debate para la historia y la cultura (Donostia: Saturraran, 2008), 37.

from exile, through their participation in the Basque cultural magazine, Euzko-Gogoa (Basque-Will).

During the years of the Franco dictatorship, censorship prevented the publication of works in Basque for almost ten years. As a form of maintaining the Basque language and literature, those individuals in exile took the responsibility of transmitting Basque memory, language, and culture in order to fight what José F. Colmeiro calls "historical amnesia."[3] One example of this effort was the cultural magazine Euzko-Gogoa, created by the Jesuit priest Jokin Zaitegi in 1950 in Guatemala. Euzko-Gogoa focused on the maintenance of both the Basque culture and the language, and created a foundation for the future of the Basque nation through its writings. Euzko-Gogoa hoped to become the place where all the globally dispersed Basque writers could find a platform for collaboration. Basque literature was thwarted by the Franco regime in Spain, and it was mainly from exile that Basque culture could continue to evolve as it had before the War of 1936.

Euzko-Gogoa was the second post-war magazine written entirely in Basque, after Argia Euskaldunak Euskaraz (The Light. Basques in their Language, 1946–1948). Euzko-Gogoa was published during two different periods and in two locations. The first period of publication took place in Guatemala (1950–1955) in the Latin-American Basque exile. Latin America was one of the first geographical areas in which exiles, both Basques and Spaniards, sought refuge during the War of 1936. The second period of the magazine took place, also in exile, in the coastal town of Biarritz, Northern Basque Country (1956–1960). After 44 issues, a total of 1,171 works consisting of 3,658 pages were

3 José F. Colmeiro, Memoria Histórica e identidad cultural. De la posguerra a la postmodernidad (Barcelona: Anthropos, 2005), 14.

published, with the efforts of 153 writers—five of whom were women. In other words, the majority of Basque writers who contributed to the magazine were men. In 1960, Euzko-Gogoa ended its publications.

In prior studies about Euzko-Gogoa, the impact and role of the women involved with the magazine has been generally overlooked. The cultural work of Basque women during Franco's regime, particularly in the 1950s, and more specifically the work of the various women who collaborated in the magazine as well as what was written there in reference to women and motherhood, deserves to be analyzed. The magazine represented the space where women might exercise roles beyond their "natural" female roles (as mothers, wives, teachers, etc.), such as cultural and linguistic transmitters, and political propaganda creators. What follows is some history leading up to the publication of Euzko-Gogoa, a description of the Basque female activists of the time, and an analysis of a few specific female authors' contributions. Additionally, an analysis of the discourse used in the articles, poems, and stories of the magazine, both from male and female authors, will be presented.

Although there were female writers prior, it was not until the beginning of the twentieth century when women became relevant in the Basque literary arena. During that time, institutional and cultural platforms were developed with the efforts of women, such as the Emakume Abertzale Batza, EAB (Association of Nationalist Women, 1922–23, 1931–36). The creation of this association brought with it many changes for Basque women, by redefining their identities and spaces. The EAB had its precedent in the Irish association named Cumann na mBan (The Women's Council) established in 1914. The EAB was born in Bilbao in 1922, by women of the Euzko Alderdi Jeltzalea-Partido Nacionalista Vasco, EAJ-PNV (Basque Nationalist

Party, 1895–). These women went from village to village spreading the EAJ-PNV's ideology, and more concretely the woman's role inside the party. Through these interventions, women gained a public voice for the nationalist ideal, and gradually began entering an environment previously monopolized by men. As Mercedes Ugalde states, their work was to create propaganda campaigns in favor of the Basque Nationalist Party and organize different events related with cultural education as well as social and charity assistance. Education and cultural values were the main areas of concern for women of the EAB.[4]

Policarpo de Larrañaga described the main objectives of the EAB as such: disseminate the Basque nationalist doctrine in the Basque Country and develop activities and initiatives in the charitable and cultural realm.[5] In order to understand the role of women in the development of Basque nationalism. He explains how the EAB manifesto lays out the religious, political, and social goals of the organization.[6] The female nationalist figure that would later thrive in the pages of Euzko-Gogoa is largely representative of the pre-war period when the EAB was born. After the War of 1936, the EAB disappeared from the Basque territory to act only in exile.

During the changing times in which women were gaining a voice in politics, they were also becoming more active in the literary community. Literature and politics for Basques during this period were oftentimes intertwined. Basque literature during the early- and mid-twentieth century was described by Amaia Alvarez as "lehen loraldia" (the first awakening). She argues that it was the time to promote Basque

4 MercedesUgalde,Mujeresynacionalismovasco:génesisydesarrollodeEmakumeAbertzale Batza (1906–1936) (Bilbao: Servicio Editorial Universidad del País Vasco, 1993), 133.

5 Policarpo de Larrañaga, Emakume Abertzale Batza: la mujer en el nacionalismo vasco (Donostia: Auñamendi, 1978), 45.

6 de Larrañaga, Emakume Abertzale Batza: la mujer en el nacionalismo vasco, 45.a

nationalism, to guard religion/faith, and to defend the Basque language. In regard to women, a patriotic motherly image was promoted.[7] Before the War of 1936, there were many cultural activities in the Basque Country promoted by Euskaltzaleak, an association committed to the development of the Basque culture in the Basque language, where many women participated. Also, several magazines were published before the war, such as Euskal Esnalea (Basque Language Awakener, 1908–1931), Euskalerriaren Alde (In Favor of the Basque Country, 1911–1930), Euzkerea (The Basque Language, 1929–1936), Bizkaitarra (The Biscayan, 1893–1895), and Amayur (Amayur, 1931–1936) with the contributions of various female writers, such as Errose Bustintza, Tene Mujika, and Mayi Ariztia.

Mikel Atxaga argues that women authors were able to write in Basque because they had an academic background.[8] As Virginia Woolf states in her classical essay, "A woman must have money and a room of her own if she is to write fiction."[9] Basque female writers came from concrete environments; they were teachers, activists, or relatives of a writer/poet. However, due to the War of 1936, many of these women were forced to go into exile because of their implication with the EAJ-PNV. It was from exile where some of them continued working in favor of the Basque language. In this regard, Euzko-Gogoa gave these women a platform to maintain the Basque language while also opening a door for female writers into the literary canon during one of the darkest eras for the Basque language. However, examining the works written by these female writers and the works written by men

7 Amaia Alvarez,"Euskalemakumeidazleenlekualiteraturarenhistorian.Dorrearenarrakalak agerian uzten," Jakin 148, (May–June 2005): 50.
8 Mikel Atxaga, Euskal emakume idazleak (1908–1936) (Gasteiz: Eusko Jaurlaritzaren Argitalpen Zerbitzu Nagusia, 1997), 6.
9 Virginia Woolf, A Room of One's Own (San Diego: Harcourt, 1989), 4.

referring to womanhood, one can see how the magazine embraced a double standard. Sandra Gilbert and Susan Gubar state that for female artists, the essential process of self-definition is complicated since it is shaped by patriarchal definitions that intervene between herself and her definition of self.[10] This is certainly the case in the Euzko-Gogoa, where self-imposed and imposed definitions of female authors were often polarized, as will be shown later. Nevertheless, in the case of these Basque women writers, who were part of the Basque Nationalist Party, they proudly assumed and embraced their maternal-teacher-language transmitter roles, imposed by the party/men. These women truly believed in and admired the foundations of the Basque Nationalist Party and the figure of the father founder, Sabino Arana. Mercedes Ugalde analyzes how Arana used the symbolic reference of the preindustrial family, with its two basic elements—the baserritarra (farmer) and the etxekoandre (woman of the house)—to elaborate on the role of women in the party. The baserritarra represented the Basque race and the etxekoandre was key for the perpetuation of the race and the transmission of values.[11] The women, therefore, played a decisive role in Arana's nationalism construction since they would contribute to the homeland's continuity through their children.

Ander Gurruchaga argues that the biggest contribution of the Basque exile to Basque culture is the political attitude which rejected the Francoist system, as well as giving continuity to the culture.[12] The desire of the Basque exile was to link the old generation with the new generation in order to keep the memory of the past alive, especially

10 Sandra Gilbert and Susan Gubar, "The Madwoman in the Attic," in Literary Theory: An Anthology (2nd. ed.), ed. Julie Rivkin and Michael Ryan (Oxford: Blackwell, 2004), 813.
11 Ugalde, Mujeres y nacionalismo vasco: génesis y desarrollo de Emakume Abertzale Batza (1906–1936), 43.
12 Ander Gurruchaga, El código nacionalista vasco durante el franquismo (Barcelona: Anthropos, 1985), 187.

in the political and cultural arenas. The Basque exiles maintained the nationalist code based on a traditional Basque nationalism in line with the utopic preindustrial Basque society. The Euskara (Basque language), the fueros (Basque laws), tradition, and historical peculiarity were the main ideas promoted. Basque nationalism produced its own space, redefining its limits in exile. Euzko-Gogoa, faithful to the traditional nationalist ideals, tried to maintain the Basque Country by rebuilding the Basque national identity and memory. In other words, it generated and perpetuated a Basque community based on the ideas of the traditional, linguistic, and symbolic Basque world.

Given the political circumstances of the time, and the political nature of the writers themselves, it is not surprising that Euzko-Gogoa promoted the archetypal and ideal nationalist Basque woman. Through its publications, Euzko-Gogoa advocated for the "noblest femininity"[13]: a pure, almost virginal woman; patriotic; Christian; and tasked with conserving and spreading the Basque language and culture. Feeding the Basque language and love for the motherland to her children was of utmost importance, as those children were the future of the nation and the future torchbearers of the Basque language. In the pages of Euzko-Gogoa, as well as in the Basque political arena, it was a central argument that women had a greater responsibility of teaching their children the Basque language than did men. As the Kenyan scholar Ngũgĩ wa Thiong'o states, "Language is the symbol of a person's soul and an inseparable tool of any human community."[14] The transmission of the mother-tongue, in the case of the Basque exiles, was crucial in keeping the national identity alive.

13 Hans Eichner, "The Eternal Feminine: An Aspect of Goethe's Ethics," in Johann Wolfgang von Goethe, Faust, ed. Cyrus Hamlin (New York: Norton, 1976), 616–617.
14 Ngũgĩ wa Thiong'o, Decolonising the Mind: The Politics of Language in African Literature (London: J. Currey; Portsmouth, N.H,: Heinemann, 1986), 11.

The lives and contributions of specific women authors whose works appeared in the magazine will be discussed in order to further understand their role. Sorne Unzueta, who used the pen name "Utarsus," was a political activist during the Basque nationalist movement of the early twentieth century, a teacher, a member of the EAB, a writer, and a mother. She shared the EAJ-PNV's ideology in different meetings throughout the Basque Country and was a well-known demagogue inside the party. As Igone Etxebarria says, "Her party conferences were vehement."[15] However, when the political uprising began in 1936, she was forced into exile and moved to France. Once there, she became an active member of the resistance during the Second World War. She was the only woman of the resistance group in which her husband also participated. Etxebarria explains the very dangerous tasks carried out by Sorne: "[Her] job was to carry messages from the free zone to the area occupied by the Nazis."[16] After more than a decade in exile, in 1953 she returned to the Southern Basque Country with her family. Sorne Unzueta published two works in the magazine, the first being the composition Itxartu, eusko alabea (Wake Up, Basque Daughter, 1950), a poem with a nationalistic and propagandistic discourse. The scholar Maite Nuñez-Betelu calls it a "pamphlet poem".[17] The poem was a call to action for increased participation of women in the national struggle. In the poem, Unzueta also mentioned the father founder of the Basque National Party, Sabino Arana. Unzueta promoted a proactive relationship between women and nation, but always completing her assigned role. She recognized and promoted the minor role of women in politics. Nuñez-Betelu explains that "Utarsus" advocated for the

15 Igone Etxebarria, Sorne Unzueta "Utarsus" (Gasteiz: Eusko Jaurlaritzaren Argitalpen Zerbitzu Nagusia, 2000), 8. (my translation)

16 Etxebarria, Sorne Unzueta "Utarsus", 12. (my translation)

17 Maite Nuñez-Betelu, "Género y construcción nacional en las escritoras vascas" (PhD dissertation, University of Missouri-Columbia, 2001), 143.

equality of women and men with regards to their participation in the patriotic struggle, but each one fulfilling his or her corresponding role as indicated by gender.[18]

Unzueta's second work published in the magazine was the patriotic poem, Artxanda (Artxanda, 1952), in which the author examined the relationship between a mother and her son. Maternity was one of the pillars of Unzueta's work. As Etxebarria explains, "In Unzueta's works, common themes are the relationship between the mother and children, the feelings of the mother, and what a mother should teach her children."[19] The poem showed the reality that many mothers faced during the War of 1936: the sorrow of letting their sons fight for the motherland, the loss of the war, the destiny of the sons in the hands of the enemy, and the emptiness and lost identity. The title of the poem is also significant. Artxanda is a mountain in Bilbao, and it was the place where the gudaris (Basque soldiers) made a "suicidal" counterattack against the Francoist troops before the inevitable fall of Bilbao. This battle allowed the general population to escape Franco's troops and leave the city. The defeat of the city and the destiny of the soldiers taken in Artxanda was embraced in the poem through the conversation between the mother and the son. The intrinsic relationship between the mother, the son, and the motherland is apparent. Nerea Aresti collects the statements made by Polixene Trabudua, an active member of the EAB, about the pain and containment of emotions of the Basque mothers seeing their sons going to war.[20] She shows how much they loved not only their homeland but also their sons. Rather

18 Nuñez-Betelu, "Género y construcción nacional en las escritoras vascas," 149.
19 Etxebarria, Sorne Unzueta "Utarsus", 16. (my traanslation)
20 Nerea Aresti, "De heroínas viriles a madres de la patria. Las mujeres y el nacionalismo vasco 1893-1937" Historia y Política 31, (January–June 2014): 305.

than attempting to be emotional, these mothers accepted the reality of the situation, knowing they could see both their sons and country lost.

Another author who contributed to the magazine was Karmele Errazti. Errazti was the first president of the EAB and an active writer in the nationalist press, using the pseudonyms "Etxakin" and "Emakume batek" (which translate to "Unknown" and "A woman," respectively). She was married to the Basque writer Keperin Xemein. She was exiled in Pau, France, during the War of 1936 and never returned to the Southern Basque Country. In Euzko-Gogoa, she wrote two works: an obituary about the death of Basque patriots, Yoan Yakuzan bixitz oroigarrijak (They Left Us, 1951) and a letter titled "Euzko-Gogoa" (Basque Will, 1950) where she highlighted the good work done by the magazine, especially approving the Basque dialect promoted in the magazine, enhanced Gipuzkoan. Nuñez-Betelu states that Errazti tried through her writings to educate the children to love God, the nation, and the Basque language.[21] Errazti was very active in the EAB, and very much pro-"Sabinian" (pro-EAJ-PNV ideology). Sabino Arana advocated for a purist version of the language that replaced Romance roots with neologisms, and a safeguard of the Basque dialects, especially of the Biscayan dialects. According to Sabino Arana's view, women should be the most important figures in the promotion of language and culture. Hence the rationale for why Erratzi was so focused on the use of correctly written Basque.

The third and final female Basque writer included in this analysis, Julene Azpeitia, who signed her work as "Arritokieta," was one of the main writers who defended the Basque traditions, especially the importance of education in the Basque language. Azpeitia was a vocational teacher

21 Nuñez-Betelu, "Género y construcción nacional en las escritoras vascas," 101.

whose main priority was to create an educational model to use with Basque children for promoting the Basque language. For her, the Basque language was the engine that was strongly bound to the nation. In Euzko-Gogoa, she wrote Goizeko izarra (The Morning Star, 1959), a Christmas-themed tale, where it is possible to appreciate her center of interests: children, the Basque language, and religion. In 1975, Azpeitia received a tribute from Euskaltzaindia (Royal Academy of the Basque Language, 1918–), as she was nominated as an honorary member of the academy. Julene Azpeitia was also an active member of the EAB, like Unzueta and Errazti, and promoted the secondary position of women in the Nationalist Party. Nuñez-Betelu states that Azpeitia defended the generic separation of the party and accepted the reserved role for women.[22] Due to her implication in the EAB, she too was forced into exile when the war began. Shortly after she returned to the Basque Country in 1947, she was banished and sent to Burgos (Spain) by the Spanish regime in 1949 as a punishment for having returned.

Overall, Sorne Unzueta, Karmele Errazti, and Julene Azpeitia are clear examples of the literature and actions promoted by Basque women at the beginning of the twentieth century. Their educational work was relevant in the transmission of the Basque language, Basque traditions, memory, and the ideal motherhood practices. Leyre Arrieta argues that in this eagerness to preserve the Basque language, the emakumes (women) were able to transcend their existence as exiles and teach the Basque language and traditions to the community.[23] Their participation in patriotic and political activities was also important,

22 Nuñez-Betelu, "Género y construcción nacional en las escritoras vascas," 181.
23 Leyre Arrieta, "Desde las cunas y los fogones:'Emakume'y emociones en el nacionalismo vasco," in Emoción e identidad nacional: Cataluña y el País Vasco en perspectiva comparada, ed. Geraldine Galeote, Maria Llombart and Maitane Ostolaza (Paris: Editions Hispaniques, 2015), 5.

but always in their assumed "secondary" role as a complement to the work done by men. Mercedes Ugalde states that women's activities were more focused on collaboration in the defense of the Basque language, emotional assistance and support, and collaboration in nationalist politics propaganda.[24] Therefore, it is not surprising that the role promoted and embraced by these women in their works was closely linked to motherhood, memory, faith, and patriotism. Etxebarria explains that these women were happy and proud of being women and saw their primary role as mothers of the family.[25] Consequently, one can assume that during this time period women were not necessarily focused on being writers, as their priorities were more linked to their family duties. One can also observe that the transmission of the Basque language was central in the ideal woman's role portrayed in the magazine. Euzko-Gogoa's pages, due to its ideological values, was the perfect space to illustrate the "ideal" Basque woman: patriotic, proactive in the fight for the country (with her limitations), honest, pure, and above all a Basque speaker and promoter.

Turning to an examination of how the male writers of the magazine characterized women, one can find a very polarized discourse where women are either glorified or strongly criticized. The anthropologist Sherry Ortner states, "The psychic mode associated with women seems to stand at both the bottom and the top of ambiguity."[26] Ortner argues that women can be defined or represented as "subversive feminine symbols" or as "feminine symbols of transcendence"; in other words,

24 Ugalde, Mujeres y nacionalismo vasco: génesis y desarrollo de Emakume Abertzale Batza (1906–1936), 268–280.
25 Etxebarria, Sorne Unzueta "Utarsus", 16.
26 Sherry Ortner, "Is Female to Male as Nature Is to Culture?" in Woman, Culture and Society. ed. Michelle Zimbalist Rosaldo and Luise Lamphere (Stanford: Stanford University Press, 1974), 8ff.

women are portrayed as witches/evil or mother goddesses, but nothing in between.

In 1952, Keperin Xemein, also Karmele Errazti's husband, wrote a text about a married couple (referring to himself and his wife) that were writing in the magazine together:

> Senarr-emazte bi ezautzen dodaz nik, Euzko-Gogoa'n euzkeraz idazten dabenak eta Z'zaliak diranak. Bijok, senarr-emaztiak ixan baño lenago, euzkeraz idazten eben, orain berrogetalau urte dirala. Ordutik ona amaika lan egin dabe, bakotxa bere aldetik. Emaztia senarra baño len euzkeraz idazten asi zan. Senarr-emaztiok, bijok dakiz makiñaz idazten eta bijok makiñaz idazten dabe, baña, jakiña, makiña bat baño eztauke, eta bijok makiña berberaz idazti-biarr. Ulertzalle onari itz erdi.[27]

> I know a couple that writes in Basque in the magazine. Both were writers before they got married. Since then, they have published so many works. The wife began to write before the husband. And both of them write using the same typewriter. A word to the wise is sufficient. (my translation)

Xemein's comments can be interpreted as a step to break the patriarchal hegemony amongst writers, giving credit to women writers' work. He shows how there is no jealousy between him and his wife and that both are capable of working together for a common goal. However, he was writing about his own wife, not about women writers as a whole. In 1954, in the section "Irakurlearen Txokoa" (Reader's Corner), one of

27 Keperin Xemein, "Laburrkiro," Euzko-Gogoa, no. 3–4 (March–April 1952): 25.

the readers wondered why women did not write in the magazine, and Andima Ibiñagabeitia answered the following:

"Emakumeak zergatik ez dute zuen aldizkarian idazten?" Orixe galdetzen diot maiz nere buruari, "Zarautz'ko Eleder" adiskide ona. Zergatik ez dute euskeraz idazten? Gure ateak zabalik dauzkate beñipein... Alare bat baizik etzaigu urbildu, "Emakume bat" abertzale zintzo ta euskal-idazle apaiña. Lenago ba'ziran emakumeen artean idazle punterenguak, Azpeitia'tar Julene, Tene, Zipitria t.a. Orantsu zerura zaigu Mañari'ko Errose (g.b.) bere ipui ederrekin. Ez ote ditu norbaitek aren ipui bikaiñak liburutxo baten bilduko? On eta bearrezko litzake. Azken galdera au, gurean oi bezala, basamortuan galduko da iñolako erantzungabe. Lotsagarriak gu! Bañan goazen emakume bizietara. Zergatik ez dute euskeraz idazten. Bear bada, seme-alabatxoei gure izkera ederra irakasten gogozari dira eta ez daukate idazteko betarik. Ai orrela balitz! Barkakizun lirake, ezin dezakete bada lan ederragorik burutu. Beldur naiz ordea, geienak beren agure saloen sabel-zorroak nola bete ezin asmaturik ote dabiltzan ater-gabeko erdeljarioan. Emakumeak; noiz iarri bear duzute bete-betean euskerari begira? Zuek nai ba'zenute laister pizkortuko eta apainduko litzake gure izkera maitea: emakumeen ezpain zamurrek doai berezi bat dute ortarako. Gure ateak zabalik dauzkatzute; ekin bada, itzez ta idatziz.[28]

"Why don't women write in the magazine?" This is what I am asking myself, good friend. Why don't they write in the Basque

28 Andima Ibiñagabeitia, "Irakurlearen Txokoa," Euzko-Gogoa, no. 3–4 (March–April 1954): 68–69.

language? Our doors are open if they want to write; however, only "one woman" came to us—a good patriot and honest woman. Before there were very good Basque women writers—Julene Azpeitia, Tene, Zipitria, etc. Errose Mañari just passed away. Does anyone want to publish an anthology of her work? It will be a good and right thing to do. This last question, as always, will disappear in the desert without an answer. Shame on us! But let's continue talking about the women writers, and why they don't write in Basque. Maybe they are busy teaching Basque to their children and they don't have time to be writing. If that is true, they will be forgiven; there is nothing more beautiful. However, I am afraid that they are speaking in Spanish. Women, when are you going to put all your efforts into speaking the Basque language? If you wanted, our language would improve and develop: the tender lips of women have a special capacity for language. (my translation)

Ibiñagabeitia is aware of the work and presence of the Basque women writers and he also acknowledges their publications, but he ends up using these women as a symbolic image of the Basque nation where, he assumes, if they are not writing it is because they are doing their duties as ideal Basque mothers by teaching the language (in which case they are forgiven for not taking their time to write). Although their writing skills were welcomed, motherhood was appreciated as their strongest value and considered the main and most primordial characteristic of a woman. Margaret Bullen analyzes the intrinsic relationship between Basque women and nationalism, focusing on the works of Teresa del Valle, Mercedes Ugalde, Begoña Aretxaga, and Joseba Zulaika. These works show that in the contemporary Basque Country's nationalism

system, as much in the EAJ-PNV as in ETA (Euskadi ta Askatasuna, Basque Homeland and Freedom, 1959–2011) before its cessation of armed activity, the figure of women was based on the traditional role of the mother.[29]

At the end of his article, Andima Ibiñagabeitia suggests that it is more likely that women are speaking in Spanish, and for that reason they are not writing. While he appeared critical with women toward their use of the Spanish language, he made no mention of the men that used the Spanish language. The use of Spanish increased in the Basque population due to the social changes that the Basque Country experienced with the growth of Spanish immigrants that came during the Industrialization period. In this regard, in both the Basque Country and the Latin-American exile the cities were considered in the eyes of many Basque nationalists as a bad influence for Basque women, as it was there that the Spanish language was being substituted for the Basque language. For them, it was the Basque women who were the transmitters of Euskara to their children, and therefore the survival of the language was in women's' hands. Nerea Aresti demonstrates how the EAJ-PNV tried to encourage women to stay in their rural areas: "Given this threat, it seemed necessary to address the beautiful daughters of the mountain and invite them to leave the cities and return home, to the traditional life of the race."[30] They tried to create propaganda for a more romanticized view of the "purer" women of the rural Basque Country, where they spoke in Basque and avoided the "contamination" of the Spanish influence. This created a dichotomy between subversive/Spanish speakers and transcendence/Basque speakers. Andima Ibiñagabeitia was

29 Margaret Bullen, Basque Gender Studies (Reno: Center for Basque Studies, University of Nevada, Reno, 1964), 197–201.
30 Aresti, "De heroínas viriles a madres de la patria. Las mujeres y el nacionalismo vasco 1893–1937," 293. (my translation)

not the only one who denounced women's inclination to the Spanish language. Antonio M. Labaien argued in his article "Euskeraren kinka gaiztoa" (The Crisis of the Basque Language, 1958) that some women considered the Basque language arrunta (vulgar) and to appear more sophisticated, they preferred to use the Spanish language, even though they came from rural areas. Jaime Kerexeta in his article stated:

> Emakumea, bere utsalkeri bereztasunez, erderara doia geienetan, buru ariñak diran emakumeak batez bere, (ta buru aundiputzak dirala geienak autortu bear, ezkondu aurretik batez bere). Baiña ezkondu ezkero, jakin egizue, senarrok, zuek zariela etxeko buru ta gogor egin daikezuela emazteari norberen gauzai eutsiten, semeai euzkeraz irakasten eta egiten.[31]

> Woman, with her natural triviality, has the tendency to speak in Spanish, especially the ones that are feisty (we have to admit that women are vain in general, mostly before they get married). But once they get married, husbands, you must know that you are the heads of the family, and you must be firm with your decisions, that they have to teach and talk in Basque to the children. (my translation)

The prejudice of female inferiority with respect to men is apparent. Kerexeta's opinion is one that considers women as more imperfect than men—an imperfection that relates to the Genesis story and its main character Eve—but that a woman can improve once she gets

31 Jaime Kerexeta, "Euzkeraren Alde," Euzko-Gogoa, no. 1–2 (January–February 1955): 17–18.

married. Wives and mothers' main tasks should revolve around the transmission, speaking, and teaching of the Basque language. Kerexeta was a Franciscan priest, and his Catholic traditionalism is made evident in his text. For him, a woman's purpose, and even her definition of shelf, is shaped by a man.

If we analyze Jokin Zaitegi, the founder of the Euzko-Gogoa magazine, and his discourse toward women, we observe he promoted a folkloric and romanticized idea of a rural Basque community where women were angelic, virginal, patriotic, and Basque. Zaitegi wrote an article titled "'Orixe'ren 'Euskaldunak'" (an article about a nationalistic poem entitled Euskaldunak, 1950). In Orixe's poem, one of the most significant plots is the love story between Garazi and Mikel. According to the Basque scholar Ana Toledo, Garazi is a static character typical of how women were portrayed during this period. Toledo explains that in costumbrist literature, there are three common denominations among main characters: they are Basque, Christian, and honest. These characteristics are forged from the traditional motto, "Euskaldun, Fededun" (Basque and Faithful).[32] Zaitegi's article references the relationship between the two characters, Garazi and Mikel, and he acknowledges the image and perception created by Orixe of the ideal Basque female, "Garazi." Garazi, which would be translated as "Grace," is described as a beautiful and Christian girl. Sherry Ortner states: "Mankind's great teacher of purity was the Virgin Mary, a mother goddess who perfectly fit the female role as merciful dispenser of salvation."[33] The dichotomy portrayed and promoted in the magazine by the writers, between the female images of "angels" and "monsters," is certainly observable. Analyzing

32 Ana M. Toledo, Domingo Agirre: Euskal eleberriaren sorrera (Bizkaiko Foru Aldundia, 1989), 646.
33 Ortner, "Is Female to Male as Nature Is to Culture?," 8ff.

the discourse used in the articles, poems, and stories, from both male and female writers, one can see the imposed and self-imposed female identity that was polarized between these images.[34]

In conclusion, although women found a space in Euzko-Gogoa during the intellectual movement of the 1950s, their role was still secondary. In fact, the writers of the magazine, both male and female, did not promote women's agency. The female writers in Euzko-Gogoa represented women as domestic agents, as we have seen in the works of Unzueta, Errazti, and Azpeitia, as did various male writers. The image of women that thrived in the magazine's pages was based on the preindustrial ideas of Basque womanhood promoted by Arana and still embraced by these women writers. Women were portrayed as mothers, patriots, carriers of cultural memory, and a metaphor of the Basque motherland—or, as Mercedes Ugalde states, "Symbols, instruments, mediators, stimuli for the protagonists of the nationalist struggle but never subject agents of it."[35] These women writers did not devise their own self-definitions; rather, their purpose of self was written by a patriarchal and ideological discourse oriented toward promoting a Basque nationalist consciousness where women were perceived as mother-symbols of the motherland, and not as writers. This figure of women did not only belong to Basque nationalist discourse that might be considered "conservative," but also to ETA (the radical branch of nationalism), as described in studies such as Teresa del Valle's crucial milestone in 1985.[36] Through such representation of Basque women, Euzko-Gogoa showed in its pages the desired female archetype based

34 Gilbert and Gubar, "The Madwoman in the Attic," 812.
35 Ugalde, Mujeres y nacionalismo vasco: génesis y desarrollo de Emakume Abertzale Batza (1906–1936), 50. (my translation)
36 Teresa del Valle, Mujer vasca, imagen y realidad (Barcelona: Anthropos, 1985).

on those attributes, emphasizing her role as the mother and that role's centrality in the conception of an idealized Basque family.

WORDS CITED

Alvarez, Amaia. "Euskal emakume idazleen lekua literaturaren historian. Dorrearen arrakalak uzten." Jakin 148 (2005): 37-75.

Aresti, Nerea. "De heroínas viriles a madres de la patria. Las mujeres y el nacionalismo vasco 1893-1937." Historia y Política, no. 31 (January-June 2014): 281-308.

Arrieta, Leyre. "Desde las cunas y los fogones: "Emakume" y emociones en el nacionalismo vasco." In Emoción e identidad nacional: Cataluña y el País Vasco en perspectiva comparada, edited by Geraldine Galeote, Maria Llombart and Maitane Ostolaza, 197-211. Paris: Editions Hispaniques, 2015.

Ascunce, José Angel. El exilio: debate para la historia y la cultura. Donostia: Saturraran, 2008.

Atxaga, Mikel. Euskal emakume idazleak (1908-1936). Gasteiz: Eusko Jaurlaritzaren Argitalpen Zerbitzu Nagusia, 1997.

Bullen, Margaret. Basque Gender Studies. Reno: Center for Basque Studies. University of Nevada, Reno, 1964.

Colmeiro, José. Memoria histórica e identidad cultural. De la posguerra a la postmodernidad. Barcelona: Anthropos, 2005.

de Larrañaga, Policarpo. Emakume Abertzale Batza: la mujer en el nacionalismo vasco. Donostia: Auñamendi, 1978.

del Valle, Teresa. Mujer vasca, imagen y realidad. Barcelona: Anthropos, 1985.

Eichner, Hans. "The Eternal Feminine: An Aspect of Goethe's Ethics." In Johann Wolfgang von Goethe, Faust by Walter Arnold, edited by Cyrus Hamlin, 616-617. New York: Norton, 1976.

Etxebarria, Igone. Sorne Unzueta "Utarsus". Gasteiz: Eusko Jaurlaritzaren Argitalpen Zerbitzu Nagusia, 2000.

Gilbert, Sandra, and Susan Gubar. "The Madwoman in the Attic." In Literary Theory: An Anthology (2nd ed.), edited by Julie Rivkin and Michael Ryan, 812-825. Oxford: Blackwell, 2004.

Gurruchaga, Ander. El código nacionalista vasco durante el franquismo. Barcelona: Anthropos, 1985.

Ibiñagabeitia, Andima. "Irakurlearen Txokoa." Euzko-Gogoa, no. 3–4 ((March–April 1954): 68–69.

Irujo, Xabier. Gernika 1937. The Market Day Massacre. Reno: University of Nevada Press. 2015.

Kerexeta, Jaime. "Euzkeraren Alde." Euzko-Gogoa, no. 1–2 ((January–February 1955): 17–18.

Nuñez-Betelu, Maite. "Género y construcción nacional en las escritoras vascas." PhD diss., University of Missouri-Columbia, 2001.

Ortner, Sherry. "Is female to Male as Nature Is to Culture?" In Woman, Culture and Society, edited by Michelle Zimbalist Rosaldo and Luise Lamphere, 67–89. Stanford: Stanford University Press, 1974.

Thiong'o, Ngũgĩ wa. Decolonising the Mind: The Politics of Language in African Literature. London: J. Currey, Portsmouth, N.H,: Heinemann, 1986.

Toledo, Ana M. Domingo Agirre: Euskal eleberriaren sorrera. Bizkaiko Foru Aldundia, 1989.

Ugalde, Mercedes. Mujeres y nacionalismo vasco: génesis y desarrollo de Emakume Abertzale Batza (1906-1936). Bilbao: Servicio Editorial Universidad del País Vasco, 1993.

Woolf, Virginia. A Room of One's Own. San Diego: Harcourt, 1989.

Xemein, Keperin. "Laburrkiro." Euzko-Gogoa, no. 3–4 (March–April 1952): 25.

What We Have Learned on the Way: Looking Back at the Disputed Participation of Women in the Alardes of Hondarribia and Irun[1]

Margaret Bullen

Euskal Herriko Unibertsitatea-Universidad del País Vasco

> You may feel like when you're climbing that mountain, you climb and climb, but the summit is always as far away as at the beginning, and you'll never get to the top. And then, so as not to give in, you look back, to take stock of the path you have walked. I've still a long way to go, but I've come a long way. One more step.
>
> In our case, you have to have recourse to memory.[2]

It has been twenty-five years since a conflict arose over the proposed participation of women in what until then had been almost exclusively all-male parades, called Alardes,[3] central to the annual festivals of the

1 An earlier version of this paper was presented at the XIII Ankulegi conference "Anthropology of Emotions" (Donostia-San Sebastián, 2010) and I am grateful for the feedback given then, later developed for the conference "Memory and Emotion, Women's Stories: Constructing Meaning from Memory" (Boise, March 15-18, 2018).
2 Arantxa Urretabizkaia, Bidean Ikasia (Iruñea-Pamplona: Pamiela, 2016), 131. All references to this work are my own translations from the original Basque.
3 "Alarde" is a word of Arabic origin, which may be translated as exhibition or display,

seaside resort of Hondarribia and the neighboring border town of Irun. These two localities are both situated on the southern side of the Bay of Txingudi, where the river Bidasoa meets the sea and marks the frontier between the present day states of France and Spain. In 1995, a group of local women voiced their desire to take part in the Alarde of their hometown on an equal footing with men and sought permission to do so. The reaction to the proposal of opening the Alarde to women was unexpectedly violent and marked the beginning of a social conflict that has been raging ever since, causing deep rifts within families and among friends and neighbors. The divisions are still patent after all these years. Despite changes in other Basque localities where festivals have been adapted to respond to demands for equality, despite the appeals for justice to local, provincial, and national authorities, the polemic is far from being resolved.

Up until the end of the twentieth century, these parades were made up of approximately 8,000 men and 19 women in Irun, and 4,000 men and 20 women in Hondarribia. The whole parade is presided over by a general in Irun or burgomaster in Hondarribia who is accompanied by an escort. In the parade, they are preceded by the sappers (hacheros), the drummers and the band, and followed by the cavalry, the commander and the infantry (fifteen companies in Irun, sixteen in Hondarribia) under the direction of a captain and lieutenant[4]. The companies are composed of musicians (txibilitos or fifes and drums) and foot soldiers (escopeteros) carrying firearms. The artillery brings up the rear. For over

particularly of troops. In the Basque Country, it has been used to define both a military review or inspection of farms and the later festive parades. See Idoia Estornés, "Los Alardes de Iruny Hondarribia (Fuenterrabía). Informe (1997)", https://www.academia.edu/9501094/Los_Alardes_de_Irun_y_Hondarribia_Fuenterrab%C3%ADa_Informe_1997_; also Xabier Kerexeta, "Dime de qué alardeas", 2001, http://www.alarde.org/a6/dimedeque/alardeas.htm.

4 There are differences in the order and composition of the different units of the Alarde in Hondarribia and Irun, and there are variations according to the different moments of the parade during the day.

one hundred years, there was just one token woman—the cantinera—in each company, elected by the members of the company and eligible to take part once in her lifetime.

In both cases, the parade commemorates a battle against forces invading across the Bidasoa: in the case of Irun it goes back to the Battle of the Peña de Aldabe[5] in 1522 and in Hondarribia, to the siege of 1638.[6] The local victories were attributed to the saints and the Virgin Mary, and annual processions were promised in their honor. The fulfilment of the religious vow combines with the military tradition—inherited from the times in which all men between the ages of eighteen and sixty were obliged to take part in the local militia according to the fueros. These were a set of Basque laws, dating back to the Middle Ages and agreed upon with the kings of Castile, that bound the locals to defend the border area from any invaders. To this end, each year there was a military "revista" in which the local captains reviewed the troops and ensured their firearms were in working order and the men ready for battle. Once the fueros were eliminated in 1876, after the Second Carlist War, in several places in Gipuzkoa the parades were maintained, merging the revista with the procession and adding a festive or folkloric air to what would later become the center of the local festivals.

Given the increasing equality for women and men in different walks of private and public life, in the mid-nineties it did not seem outlandish to request that women be allowed to participate in any role

5 Mount Aldabe (Peña de Aldabe) was renamed Mount Saint Martial (Monte de San Marcial).
6 Idoia Estornés ("Desagraviando navarros, eliminamos mujeres", Diario de Noticias de Navarra, March 3, 1996) remarks on the way we change versions of events to suit the story we want to tell. She explains that in the case of Irun, a war between fellow Basques over the recuperation of ground lost from the kingdom of Navarre is presented as an invasion of French and German troops. She shows that in the case in hand, the focus is placed on the review of farms instead of on the battle. In doing so, women are erased from history, having had a part in the battle and siege, but not in the militia.

they saw fit, at any time in their adult lives, and without having to be chosen by male vote. After applying to the local council and junta (board) of each Alarde and receiving either blank silence or an outright refusal, they decided to take matters into their own hands and, in 1996, a group of fifty women tried to join the Alarde celebrated in Irun on June 30th—feast day of Saint Martial (San Marcial)—and twenty-six women made another attempt in Hondarribia on September 8th, the day dedicated to Our Lady of Guadalupe. It is this decision which many people—even young people who were scarcely born at the time[7]—still hold against the defenders of an egalitarian Alarde.

The polemic, then, brings two antagonistic positions into confrontation. One argues for modernizing the parade, granting free access to women and men in accordance with the laws and mores of the present age; the other posits that female participation should be limited by the dictates of tradition, cultural specificity, and local identity.[8] In Irun today, there are two Alardes: the egalitarian Alarde, open to both women and men without restrictions, and the traditionalist Alarde, the members of which refer to as "the Alarde of the People of Irun" and from which women are excluded with the exception of the cantinera. The egalitarian Alarde prides itself on being the "public" Alarde, as opposed to the privatized, traditional parade. The public Alarde is growing, even though its numbers are significantly fewer than the traditionalist parade (about 1,000 women and men combined, compared to 8,000 men and 20 women). The Basque word "betiko" for traditional - made up of beti meaning "always" and the adjectival suffix "-ko"- is used with different

7 As part of a study of changes in gender attitudes and behavior of young people in the Basque Country (2016) I interviewed men and women on both sides of the polemic and found their reasoning reproduced that of their parents' generation with little variation.
8 See Margaret Bullen, "Derechos universales o especificad cultural: una perspectiva antropológica," in Los Alardes del Bidasoa: Pueblos versus ciudadanía, ed. G. Moreno & X. Kerexeta (Lasarte: Antza, 2006), 21-47.

connotations: while the defenders of the tradition view positively the perpetuation of the parade "as it always was," the defenders of equality see it as reactionary and outmoded. In Hondarribia, however, the decision has been not to create a separate parade, but rather a single company, known as Jaizkibel (taking its name from the local mountain on which the chapel of Guadalupe is situated), which is granted permission—with the legal status of a demonstration—to march the parade route ahead of the traditionalist Alarde.

Rather than reconstruct the chronicle of this conflict, which has been amply analyzed elsewhere,[9] I aim to examine the confluence of emotions and memory in the narratives of people's personal experience, political positions, and pain in relation to the issue of women's participation in the Alardes. It is a particularly emotional polemic that stirs up strong feelings and has caused much hurt both on an individual level and on

9 In previous analysis of the Alardes of the Bidasoa, colleagues and I have examined different aspects of the conflict as follows. With regard to the relationship between gender, festive ritual, and social change: Margaret Bullen, "Hombres, mujeres, ritos y mitos: Los Alardes de Irun y Hondarribia" in Perspectivas feministas desde la antropología social, ed. Teresa del Valle (Barcelona: Ariel, 2000), 45-78; Margaret Bullen and José Antonio Egido, Tristes espectáculos: las mujeres y los Alardes de Hondarribia y Irun (Bilbao: Servicio Editorial de la UPV-EHU, 2003); Margaret Bullen and Carmen Diez, "Fiestas, tradiciones e igualdad", Kobie Serie Antropología Cultural, no. 16 (2013): 13-34. In terms of human rights: Margaret Bullen, "Eskubide unibertsalak ala kulturberezitasuna: aikuspegi antropologikoat," in Bidasoaldeko Alardeak: Herria versus hiria, ed. Gorka Moreno and Xabier Kerexeta (Donostia: Udako Euskal Unibertsitatea, 2004); Bullen, "Derechos universales o especificidad cultural: una perspectiva antropológica", 2006, 21-47. In relation to violence and nationalism Margaret Bullen and Carmen Diez, "Violencia y cambio de culturas androcéntricas", Cultura y política: actas del IX Congreso de Antropología FAAEE, (Barcelona, 2002); Margaret Bullen and Carmen Diez, "Fisiones/fusiones. Mujeres, feminismos y orden social" in Feminismos en la Antropología. Nuevas propuestas críticas, ed. Liliana Suarez, Rosalva Aída Hernández y Emma Martin (Donostia-San Sebastián: Ankulegi, 2008), 81-97. In reference to space and urban anthropology, Margaret Bullen, "En el cruce: nuevos elementos sociales en una vieja ciudad fronteriza", Cultura y política: actas del IX Congreso de Antropología FAAEE, (Barcelona, 2002);"Transformaciones socio-culturales y la recreación de una fiesta", Zainak 24 (2003), 937-952. In English, there is an early article: Margaret Bullen, "Gender and Identity in the Alardes of Two Basque Towns" in Basque Cultural Studies, ed. William A. Douglass et al., (Reno: University of Nevada, 1993), 149-177; an overview in Margaret Bullen, Basque Gender Studies (Reno: University of Nevada, 1993), and a paper that situates this issue in the genealogy of Basque women's studies, Margaret Bullen and Carmen Diez, "Matriarchy versus equality. From Mari to Feminist Demands", Feminist Challenges in the Social Sciences: Gender Studies in the Basque Country, ed. M.L. Esteban & M. Amurrio (Reno: Center for Basque Studies, 2010), 113-126.

a collective scale. Emotions are used to justify positions either for an egalitarian parade in which women can participate freely in any role, or in favor of keeping the traditional format of men only except for the emblematic figure of the cantinera. Emotions are also part of people's memories, not only in the way we remember the way things used to be and wish we could perpetuate the feelings attached to what we are remembering, but also in the way we recount the past—in this particular case, the two decades of social division and personal suffering. In the construction of meaning through the memory of the polemic, there are multiple factors at play: social and cultural identities, the interpretation and performance of history and tradition, family and local hierarchies and networks, and of course, notions of femininity and masculinity combined with a desire to maintain or challenge the gender system.

Rather than go into those arguments themselves, this work discusses how emotions have been used to argue against the participation of women in the Alardes—in particular, how they are used to justify positions taken and to circumvent reason, how they influence our memories and affect our daily lives, and how they are reflected in our bodies in the way we hold ourselves. In social anthropology, Teresa del Valle[10] has proposed exploring the way women's memories are constructed through experiences which have been incorporated and embodied as a vital part of our existence. She describes a memory which is reached through what - following Bakhtin - she denotes a chronotope, where time (kronos) and space (topos) merge in a particular event or scene:

The memory I speak of goes beyond the mere reconstruction of the past through data people give or data we can gather and

10 Teresa del Valle, "Procesos de la memoria: Cronotopos genéricos", La Ventana, Vol. 1, no.9 (1997), 7-43.

interpret about women. Rather I refer to a memory in which all human beings take part, as we have a capacity to symbolize and experience the density of different emotions: love, hate, fear, vulnerability, exposure, rejection, to name but a few; and we design processes to situate these experiences at a particular moment of the present. It is a memory exercised individually and collectively, explicitly or indirectly and it is linked non-discursively to the concept of embodiment, a term that I take from Bourdieu's habitus in the sense of something which has been filtered through a bodily experience and a process of personal interiorization which includes the emotional process.[11]

This process—the embodiment of emotion in relation to the Alarde of Hondarribia—has been powerfully described by Arantxa Urretabizkaia, in her award-winning essay, Bidean ikasia (2016), or "What has been learned on the way."[12] This acclaimed Basque writer lives in Hondarribia and, from the outset, has participated in the Jaizkibel Company, marching to claim a place for women in the Alarde. In 1997, I interviewed Urretabizkaia as part of my early research on the conflict and she told me then that one day she would write a book about what was going on. It has taken her twenty years to be able to do that, and in Bidean ikasia, literature provides a recourse to convey emotion in a way not usually achieved in the accounts I have gathered in interviews, articles, and letters of opinion. Moreover, people often say "words cannot describe" what they feel, that they are unable to put their emotions into words, or that sentiments escape expression. I borrow her title here to look back

11 Del Valle, "Procesos de la memoria," 7, author's translation.
12 This essay won the Euskadi Literature Prize for best essay in the Basque language in 2017 and has since been published in Spanish as Arantxa Urretabizkaia Lecciones del camino (Iruña-Pamplona: Pamiela, 2018).

at the way emotions inform the accounts which sustain the arguments and experiences of the conflict about women's participation over the past two decades.

The first two sections part of this paper look at the ways in which emotions are incorporated into arguments on both sides of the conflict. The first discusses the polemic as "a problem of the heart" and the second explores the embodiment of thought in the way the Alarde is experienced emotionally. The third section examines how Urretabizkaia makes use of metaphor to describe how feelings are physically embodied in the reactions of anger, fear, hurt, and hatred. The following three sections are devoted to the relational and collective dimensions of emotion, to the notion of rites of solidarity and communitas, and the gendering and hierarchical ordering of emotion. Finally, the paper concludes with some reflections on the generation and transmission of emotional memory.

A problem of the heart

> Something so spontaneous, so ritual, so primitive ... to have to suddenly explain it, defend it. ... It's a very simple story, it's a problem of ritual, of the heart. ... It's such a beautiful thing that it's not worth explaining. ... So the Alarde, well what is it? Well for me, it's simple, it's a rite. ... The day they square it up and rationalize it, it will lose its charm and become something else! (2003: MH)[13]

13 The non-bibliographical quotations included in the text are taken from interviews carried

Many people would still agree with the affirmation that the ongoing conflict over the participation of women on an equal footing with men in the Alardes of the Bidasoa area is a "problem of the heart," a sentimental one that deals in feeling rather than reason. Many would add that tradition is enmeshed with emotion, and emotions are simple and spontaneous, beyond explanation. They are personal, respectable, and untouchable. Emotions, since the dawn of modernity, have been located at the opposite pole from reason, rationalization, and objectivity. According to historian Rosa Medina,[14] they have been associated with the individual and subjectivity, in confrontation with the supposedly objective world of the social, the cultural, and the collective. This polarity endures in the popular imagination and it persists in the legitimization of arguments that reject an egalitarian Alarde.

Medina[15] explains that in the nineteenth century emotions were considered to stem from one's interior self, as an internal, uncontrollable, and harmful force that threatens to upset the balance between individual reason and the sense of social responsibility. This idea was later developed by Freud and continues to pervade Western consciousness with regard to what Jone Miren Hernández[16] refers to as the split between head and heart or the emotion-reason divide. An innovative proposal by Hernández[17] is to endeavor to overcome the dichotomy between emotion

out by the author or the research team with whom she worked in the early phase of the conflict (1995-2000). The research results of the early period are published in Bullen and Egido, Tristes espectáculos: las mujeres y los Alardes de Hondarribia y Irun, and quotes reproduced from this work are indicated with the date of publication and followed by indication of male or female informant (M/F) and reference to Irun or Hondarribia (I/H). All quotations have been translated from the original Basque or Spanish by the author.

14 Rosa Medina Doménech, "Sentir la historia. Propuestas para una agenda de investigación feminista en la historia de las emociones," Arenal. Revista de historia de mujeres, 19, no.1 (2012): 161-199.
15 Medina Doménech, "Sentir la historia," 170-172.
16 Jone Miren Hernández Garcia, "¿Acaso tiene género la sangre? O por qué los cuerpos femeninos no sirven como habitáculos para los versos", in Etnografías feministas. Una mirada al siglo XXI desde la antropología vasca, eds. M.L. Esteban and J.M. Hernández (Barcelona: Bellaterra, 2018), 108.
17 Hernández Garcia, "¿Acaso tiene género la sangre?, 104-132

and reason, applying the work of Alexandre Surrallés with the Candoshi people of the Peruvian Amazon to the study of performed improvised verse known as bertsolarismo in the Basque context. The Candoshi situate both intellect and emotion in the heart, where practice, thought, and emotion coincide.[18]

Since the 1980s, there has been a shift from the cognitive approach to a more cultural and constructivist analysis of emotion. As exemplified by the work of anthropologists Catherine Lutz and George White,[19] this shift involves the questioning of the universality and physicality of emotional reactions and proposes a link between emotion and the cultural and contextual structure of emotion. Lutz[20] discusses the invisibility of the cultural system of meaning that underlies the concept of emotion, assumed to be "essential", universal, and independent of its personal and social contexts. Michelle Rosaldo[21] goes one step further in the deconstruction of emotional essentiality, proposing that emotions are not diametrically opposed to reason but rather "embodied thoughts," which we feel in our bodies and which are responses to social constructions and a culturally conditioned way of reacting. This idea has been amply developed in the Basque and feminist context by Mari Luz Esteban.[22]

The elaboration of these theories leads us from the idea of emotion moving from inner feeling to outward expression, to the notion of the

18 Ibid., 116-117.
19 Catherine Lutz and George White, "The Anthropology of Emotions", Annual Review of Anthropology, 15 (1986): 405-436.
20 Catherine Lutz, "Emotion, Thought, and Estrangement: Emotion as a Cultural Category", Cultural Anthropology 1:3 (1986): 287–309.
21 Michelle Z. Rosaldo, "Toward an Anthropology of Self and Feeling" in Culture Theory: Essays on Mind, Self, and Emotion, eds. Richard A. Sweder and Robert A. Levine (Cambridge: Cambridge University Press, 1984) 67-87.
22 Mari Luz Esteban (2004) Antropología del Cuerpo. Género, itinerarios corporales, identidad y cambio (Barcelona: Ediciones Bellaterra, 2004); "Algunas ideas para una antropología del amor," Ankulegi. Revista de Antropología Social (2007): 71-85.

social world influencing the individual, expressed via the body first and in words later. This is what is known, toward the end of the twentieth century, as the "affective turn," explained by Jo Labanyi, who traces the evolution of this idea in cultural studies, arguing that "affect is the body's response to stimuli at a precognitive and prelinguistic level."[23] Affect, following this logic, is prior to "feeling"—which "involves a degree of judgment since it does not just register sensory information but interprets it."[24] Labanyi speaks of the difficulty of naming "affect," for it involves a kind of "thinking" done by the body and not the mind, and it is only at a third stage that feeling is interpreted and named as an emotion:

> Once a conscious response kicks in (half a second later, according to neurological research), we are in the realm of sensation (awareness of the physical experience, for example, of fear) and, following shortly after, emotion (the reflective acknowledgment "I am afraid"). Emotion is thus, in practice, an amalgam of feeling and thought—though the element of judgment involved in sensation and even affect makes it difficult to call them entirely "thought-free".[25]

In this paper, I adopt the distinction between physical affect in its raw state, feeling as the recognition and evaluation of affect, and identified and named emotions. What follows is a discussion of the ways people symbolize and experience the "density of emotions" in relation

23 Jo Labanyi, "Doing Things: Emotion, Affect, and Materiality", Journal of Spanish Cultural Studies, 11: 3 (2010): 224.
24 Ibid., 224.
25 Ibid., 224.

to the Alardes, following del Valle's use of memory as an individual and collective process, which situates emotional experience at a particular moment of the present and filters it through the body.[26]

Embodied thoughts

Feelings are not substances to be discovered in our blood but social practices organized by stories that we both enact and tell.[27]

It is common to hear people describing their feelings about the Alarde in physical terms, employing the metaphor of the heart mentioned previously, a trivialized yet still common image that recurs repeatedly in our language and affective landscape and portrays this organ as the seat of emotion, capable of multiple functions.[28] These expressions follow the head-heart divide, situating emotion in the heart as opposed to in the head, the brain, the mind, or place of reason.

The work of Urretabizkaia exploits the metaphor of the heart as the seat of feeling, vividly describing the physical reactions associated with the feeling of one's heart beating, thumping, or pounding. She uses the expression of having one's heart in one's mouth or throat to convey apprehension or fear, after a neighbor says her support for the women who had attempted to join the Alarde of San Marcial in Irun in June 1996, voiced on Basque television, had done a lot of damage to the people of Hondarribia: "It took some time for my heart to go

26 Del Valle, "Procesos de la memoria," 7.
27 Rosaldo, "Toward an Anthropology of Self and Feeling," 143.
28 Mari Luz Esteban, Crítica del pensamiento amoroso, (Barcelona: Bellaterra, 2011).

back down from my throat to my chest".[29] Her heart is also in her mouth when she is waiting in a house in Hondarribia's Calle Mayor (Main Street), about to join the Alarde for the first time the following September: "Suddenly, when I felt my heart reach my throat, someone told us it was time to go out into the street".[30]

It is not simply a case of constructing an emotional universe in terms of bodily metaphors, but rather that these emotions are embodied, that they are experienced as part of the body in a distinctly physical way. When trying to describe what they feel when they watch the Alarde, people explain how certain moments make them cry. For example at the "arrancada," when the band strikes up and the march sets off: "I can't describe it, I see the Alarde and I start crying" (2003: F/I). Others relate emotion to a physical sensation in the skin in expressions referring to goose bumps or carne de gallina ("chicken flesh") in Spanish. They also talk of a reaction being "muy de piel," which translates literally as "in the skin," but has the meaning of being physical. "It's very physical ("muy de piel") and not rational" (2003: M/H). Yet others describe how they feel a sense of euphoria or intoxication. "It's as if your whole body is laid bare that day, it's overwhelming, it's like being drunk" (2003: F/H). The idea of emotion as a liquid that flows inside the individual, like blood in the veins, is known as the "hydraulic vision of emotions," wherein emotion is conceived to be a totally natural force—unstoppable and uncontrollable. This "hydraulic vision" is related to the medical theory of the four distinct bodily fluids, or humors, and their influence on temperament, predominant from the time of the ancient Greeks to the nineteenth century.[31]

29 Urretabizkaia, Bidean Ikasia, 26.
30 Ibid., 32.
31 Medina Doménech, "Sentir la historia," 174.

The physical alteration produced in the body by emotion leads people to conclude that it is a natural process that bypasses reflection or rationalization. This interpretation of emotion as irrational and uncontrollable enters a discourse that naturalizes and justifies the violent reactions which can still be seen—albeit with less frequency and less ferocity than in the early years—in the streets of Irun and Hondarribia on the day of the Alarde. According to this discourse, which follows a social code or a culturally accepted emotional logic, it is considered perfectly understandable that people should respond to provocation physically. When women first tried to join the parade, those opposed to their participation interpreted it as an assault and justified their extremely aggressive reaction as a legitimate defense of their tradition. In the words of one woman from Hondarribia, "There has been a provocation, to which the people have responded in an equally violent way. In the face of a violent question, a violent action, you give a violent answer" (2003: F/H).

According to this conceptualization, it is inevitable that people who have felt attacked should fall prey to bitterness and hatred and unleash these feelings through violence. This equation simplifies the situation, reducing it to a typical chain reaction.[32] The anger which breaks out in this expression of collective violence is, in turn, justified by traditionalists on the grounds of the intensity of the emotion they say they feel for the Alarde. This visceral character of emotion is aided by cultural linguistic codes that easily link "feeling" not only with the heart but also with the gut, as in "gut feeling." Emotion, in this case, is considered something visceral that cannot be explained, escapes reason, and is quite "natural." Furthermore, the use of violence in defense of the traditional Alarde and the repulsion for those who take part in the

32 Bullen and Diez, "Violencia y cambio de culturas androcéntricas", 8.

mixed Alarde is conceived in terms of a "crusade"—a holy war. Following this logic, violence at the service of the traditional Alarde symbolizes a sacred act.

Metaphors of hurt and hatred and fear

> With the Alarde, my body discovered what was genuine fear, the fear that also affects the body. ... Physical fear increases the heartbeat, you hear it thumping in your ears, you feel short of breath, your mouth and throat rasp like sand paper and yet your forehead and hands sweat, your stomach surges.[33]

There exists a view that those who champion an egalitarian Alarde have done a great deal of harm to the "people of Hondarribia." "Tremendous harm," says the woman in a park to Urretabizkaia.[34] It is an accusation that causes the writer's son to ask his mother who she had hurt and why. The author tries to find metaphors to convey hurt and damage, although she admits their limitations. She uses the idea of an explosion: "You could say our entry [into the Alarde] was the detonator of the explosion, but we were also the ones who suffered the damage."[35] The members of Jaizkibel are seen to have stirred up a storm, attracting the lightening which flashes over the town, but at the same time—as in the metaphor of the explosion—it is they who get hurt: "We were

33 Urretabizkaia, Bidean Ikasia, 67-68.
34 Ibid., 26.
35 Ibid., 45.

the lightening conductor, but we got burned and the hatred that came pouring out, spilled all over us."[36] The image moves from one of the storm to a volcano in eruption; the lightening becomes molten lava that sears. The damage is conveyed in physical terms: the hurt they feel is compared to the pain of being burned by red-hot fire.

Storm, volcano, and abscess are used by the author to try to conjure up the social reaction to the seemingly simple request for women to take part in a parade. Local society is portrayed as the storm whipped up by Jaizkibel; as a volcano which had seemingly been a solid rock, now set into motion with the lava bubbling up from below; or as a body with a ghastly infection deep inside, stored up and swelling into an abscess which finally bursts, letting out the pus. "In the Alarde, we pierced the outside skin, and the infection stored in the body splattered out. But when pus comes out, it should help cure the wound; in this case it was the germ which produced a greater infection."[37]

In Hondarribia, the action of Jaizkibel is interpreted by the traditionalists as an act of provocation and they are charged with full responsibility for bringing their wrath down upon themselves. After the first attempt to join the parade, which meets with physical violence from the men in the Alarde, the anger directed towards them takes the form of ostracization through silence and terrorization through insult. Urretabizkaia describes how sowing fear is an effective strategy to achieve an end, but in order to do so it must be both deep and extensive.[38] It is a fear that grows in proportion to the campaign waged against the women who wish to take part in the parade. They are depicted as infected, contagious elements who need to be singled out and separated from

36 Ibid., 46.
37 Ibid., 46.
38 Ibid., 55.

the rest of society. Urretabizkaia describes how the tactic employed is to isolate the group of people considered to be "the lepers": they must be threatened and ostracized, removed from the rest of the flock, a sign to all those who might be thinking twice about being so unkind. "An easy job," she says, to signal "300 people in a town with a population of 15,000 inhabitants."[39]

The fear of being isolated, according to Urretabizkaia, is an inherent part of the human condition. "The person singled out should be made to feel their ostracization in each and every place, without possible escape."[40] The first step, she continues, is to withdraw a greeting, not to say hello, for that way you are nobody. So, mothers and fathers you have talked to in the park, break off all conversation, refuse to let their children play with yours, look straight through you as though you were transparent, rather than look away, in case you thought they just hadn't seen you. In a society where greetings are not only mere courtesy but rather fundamental indicators of belonging through a show of knowing and being known, being ignored by those who previously recognized and welcomed you with their greeting is an act of social excision: you are literally cut off.[41]

The next stage is the insult. Urretabizkaia tells us that the act of insulting makes the aggressor feel superior, powerful, and able to avenge themselves for the insults they received as a child, for example, in the case of one man who had been bullied at school. She claims that the act of insulting not only hurts those who receive the insult, but also

39 Ibid., 55.
40 Ibid., 55.
41 Other actions to show women are not welcome in the Alarde are turning one's back on the mixed parade as it passes through the streets of Irun or putting up banners in the Hondarribia's Main Street, saying "We have not come to see you," and unrolling black plastic, creating a barrier which blocks out the passage of Jaizkibel (Bullen y Diez, 2002; Bullen y Kerexeta, 2013). The spectators awaiting the traditional Alarde thus express their rejection of the egalitarian parade by literally blacking them out.

affects the one who delivers the hurtful words. The physicality of the act of insulting is expressed by the metaphor of vomiting, throwing up the insults "with body and soul."[42] The writer describes the way those memories make this man's body shake, but the act of insulting others gives back the power he had been robbed of when insulted in his youth. Insulting makes him feel he is someone, that he is not a total failure, especially when he does it in front of other people. It carries a feeling of victory such as that felt by a fisher or a hunter who pursues the prey and rejoices triumphantly at the catch: "For this man, insulting was like hunting, like fishing a good tuna in the sea."[43]

Ignored, excluded, and insulted, Urretabizkaia explains that this was the first time in her life that she had physically experienced fear. "Until then, fear had not had been a perceptibly physical experience."[44] The fears she had were more abstract—fear of sickness, of poverty, of losing a job, of getting old. Yet the author employs physical terms to describe the flutter of fear as "the contraction of the soul" or as a "fleeting shiver"[45] which could be easily cast off. This time though, the body reacted ("affect") before she knew she was experiencing fear, whereas in the past there was no such physical reaction: "The body remained dumb."[46] This time, the fear felt in her body is also managed with physical strategies to prepare herself to be insulted: holding her body straight and stiff, chin up, a fixed smile on her lips.[47] Sometimes, she says, she would sing or, on a more mental note, think of ways of seeking revenge.[48] Fear emerges as an atavistic instrument, a mechanism to put people on alert and prepare them to fight or flee, a tool for survival.

42 Urretabizkaia, Bidean Ikasia, 58.
43 Ibid., 58.
44 Ibid., 67.
45 Ibid., 67.
46 Ibid., 67.
47 Ibid., 65
48 Ibid., 61.

And yet we also glimpse the possibility of controlling that fear and the physical affect it has, of grappling with the accelerated beating of the heart and being able to retaliate by simply answering our attacker, as one woman in Urretabizkaia's account manages to do: "With her heart in a fist, but pretending to be calm, she spat at the man the phrase that she had ready prepared."[49]

Interestingly, though not surprisingly, fear is—along with love—one of the emotions that has been given greatest attention in feminist analysis and there is a growing literature on the subject. Del Valle[50] discusses the communal fear felt by women who are socialized into fear and taught to develop strategies to overcome being frightened of darkness, solitude, or the threat of sexual attack. In this sense, Urretabizkaia's description shows both the individual and collective dimensions of fear, and in the way it is wielded to threaten the members of Jaizkibel we perceive a more general and gendered use of terror as a means of control.

Emotions as relations

> This is what the people have feared with the entry of these women, the day women enter the Alarde as armed soldiers, it is very possible that this . . . leads to other situations which could be very different from what it's like now and we lose that sense of feeling, of rite. (2003: M/H)

49 Ibid., 66.
50 Del Valle, "Procesos de la memoria," 7-43.

They told [the journalist] that an outsider would
never understand the feeling for the Alarde, that
words and reasoning were useless.[51]

Emotions become a symbol of cohesion among supporters of the
traditional Alarde who consider themselves "the people" and establish
their belonging to this category in terms of their emotional ties to the
parades. This relational aspect of emotion has been noted by David
Le Breton who stresses that not only are emotions socially constructed
and physically experienced, they exist in and through social relations:
"Feelings and emotions are not substances that may be transferred from
one individual or group to another ... nor are they mere physiological
processes whose secret is kept by the body. They are relations."[52] Enrique
Gil Calvo[53] maintains that the recreation of the collective is the main
objective of a festival, where the priority is integration, ironing out
differences, and joining in a common cause. The relation between
the festival, the people, and feeling reappears whenever the Alarde
is described, whether in the press or on web pages providing tourist
information, such as the Revista Ibérica[54] which, in an article entitled
"The Alarde of Irun: the feeling of a people," affirms that the festival of
San Marcial cannot be described with words, that it is far more than a
simple celebration, and that it is "the feeling of a people ... who fight
for their culture." The home page website of Irun's traditional Alarde,
announcing itself as "the Alarde of Irun," displays in succession banners

51 Urretabizkaia, Bidean Ikasia, 54.
52 Author's translation from David Le Breton (2012) "Por una antropología de las
 emociones",RevistaLatinoamericanadeEstudiossobreCuerpos,EmocionesySociedad,10
 (2012): 77.
53 Enrique Gil Calvo, Estado de fiesta, (Madrid: Espasa-Calpe, 1991).
54 "El Alarde de Irún: el sentimiento de un pueblo", Revista Ibérica, accessed October 23
 2018,http://www.revistaiberica.com/Rutas_y_destinos/pvas/irun_fiestas_san_marcial.
 htm.

that appeal to the emotions as a prerogative of this people: "Sentiment, pride, passion and the tradition of a people"; "One flag, one people, one passion, one Alarde"; or "A day full of feelings."[55]

The emotions and feelings experienced in relation to the Alardes become symbols of local identities and cultural heritage. It is precisely this heritage that the traditionalist sector feels to be threatened by the transformation of the parade to allow women to take part in roles other than that of cantinera, an option they feel called upon to protect and perpetuate. It is, then, an emotional heritage. Those who defend the Alarde "as it always was" point to their fear of the Alarde losing its power to provoke emotion as one of the main motives for opposing the incorporation of women. It is noteworthy that the traditionalists invented a new tradition in order to give women a place in the festival while still keeping them out of the Alarde: the commemoration of the antorcheras or torchbearers.[56] This event, which re-enacts the story of how women and youths left the town at night with burning torches to trick the enemy into thinking the forces had fled or gone in search of reinforcements, while the local men prepared an ambush on the enemy camp, takes place on the eve of the Alarde of San Marcial, in the twilight and in silence. On the website, it is announced as "Silence and Solemnity," while the day of the Alarde is proclaimed "a day for joy and celebration," where "music is the soul of the festival."

The defenders of the traditional Alarde talk of the "fear" that underlies their opposition to change, but it is clear it is a different kind of fear from the embodied feeling described by Urretabizkaia. It is a concern that they will lose the sentiment attached to the ritual and an

55 "Irungo Alardea/El Alarde de Irun", accessed October 23 2018, https://www.alardedeirun.com/ .

56 Margaret Bullen and Carmen Diez, "Fisiones / fusiones. Mujeres, feminismos y orden social," 81-97.

apprehension that the meaning of the Alarde would be corrupted. The Alarde would cease to be a parade of cultural status capable of moving people who take part in it or watch it go by, and would instead be seen as a carnival, provoking a sense of ridicule and bringing forth mockery. In this sense, we can understand why on the 8th of September, 2007, defenders of the traditional Alarde dressed in yellow plastic and Mickey Mouse or Donald Duck masks to convey the message that they considered Jaizkibel to be a carnival.[57]

In arguing for keeping things the way they always were, several people testify that emotions are intrinsically linked to the memory of a tradition that has been experienced over and again during their lifetime. Remembering the past, even as they act out or observe the present, takes them back to a particular moment in their lives, to a special person who is no longer with them—in short, to del Valle's emotional crossroads or chronotopes,[58] where place and time come together as markers or milestones of memory, condensing feelings and evoking memory. An article of opinion by Javier Muguruza (1996) expressed it this way:

> There are strong ties that attach us to the affective landscape that we have experienced fundamentally in the first stages of our lives. We like our hometown's festivals more than anything for this emotional aspect. Otherwise it would be exactly the same to be in the festivals of any other town and that is just not the case.[59]

57 Ibid.,92.
58 Del Valle, "Procesos de la memoria," 7-43
59 Author's translation from the original article by Javier Muguruza, "De acuerdo con mis consejeros," El Diario Vasco, June 28, 1996.

In a letter to the editor,[60] Juan Zapirain understands the sentiment of not wanting the Alarde to change, for we want things to stay the way we have always known them, especially when they are things we associate with pleasant and happy feelings. He compares the sentiment to that of someone returning to their native Irun after a long time away and bursting into tears upon finding the fields and streams of their youth converted into a residential area. His conclusion is that, on hearing the proposal to change the Alarde, people are concerned that the new version will not carry the same emotional charge as the one they knew, that they will have lost it forever and with it, a part of their lives.

The emotional experiences described by del Valle and the aforementioned opinion writer is often related to loved ones and the ties forged over the years, strengthening the sense of belonging to a family. The visceral and ancestral thread reappears in accounts such as "I have taken part ever since I was in my mother's tummy," or in recalling people who have passed away, but whose memory is kept alive by the emotional ties reactivated that day. The memory of the grandfather who used to take you to watch the Alarde, the brother whose hand you held as children when you went running down the street to see your father go by. In the fishing families of Hondarribia, some recall that the local festivities meant father would be home from sea that day, something exceptional during the summer anchovy campaign, when the men came home for Saint Peter's Day (June 29) and stayed over for the Alarde of San Marcial the next day.

The social group includes the cuadrilla, a group of friends forged in youth and maintained through the years, often reinforced by joining in the parade or celebrations together, a rite which people who live away

60 Juan Zapirain, "¿Qué es el Alarde?", El Diario Vasco, June 5, 1996.

during the year come back to, renewing their links with the group and their hometown. The force of the group is expressed by a woman from Hondarribia who relates the pride the cuadrilla feels when one of them is chosen to be cantinera: they buy her gifts, specifically one of the fans she will carry in the parade and wave to greet those who applaud her from the pavement (2003: F/H).

These symbols are not the prerogative of the traditionalist sector. People continually create their own symbols, catalysts of emotional experiences translated into social sentiments of belonging. In one of Irun's egalitarian companies, Landetxa, as the formation approaches the town center on the morning of the Alarde of San Marcial, members break ranks to pick lavender from one of the roundabouts they pass and hand around the sprigs to put in their jacket pockets in memory of one of the first women to attempt to join the parade in 1996 and who died in 2010. As a woman from Irun affirmed, there are "infinite details" which together make up the Alarde, "for it is sentiment, something very personal" (2003: F/I). It is something individual and intimate, but at the same time undeniably social.

The Alardes function as collective rites that rely on the participation of those who march and those who watch and clap. The music is another element vital to both the festival and the affective experience and is repeatedly named—on both sides—as the principal catalyst of the most intense emotions. On the traditionalist website, the Alarde is heralded as "the warmth of the music and the people," and "a music which gives you goose bumps". A veteran supporter and participant of Jaizkibel, a retired local policewoman who used to escort the companies of Hondarribia on the day of the Alarde, relates how she was always thrilled with the music of the band, the pipes, and the drums, and

was moved by the desire to be part of that enthralling experience and to feel one with the music (2003: F/H). One of the first accounts of Urretabizkaia's tale is that of a mother who observes a practice for the Alarde of Hondarribia with her daughter. Seeing the child's glee and desire to follow along and join in the drumming, moving her hands as if banging on a pretend instrument, she imagines a future where girls too might be part of the parade.[61]

Music also triggers memory. One of the characters in Urretabizkaia's essay, a music teacher, puts music to the most important moments she wishes to remember, adding the notes and bars to the mental image or associated words before committing them to memory: "The fragment of a symphony or the top song of the moment, sometimes suggested by the lyrics; other times letters are unnecessary and it is the song of a sad violin or the same violin bursting with joy."[62]

Each person's affective landscape is painted with certain scenes, places, objects, and sounds which activate memory and with it, emotion. The reiteration of an emotional and individual experience is projected through a process of socialization and creates, in turn, an emotional tie between the citizens, the festival, and the participants themselves. It seems that the desire to recreate and relive the memories that these celebrations revive through the festival, requires that the present-day celebration is as similar as possible to the one remembered in the past. That implies that it should be subject to as few changes as possible, which makes it difficult to introduce modifications. The ties between experience, memory, and emotion are imagined to be unmovable, cementing social and affective relations.

61 Urretabizkaia, Bidean Ikasia, 15-16.
62 Ibid., 33.

A rite of solidarity

> Flow denotes the holistic sensation present when we act with total involvement, and is a state in which action follows action, according to an internal logic which seems to need no conscious intervention on our part... we experience it as a unified flowing from one moment to the next, in which we feel in control of our actions, and in which there is little distinction between self and environment; between stimulus and response; or between past, present and future.[63]

Rites of solidarity help understand how identity is constructed and confirmed through the festival. These rites are important generators of collective identities, underlying the sense of belonging to a determined cultural group through the participation of its members. The repetition of a rite representing the origins or history of a town and the real or mythical battles fought, according to Josefina Roma, is a show of identity in which "the community shows itself off, to the new members of the group and invited visitors, symbolically summing up its identity."[64] In a ritual like the Alarde, the group presents itself as a paratheatrical form through its mythicized and sacralized history, celebrating its survival capacity as a group which has lasted in time and triumphed in battles against enemy and invading peoples.[65] Ritual reproduces the

63 Victor Turner, From Ritual to Theatre (New York: Paj. Publications, 1982), 55-56.
64 Josefina Roma, "Fiestas: Locus de la iniciación y de la identidad", Ensayos de Antropología Cultural, eds. J. Prat and A. Martínez (Barcelona: Anthropos, 1996), 210.
65 Bullen and Egido, Tristes espectáculos: las mujeres y los Alardes de Hondarribia y Irun, 99-

link between the members of a group, both horizontally and vertically through the fulfilment of a vow and the maintenance of a tradition, reminding a community of their ancestors and passing on their heritage to future generations.

In the celebration of a popular festival or ritual in which citizens participate on a massive scale, an individual can participate in their own right but also through their identification with the mass. The individual delights in being recognized as part of the whole. Rather than merely being a show or spectacle, the Alarde is a platform for the mutual appreciation of those who march and those who witness from the sides, greeting loved ones, friends, and acquaintances and provoking what Miguel Chavarría[66] in an article of opinion, describes as a "shared pride":

> Shared pride, the delight of seeing and being seen as individuals and as a group. The individualities join in a common identity which inevitably becomes an occasion for strutting and showing off and feeling rightfully boastful.

In ritual, emotions are evoked by the confluence of time and place in the performance of events in sacrosanct order, following—in the case of the Alardes—the established route, climaxing in the emblematic space of the Calle Mayor at the end of the day. In the following description, emotion comes to the fore: a feeling you can "touch," the happiness of the spectators mixed with the sadness of the end.

100.
66 Author's translation from the original article by Miguel Chavarría, "Alardea", El Diario Vasco, June 28, 1996.

The streets overflow with people once again, trying to get a last glimpse of the Alarde. It's the middle of the afternoon, the march of San Marcial can be heard afresh on the town streets. Urdanibia Square, Church Rise, Columbus Parade, . . . and Main Street. Narrow and cobbled, here some of the most emotive moments of the Alarde will be experienced. People's shouts, their heart and happiness will be felt with every step. Tears of sadness and emotion mingle. The heart of the people is immersed in these last moments. The day of San Marcial is about to end.[67]

The experiences described above approach Turner's concept of communitas, defined as the "relationship between concrete, historical, idiosyncratic individuals,"[68] a spontaneous and informal affiliation generated by taking part in a common task, a sharing of life experiences. Turner distinguishes between society as structure—with its political and economic hierarchies—and the non-structured transitional community arising from a temporary set of social relationships forged momentarily in extraordinary situations like this festival. Turner relates the concept of communitas to the notion of liminality that refers to being in transition between one state of being and another and is characterized by changes in or the suspension of habitual social relations.[69]

The idea of communitas is crucial to understanding the social relationships surrounding the Alarde because it helps explain the importance attributed to being a spectator of the march and the sensation many women have of fully participating in the parade even though they

67 Author's translation from "Euskal Herritik zehar: Gorria, zuria eta beltza. Gora San Martzial!" Euskonews, no. 492, 26 June -03 July 2009, accessed October 23 2018, http://www.euskonews.com/0492zbk/gaia49205eu.html.
68 Victor Turner, Ritual Process: Structure and Anti-structure. (Ithaca, New York: Cornell Univeristy Press, [1969] 1991), 131.
69 Turner, Ritual Process: Structure and Anti-structure, 96.

do so from the roadside. The full identification of the person with the group and their surroundings, the act of observing or participating, is expressed by another concept employed by Turner: confluence or simply, the experience of flow.[70] Going back to the work of Émile Durkheim[71] the intersection of a sacred ritual with a profane festival converts the individual into an accomplice of a shared social experience, reinforcing the feeling of solidarity and maintaining social harmony. In this sense, ritual functions as fusing the group as well as strengthening the social order.

As Dolores Juliano[72] has pointed out, since the festive space is open to the protests and demands of otherwise invisible or marginalized sectors, festive ritual can also work the other way, to question and subvert the norm.[73] In the Middle Ages described by Homobono[74], the feeling of belonging to a community within city walls and united by a solidarity inspired by the defense of the city, arises in opposition to an invading and external enemy; while in the present, the threat comes from "within." This fact complicates the forging of identities: the festival ceases to function to reinforce a common identity and instead affirms the expression of a majority, dominant, and hegemonic identity while excluding an ostracized group who are reinterpreting and remaking their own identity. Identity, insofar as being one of "the people" ("pueblo") of a particular locality, is fought over on a discursive level in relation to one's stand for the traditional or egalitarian Alarde: the traditionalist majority reaffirms an exclusive identity of being

70 Turner, From Ritual to Theatre, 56.
71 Émile Durkheim, The Elementary Forms of Religious Life, trans. Karen E. Fields, New York: The Free Press, 1995), 420-421.
72 Dolores Juliano, "Participación de las mujeres en los espacios festivos", interview by Begoña Zabala, Hika, Bilbo/Donostia, 1997, 42-3.
73 Bullen, "Hombres, mujeres, ritos y mitos: Los Alardes de Irun y Hondarribia", 48.
74 José Ignacio Homobono, "Espacio y fiesta en el País Vasco", Investigación y Espacio, (Donostia: Ed. Lurralde, 1982): 106-7.

irundarra or hondarribitarra, ascribing to themselves the category of "people" of Irun or Hondarribia, and expelling as outcasts—as we have seen in Urretabizkaia's work—those who push for change.

In this conceptualization of ritual, it is the fulfilling of the rite, step by step, without straying from the established order, which conjures up the treasured sentiment or feeling. Consequently, changing the rite would change the sentiment. But why does this not happen when other elements change and shift? Why is ritual threatened by the incorporation of a specific gender of people, when the rite itself is unchanged?

Emotional and gender hierarchies

The answer to these questions must lie in the workings of the gender systems which function to reproduce the dichotomous and hierarchical structures of society in general, and the ritual under examination in particular. Estibaliz de Miguel explores the notion of an "emotional stratification" that reinforces social class, ethnicity, gender, and other categories of differentiation, and goes on to discuss the gendered value attached to the expression of certain emotions: "A person has [differential] permission to feel worried, guilty or ashamed, constituting a metaphorical floor and ceiling for expected and accepted sentiments [according to their gender]."[75]

Another aspect of the emotional weight of the Alarde I wish to mention here is the hierarchy established in terms of "who feels it

75 Author's translation from Estibaliz de Miguel, "Emociones y desigualdades sociales. El caso del miedo", in IX Premio de Ensayo Breve "Fermín Caballero, eds. S. Gallego and E. Diaz (Toledo: ACMS, 2011), 60.

the most." As we have seen, the reaction against change exploits the opposition of rationalization-emotion and the naturalization of embodied emotion, but in this case, it is a romantic notion that perceives emotion not only as natural to the human condition, but also spiritual, pure, and incorrupt, in contrast to an artificial, forced rationality.

In relation to the Alarde, it is interesting to observe the projection of emotions in gendered terms. Just as what happens in the Alarde is situated in the sphere of the extraordinary, sacred, or symbolic, separate from everyday life, norms, and values, so gendered behavior is seen to be different in the festive context. For example, it is considered acceptable for both men and women to cry, whether from emotion or rage. The fact that it is rare to see men in tears seems to make those tears more feared or more revered. The exceptionality of the expression of emotion in men is seen as potentially damaging to their physical person: supporters of the egalitarian Alarde tell of their mothers' warning not to provoke their fathers, fearing that the emotional impact might have a serious effect on his health.

One of the arguments of traditionalists is that those in favor of change do not "feel" the Alarde. Following the logic that a ritual functions via the emotions and not reason, their impassive, unfeeling participation would diminish the exalted nature of the Alarde:

> For me, the Alarde is a bunch of sentiments inside and it makes me angry that they take the Alarde lightly...In my mind, it is a very serious thing that needs to be protected and there are people who do this with respect. (2003: M/H)

In this sense, Robert Solomon[76] suggests we contemplate the "cultural value of sentiment" and treat emotion as "a complex system of value judgment of the world." Thus, the emotion one feels for the Alarde becomes an indicator of one's true allegiance to tradition and the town. As we have seen previously, it is worn as a badge of local identity and interpreted as a sign of being one of the "people." Following this logic, one who truly loves the Alarde would not allow another, of lesser sensibility than themselves, to introduce change against the will of the true Alarde-zale (lover of the Alarde). Communitas is hence built around the love for the festival and fervent desire to protect it from perceived manipulation by kanpotarrak ("outsiders").[77] One traditionalist admits "there is no apparatus for measuring the feelings one has for the Alarde, not by any means" (2003, M/I), but it is assumed that people who want to transform the festival cannot feel the same way about it—otherwise they would not want to change it. In Hondarribia, a distinction is made between those who live or sleep in the town without forming part of the emotional and cultural heart of the Alarde, and those who "make the Alarde happen, feel it, and live it" (2003, M/H).

On one occasion, I was witness to a public display of sentimental rivalry over which side feels more strongly about the Alarde. This occurred at the Seminar on the Alardes of Euskal Herria held in Antzuola in 2007,[78] when those who attended in representation of the traditional Alarde in Irun centered their presentation on emotion. They finished off with the viewing of a scene from a DVD recorded during an event

76 Robert C. Solomon "Emotions and Anthropology: The Logic of Emotional World Views", Inquiry, 21 (2007): 181-199.
77 Many supporters of an egalitarian Alarde are deemed outsiders, although they were born in the area.
78 The local council of Antzuola in collaboration with Eusko Ikaskuntza (Society of Basque Studies) organized this seminar on 6-05-2007. Participants of different localities of Euskal Herria were invited to present their Alarde in the morning and join in a parade in the afternoon.

in honor of the cantineras of Irun, in which we heard the words of ninety-five-year-old Margot Larretxea, cantinera of the Real Unión company in 1928. Moved by her words, all the women present got to their feet and jumped up and down to the rhythm of the march of San Marcial.[79] The representatives of Hondarribia's Jaizkibel, represented by their captain, Ixabel Alkain, did not miss the emotive intentionality behind the showing of that scene. When her turn to speak came, Alkain—with the legitimacy of a born and bred hondarribitarra and former cantinera—replied in kind, avoiding the issue of women's rights and framing the desire for women to take part in the Alarde in similarly emotional terms.

It is true that there are people who support the participation of women in the parade and who are not great lovers of the Alarde itself, but as they are in favor of broadening women's participation in all walks of life, including ritual, they support the initiative. Nonetheless, for those who support the traditional Alarde, the defense of women's rights to participate obeys a logic and a reasoning at odds with their emotional experience and interpretation of the ritual. The question remains of why women should be prevented from taking part in the parade "from within" and "feeling" the Alarde for themselves.

Groundhog Day

In 2015, when Jaizkibel met in mid-September to evaluate that year's events, a member who had

79 See Diario Vasco (12-13-2006) for information on the presentation of the DVD, "Nuestros Recuerdos - Gure Oroimenak" ("Our Memories"), showing "the most representative and emotive episodes."

been there from the very beginning said that
she had an acute feeling: of groundhog's day.[80]

Urretabizkaia's powerful review of the her own and others' experiences
in the twenty years since she first ventured out into the Main Street of
Hondarribia, air rifle in hand, red beret on her head, brings us up to a
present where history seems to repeat itself, as in Harold Ramis's 1993
film, Groundhog Day. As I write these closing lines in the autumn of
2018, the impression is that the clocks have been turned right back
to those first Septembers when the opposition to the women in the
Alarde was at its fiercest, violence at its most physical, and emotion at
its strongest. Nowhere is this as evident as on Main Street on the day of
the Alarde, where this year the traditionalists were not only particularly
vociferous—making more noise than ever behind the black plastics
they raise in protest, drowning out the music of the company's pipes
and drums—but also claimed they felt attacked and humiliated by the
presence of Jaizkibel.

In this paper, I have combined Urretabizkaia's expression of
emotion as she describes the path taken over the past twenty years, with
a review of my own research into the conflict over the participation of
women on equal terms with men in the Alardes of Hondarribia and
Irun. Placing the epicenter of the stand against the incorporation of
women in the heart and not in the head, in feeling and not in reason,
emerges as a strategy to avoid rationalization. Not only the discourse
but the embodied experience of emotion allows a naturalization and
justification for the traditionalist position and takes away the capacity
to feel from those supporting change. However, the way we perceive

80 Urretabizkaia, Bidean Ikasia, 131.

and theorize on emotion is open to discussion. Urretabizkaia's book uses literary recourse to convey emotions in a way everyday language fails to do. It also shifts the emotional spectrum from the passionate love for and pride in the Alarde to the feelings of hurt, hatred, and fear.

Ritual emerges as central in the purveying of feeling with regard not only to an individual attachment to the Alarde—cultivated over the years and stored in memories, sparked by music, places, and symbols—but also in the creation of communitas, forging emotional ties to those with whom the Alarde is shared and excluding those who are seen to threaten the community. Moreover, emotions color memories and intervene in the way history is recounted, as well as in our desire for the past to repeat itself or—rather—to change, to take us to the end of the road, to the top of the mountain, to new horizons.

WORKS CITED

Bullen, Margaret and Kerexeta, Xabier. "Genero-indarkeriaren erakundetzea Bidasoaldeko alardeetan." Ankulegi. Revista de Antropología Social, no. 17 (2013): 11-28.

Bullen, Margaret. "Changing the gender of festivals." In Basque Gender Studies, by Margaret Bullen, 252-270. Reno: University of Nevada Press, 2003.

Bullen, Margaret. "Derechos universales o especificidad cultural: una perspectiva antropológica." In Los Alardes del Bidasoa: Pueblos versus ciudadanía, coordinated by G. Moreno and X. Kerexeta, 21-47. Lasarte: Antza, 2006.

Bullen, Margaret. "En el cruce: nuevos elementos sociales en una vieja ciudad fronteriza." Cultura y política: Actas del IX Congreso de Antropología FAAEE. Barcelona, 2002.

Bullen, Margaret. "Eskubide unibertsalak ala kultur berezitasuna ikuspegi antropologiko bat." In Bidasoaldeko Alardeak: Herria versus hiria, coordinated by G. Moreno and X. Kerexeta, Eibar: Udako Euskal Unibertsitatea, 2004.

Bullen, Margaret. "Gender and Identity in the Alardes of Two Basque Towns." In Basque Cultural Studies, edited by William A. Douglass et al., 149-177. Reno: Basque Studies Program, University of Nevada, 1993.

Bullen, Margaret. "Hombres, mujeres, ritos y mitos: Los Alardes de Irun y Hondarribia." In Perspectivas feministas desde la antropología social, edited by Teresa Del Valle, 45-78. Barcelona: Ariel, 2000.

Bullen, Margaret. "Transformaciones socio-culturales y la recreación de una fiesta." Zainak (2003): 937-952.

Bullen, Margaret and Diez, Carmen. "Fiestas, tradiciones e igualdad." Kobie Serie Antropología Cultural (Bizkaiko Foru Aldundia-Diputación Foral de Bizkaia) no. 16 (2013): 13-34.

Bullen, Margaret and Diez, Carmen. "Fisiones / fusiones. Mujeres, feminismos y orden social." In Feminismos en la Antropología. Nuevas propuestas críticas, edited by Rosalva Aída Hernández and Emma Martin Liliana Suarez, 81-97. Donostia-San Sebastián: Ankulegi Antropologia Elkartea, 2008.

Bullen, Margaret and Diez, Carmen. "Matriarchy versus equality. From Mari to Feminist Demands." In Feminist Challenges in the Social Sciences: Gender Studies in the Basque Country, edited by M.L. Esteban and M. Amurrio, 113-126. Reno: Center for Basque Studies, 2010.

Bullen, Margaret and Diez, Carmen. "Violencia y cambio de culturas androcéntricas." Cultura & política: Actas del IX Congreso de Antropología FAAEE. Barcelona, 2002.

Bullen, Margaret and Egido, José Antonio. Tristes espectáculos: las mujeres y los Alardes de Hondarribia y Irun. Bilbao: Servicio Editorial de la UPV-EHU, 2003.

De Miguel, Estibaliz. "Emociones y desigualdades sociales. El caso del miedo." In IX Premio de Ensayo Breve "Fermín Caballero", coordinated by S. Gallego and E. Diaz, 49-75. Toledo: ACMS, 2011.

Del Valle, Teresa. "Procesos de la memoria: Cronotopos genéricos." La Ventana 1 no. 9 (1999): 7-43.

Durkheim, Émile. Las Formas Elementales de la Vida Religiosa. Madrid: Akal, 1984.

Esteban, Mari Luz. "Algunas ideas para una antropología del amor." Ankulegi. Revista de Antropología Social, 2007: 71-85.

Esteban, Mari Luz and Hernández, Jone Miren, eds. Etnografías feministas. Una mirada al siglo XXI desde la antropología vasca. Barcelona: Bellaterra, 2018.

Esteban, Mari Luz. Antropología del Cuerpo. Género, itinerarios corporales, identidad y cambio. Barcelona: Ediciones Bellaterra, 2004.

Esteban, Mari Luz, Bullen, Margaret, Diez, Carmen, Hernández, Jone, Imaz, Elixabete. Continuidades, conflictos y rupturas frente a la desigualdad: jóvenes y relaciones de género en el País Vasco. Vitoria-Gasteiz: EMAKUNDE Instituto Vasco de la Mujer, 2016.

Estornés Zubizarreta, Idoia. "Desagraviando navarros, eliminamos mujeres." Diario de Noticias de Navarra , March 1996.

Estornés, Idoia. "Los Alardes de Irun y Hondarribia (Fuenterrabía). Informe (1997)." Informe histórico, Donostia-San Sebastián, 1997.

Gil Calvo, Enrique. Estado de fiesta. Madrid: Espasa-Calpe. 1991.

Hernández Garcia, Jone Miren. "¿Acaso tiene género la sangre? O por qué los cuerpos femeninos no sirven como habitáculos para los versos." In Etnografías feministas. Una mirada al siglo XXI desde la antropología vasca, edited by M.L. Esteban & J.M. Hernández, 104-132. Barcelona: Bellaterra, 2018.

Homobono, José Ignacio. "Espacio y fiesta en el País Vasco." Lurralde: Investigación y espacio, no. 5 (1982): 91-120.

Juliano, Dolores. "Participación de las mujeres en los espacios festivos." Interviewed by Begoña Zabala. Hika, 1997: 42-3.

Kerexeta, Xabier. "Dime de qué alardeas." www.alardepublico.org. 2001. https://www.alardepublico.org/down/Kerexeta_historia.pdf (accessed December 31, 2020).

Labanyi, Jo. "Doing Things: Emotion, Affect, and Materiality." Journal of Spanish Cultural Studies 11 no. 3 (2010): 223.233.

Le Breton, David. "Por una antropología de las emociones." Revista Latinoamericana de Estudios sobre Cuerpos, Emociones y Sociedad 10 (2012): 69-79.

Lutz, C. and White, G. M. "The Anthropology of Emotions." Annual Review of Anthropology 15 (1986): 405-436.

Lutz, Catherine. "Emotion, Thought, and Estrangement: Emotion as a Cultural Category." Cultural Anthropology 1 no. 3 (1986): 287–309.

Mari Luz, Esteban. Crítica del pensamiento amoroso. Barcelona: Bellaterra, 2011.

Medina Doménech, Rosa. "Sentir la historia. Propuestas para una agenda de investigación feminista en la historia de las emociones." Arenal. Revista de historia de mujeres 19, no. 1 (2012): 161-199.

Roma, Josefina. " Fiestas: Locus de la iniciación y de la identidad." In Ensayos de Antropología Cultural, edited by J. Prat and A. Martínez, 204-214. Barcelona: Anthropos, 1996.

Rosaldo, Michelle Z. "Toward an Anthropology of Self and Feelings." In Culture Theory: Essays on Mind, Self, and Emotion,

edited by Richard A. Levine and Robert A. Sweder, 67-87. Cambridge: Cambridge University Press, 1984.

Solomon, Robert C. "Emotions and Anthropology: The Logic of Emotional World Views." Inquiry, no. 21 (2007): 181-199.

Turner, Victor. From Ritual to Theatre,. New York: Paj. Publications, 1982.

Turner, Victor. Ritual Process: Structure and Anti-structure. Ithaca, New York: Cornell Univeristy Press, [1969] 1991.

Urretabizkaia, Arantxa. Bidean Ikasia. Iruña-Pamplona: Pamiela, 2016.

Mnemonic Battles,[1] Intersubjective Memories, and Outlawed Emotions in Begoña Aretxaga's States of Terror.

Marina Pérez de Mendiola Arizmendi

Scripps College

To Begoña Aretxaga in solidarity

In some ways, this essay has been thirty years in the making, and merely offers a conflicted and deferred glimpse of what it would like to convey. It begins with an encounter drawn out of memory from my early years as a graduate student doing research at an East Coast, North American university. The context of a 2018 conference in Boise on memory and emotion gives me license to describe what Kathleen Woodward calls the "mood of my memory"[2] of that day. It also allows me to reflect on why I have always felt not only a strong kinship with Begoña Aretxaga's academic work but also, paradoxically, a complex of adverse feelings associated with this encounter and my memory of it. When I say that the rendering of my affective response to that event has taken thirty years to be somewhat articulated, it is because it has been part of what

1 "Mnemonic battle" is a concept coined by Eviatar Zerubavel in Time Maps: Collective Memory and the Social Shape of the Past. Chicago: Chicago University Press, 2003. "Intersubjective memories" is a concept coined by Barbara Misztal in Theories of Social Remembering, Maidenhead: Open University Press, 2003.
2 Kathleen Woodward, "Psychoanalysis, Feminism, Ageism," in Images of Aging. Cultural Representations of Later Life, eds. Mike Featherston and Andrew Wernick. London & New York: Routledge, 1995, 82

Freud refers to as "the disturbance of memory," or as "the notion of the repetition not of an event but of a complex of emotions." [3]

I met Begoña Aretxaga during a fundraising event that graduate students organized to help victims of the 1985 Mexico earthquake. I cannot say that we met because I am not sure she would remember us "meeting" if she were alive today. She was a doctoral student in the Department of Anthropology at Princeton University, and I was a doctoral student in Latin American Studies at the Sorbonne in Paris, researching Mexican writer Carlos Fuentes whose manuscripts were housed at the Firestone Library at Princeton University. As a Basque anthropologist, Aretxaga dedicated her short life to the indefatigable study of cultural politics and state violence in Northern Ireland and Spain, and she is one of the first Basque scholars to concentrate primarily on women's roles and gender in the formation of political subjectivities. I only knew her superficially while we overlapped at Princeton. Yet, as a woman of my own politicized generation, and as a Basque who immigrated, like I did, in the early 1980s to the United States to pursue an academic career, Aretxaga came to represent for me, over the years, that sister from Donostia (San Sebastián) who unknowingly and unwillingly made sense of my own fears of physical and emotional detachment from the homeland. Guilt for leaving and for experiencing, at first, "a great sense of personal freedom" [4] in the United States, was something we had in common. That meeting at Princeton was intensely short and marked me forever. Although working side by side at the fundraising table, we had not introduced ourselves to each other; however, I detected an accent when she spoke English that was uncannily familiar. It was not just any

3 Woodward, "Psychoanalysis, Feminism, Ageism," 81
4 Kay B. Warren, "Critical Voices and Representational Strategies from Begoña Aretxaga's Ethnography on Northern Ireland," in Aretxaga, Begoña. States of Terror. Begoña Aretxaga's Essays. Reno: Center for Basque Studies, 2005, 22

Spanish accent. No, it was a way of speaking English, gestures, and an intonation that seemed unmistakably Basque from Hegoalde (Southern Basque Country), and from the province of Gipuzkoa in particular. When I turned to look at her, my intuition became somehow confirmed. "Are you Basque?" I asked her in Spanish. I did not want to assume that she spoke Euskara (the Basque language) since this was a very politically charged issue at the time that divided many of us back home. She turned toward me and stared, half puzzled, half annoyed. "Yes" she answered in Spanish, but the "and you?" never followed. She proceeded with the collection of donations while looking at me askance. I felt a violence that was not unlike the violence I had felt many times before as a teenager growing up in Iparralde (Northern Basque Country) trying to engage the activists from the "other side," as we called each other, when meeting during demonstrations against Franco, and later during what so many insisted on calling, problematically, the "transition." I pushed her to acknowledge my presence, a presence that I thought should be translated as an immediate connection, particularly in this setting: two Basque women, far away from home, working to raise funds for a country with a colonial past that we, as Basques, shared on many levels but that we also helped to produce in the Americas. I explained that I grew up in Ciboure, granddaughter of a Basque republican from Gipuzkoa, exiled in Iparralde during Franco's dictatorship; that I was born and raised until eight years old in Germany, where my parents immigrated for economic reasons; that my Aitatxi (grandpa) and Amatxi (grandma) spoke to me in Euskara during the summers and years I lived with them, but that I had forgotten a lot because speaking Batua (Standard Basque) versus classical Basque was not an option in my family; that my parents, when we came back from Germany, decided to keep me living and studying on the French side of the Basque Country as long

as Franco ruled, although my father crossed the border to the "other" side every day to work in Donostia; and that many of my aunts, uncles, and cousins lived there as well. There was so much I wanted to share with her and for her to share with me, but she remained impassible, as if saying "Oh good for you," while also retaining what I remember interpreting as a contemptuous demeanor. At the time, I did not know that we shared the same birthday almost to the day, which could have helped me explain her initial reticence—characteristic, I have been told, of our astrological sign.

It did not take me long, however, to realize that I had broken a basic rule that I would have never broken back home: the "too much information" rule. Growing up in an environment and time where revealing too much about who you were and what activities you engaged in, could have serious consequences for you and your family. The Franco years and its police's pervasive harassment and undercover surveillance of Basque people and particularly nationalists, made us even more distrustful and suspicious of one another, as in our culture, like in many others, trust is not a given but rather earned. One also had to be weary of the potentially intransigent response from ETA (Euskadi ta askatasuna, Basque Country and Freedom) to anyone not willing to "help"—either through the revolutionary tax or any other direct or indirect form of support—even as an open sympathizer or no matter how Basque one actually was. To be Basque was not enough, or at least was constantly being redefined by those who asserted their right and the privilege to do so. Being thousands of miles away from Euskal Herria (the Basque Country) did not imply I could break the rules of safe engagement, nor that being Basque myself was enough to establish any intimate connection with a fellow Basque. Aretxaga had no way of knowing who I really was, and as an activist while growing

up in the Basque Country during those years, she too, of course, knew better than to openly embrace me "just because."

Although I understood much of the unspoken subtext that probably defined this encounter, I remember feeling a sense of betrayal. Moreover, in spite of the fact that I did not naïvely embrace "cultural intimacy," which Aretxaga based on Michael Herzfeld's definition— described as "a set of known and shared practices and life-forms that define a sense of group belonging and, likewise, for which the group is stereotyped and condemned from positions outside the group"[5]—the "affective glue"[6] that stems from "cultural intimacy" was difficult to shake off. Why could the distance from our homeland, and our presence in this new land, not free us from so much terror, misunderstanding, suspicion, and segregation that exists among our own people? Or, was it because I lived in Iparralde (which by many accounts made me safer to make assumptions to speak candidly than those who lived in Hegoalde)? Did she perceive me as removed from the plight of other fellow Basques? Or was it because she saw me as being Basque "differently than she was"? The two states that control Basques, the French and the Spanish, certainly have a long history of enmity that colors the ways in which Basques from both sides of the border sadly often relate to each other, even to this day—a legacy of years of cultural impositions and molding. Was it because our sexual orientations were different, and she saw me as normative? It was probably an array of complicated issues that the simple fact of being Basque could not magically solve. This encounter, however, defined how I would engage, or not engage, with the Spanish Basque diaspora in the United States for years. I followed the academic work on the Basque Country produced here and at home,

5 Aretxaga, States of Terror, 166
6 Aretxaga, States of Terror, 166

without daring to venture into the complicated debates around nation, state, and violence that had so defined my childhood and youth.

While I focused on these issues in the Mexican and Latin American academic context, Aretxaga also studied these questions mostly in another context—namely, Ireland—almost as if we both needed that academic displacement before feeling that we could fully, further, and freely dig in certain parts of our own backyard. It is through rereading much of her groundbreaking work on Ireland, and then later on Euskadi (Basque Country autonomous community), that I realized how much of what our generation of Basques, and particularly women, have lived and endured, remains in many ways unexamined. Straddling two eras, one being at the tail end of Francoism (and what many still persist calling the transition to "democracy"), the other being leaving the homeland and becoming academics "elsewhere," made our positions, as she puts it, "characterized by a displacement from militancy by academic writing and a displacement from academic writing by past militancy (…) [and our] contemporary relation to both was displaced by spatial and temporal distance."[7]

Although I unfortunately never had the opportunity to cultivate a friendship or even to engage with her intellectually during her life so tragically cut short, my intervention here about her work is reminiscent of how Aretxaga speaks about the production of her work, States of Terror, as "a product of personal, social and political displacement and, in complicated ways, it re-articulates a relation to that displacement." In her work, Aretxaga focused a great deal on the structure of affect, attachments, everyday styles of being in the world, psychological dynamics, political imaginaries, and "typologies of violence."[8] I have always been

7 Aretxaga, States of Terror, 134
8 Warren, "Critical Voices and Representational Strategies", 29

struck by the prevalence of carefully crafted semantics in her scholarship that could translate her own emotional state, or "structure of affect"—as a Basque woman, working as an anthropologist, and whose goal is to "study humans, past and present"—from an objective standpoint.[9] The fresh memory of her coming-of-age as a disenfranchised queer, feminist, environmentalist, Basque intellectual, and activist during the last part of a most repressive state dictatorship whose power is, as she puts it, "harnessed not so much from the rationality of ordering practices as from the passions of transgression,"[10] left indisputable imprints in her "American" academic production. Her being physically away from the Basque Country contributed to shaping her academic communication of emotional states such as anxiety, fear, irritation, anger, and patriotism in her analysis of Basque nationalist activists.

This essay is twofold. In what follows, I humbly try to address, albeit summarily, how Aretxaga's re-articulation of the relation to that displacement, in two of her iconic essays, paradoxically has been crucial to my own, and how her work has, also paradoxically, given me the courage to break with a somewhat self-imposed isolation from the Spanish Basque diaspora in the United States, bringing me to Boise for the aforementioned conference in 2018. As Woodward powerfully stated, "Understanding [our] own thoughts and feelings is an irresistible collaboration between other lives and other texts."[11] Aretxaga's texts have provided me the space to do so despite our initial fraught encounter. In that process, my aim is to also focus on how Aretxaga structures feelings around the issue of "terrorism" and "displacement." I use here Raymond Williams's concept of "structure of feeling," which he defines

9 http://www.americananthro.org/
10 Aretxaga, 264
11 Kathleen Woodward, Statistical Panic. Cultural Politics and the Poetics of the Emotions. Durham: Duke University Press, 2008, 14

in his book Marxism and Literature as "a cultural hypothesis (. . .) actually derided from attempts to understand such elements and their connections in a generation or a period."[12] Woodward[13] explains that the concept "structure of feeling" has been applied in different contexts and according to different analytical needs. In this present context, it provides me with "an understanding of experience as simultaneously cultural, discursive, and embodied with feeling a site for insight into social control (. . .) in a certain historical moment and period."[14]

In her introduction to the second part of her book of collected essays, States of Terror, dedicated to the Basque Country, Aretxaga begins in the first person and writes: "I don't remember the first time the word terrorism entered my consciousness as a powerful and mysterious reality of a dubious character."[15] The semiotics that she builds on, immediately lends itself to questioning the fact that a particular narrative may have been imposed, written for her, and could, therefore, be debatable. Aretxaga begins by stating that she does not "remember" the moment, the "time," during which the word terrorism first "entered her consciousness as" She confines "terrorism" to the classification of word, allowing her to focus on which connection her "consciousness" choses to make in reference to the word and, more specifically, between the signifier and signified. The connection she chooses, emphasizes power, mystery, and dubiousness. I read it as a form of resistance, as a way of keeping at bay the potential manufacturing and determination of how society and politics wish that word to "enter" our consciousness as, and what

12 Raymond Williams. Marxism and Literature. Oxford: Oxford University Press, 1977, 132-33
13 Kathleen Woodward has been the leading authority in the field of discourse of emotions for the past thirty years. Her writing remains the clearest, most thought-provoking, and most influential for anyone working on how emotions inform and shape our thinking and academic writing. I am indebted to her work and to her mentoring during the early stages of my career.
14 Woodward, Statistical Panic, 12
15 Aretxaga, States of Terror, 127

it should mean for everyone. Yet, the word entered paradoxically feels as if it came into her intimacy uninvited, in spite of her-self, leaving "powerful" and "mysterious" traces. I use the word trace because it embodies the paradoxical nature of how she refers to the words terrorism and entering—"trace" meaning the Derridian fundamental presence that shines by its absence. It is almost as if the moment the word terrorism "entered" her consciousness as were absent and only becoming an essential presence at the time of her writing. Aretxaga knows that she experienced the entering as something, but she writes that she does not recall the time of that experience. She perceives it as a trace. The fact that she "does not remember" the time of the original event, allows her to keep the origin of the event, rather than recessed, endowed with heterogeneity—what Derrida calls "origin-heterogenous."[16] By stating "I do not remember," Aretxaga may also be putting into question the origin of the event itself, thanks to a multilayered semiology, and choosing to emphasize the ever-heterogenous nature of "origin" which indicates that "nothing is ever given as such in certainty."[17] Her way of approaching "terrorism" in this short but very pregnant and loaded sentence, also points to Derrida's understanding of experience: "Every experience then is always not quite on time or, as Derrida quotes Hamlet, time is 'out of joint.' (. . .) The phrase 'out of joint' alludes to justice: being out of joint, time is necessarily unjust or violent."[18] Furthermore, her negation ("I do not remember") during the process of analysis of her experience, reminds us of what Derrida has called "auto-affection" which he links to autobiography. Auto-affection, as Derrida understands it, "is hetero-affection; the experience of the same (I am thinking about myself) is the experience of the other (insofar as

16 Jacques, Derrida. Of Spirit. Heidegger and the Question. Chicago & London: University of Chicago Press, 1989, 107-108
17 Stanford Encyclopedia of Philosophy, "Jacques Derrida," November 22, 2019, 3
18 Stanford Encyclopedia of Philosophy, "Jacques Derrida," 3

I think about myself, I am thinking of someone or something else at the same time)."[19] The denial of remembrance may, therefore, point to an affirmation of an experience that many of us Basques may have also had. It reads as a potentially private experience, or secret, albeit a sharable one, which she first tells herself when alluding to the traces of mysteriousness, powerfulness, and dubiousness surrounding the word "terrorism":

> This denial [denegation; in Aretxaga, of the time of the experience or memory of it] does not happen by accident; it is essential and originary [...] The enigma [...] is the sharing of the secret [that the experience happened], and not only shared to my partner in the society but the secret shared within itself, its 'own' partition, which divides the essence of a secret that cannot even appear to one alone except in starting to be lost, to divulge itself, hence, to dissimulate itself, as secret, in showing itself: dissimulating its dissimulation. There is no secret as such; I deny it. And this is what I confide in secret to whomever allies himself to me. This is the secret of the alliance.[20]

The concept of "consciousness" is of course loaded as well, and Derrida's interpretation may, again, be useful in this context:

> But what is consciousness? What does 'consciousness' mean? Most often [...] consciousness offers itself to thought only as

19 Stanford Encyclopedia of Philosophy, "Jacques Derrida," 3
20 Jacques Derrida. "How to Avoid Speaking: Denials," in Languages of the Unsayable. The Play of Negativity and Literary Theory. Edited by Sanford Budick and Wolfgang Iser. Palo Alto: Stanford University Press, 1987, 25

self-presence [...] And what holds for consciousness holds here for so-called subjective existence in general. Just as the category of the subject cannot, and never has been, thought without reference to presence as hupokeimenon or as ousia, etc., so the subject of consciousness has never manifested itself except as self-presence. The privilege granted to consciousness therefore signifies the privilege granted to the present.[21]

On the one hand, Aretxaga's assertion that chooses to underline her subjective perception, and on the other, she expresses it through her thinking about that subjective perception of a moment (or the absence of it) in a less elusive and more grounded critical fashion—one that bestows on it a quality of certainty (albeit still subjective of course) when it comes to how she approaches her perception of the event and the word "terrorism." It is in that critical subjective realm that we, as readers, are invited to ally ourselves, to share in what after all was/is a public, collective secret; a non-dit; an exposure to the word terrorism. Aretxaga is not solely attending or reporting on the state of her own consciousness, which could mean that she understood consciousness in the Derridian sense by which "consciousness is not any less a function of a system of differences than any other word."[22] In her statement about terrorism, she is "discriminating attention to what cannot be seen"—the mysterious, powerful, and dubious—although remaining "perceptually accessible and explainable."[23] Moreover, the language she uses presupposes that "terrorism" is actually not "a presence before and

21 Derrida quoted in Simon Glendinning, "Derrida and the Problem of Consciousness: What Would They Have Said About our Mind-Body Problem," in Consciousness and the Great Philosopher. Edited by Stephen Leach and James Tartaglia. Oxford: Routledge, Taylor and Francis Group, 2016, 1
22 I use Glendinning's wording here, in "Derrida and the Problem of Consciousness," 8
23 Glendinning, "Derrida and the Problem of Consciousness," 8

outside semiological difference."[24] Therefore, even though she does not remember when the word entered as her consciousness, the semiological difference she relies on in her written assertion presupposes that the word "terrorism" was/is also present—differently, before, somewhere else—a "presence" to which she brilliantly refuses her own presence when she writes that she does not remember when it became for her in the first place.

As Glendinning explains, "What Derrida calls 'différance' (with an 'a') can be understood as the 'difference producing' movement through which every sign is constituted historically in a structuring and differentiating weave of differences."[25] Aretxaga's sentence is deceivingly simple, yet emotionally and politically charged. As her contemporary, I feel her words and "structure of feelings" as a need to release, somehow, an "outlawed" emotion.[26] It carries the burden of that which could not be said then, and, to a certain extent, even today. It reveals a cautious yet forceful refusal of official narratives surrounding the meaning of "terrorism" in relation to the Basque Country. It also oozes a need to shroud her ideas and feelings in metaphor and symbolism, and to inscribe them into a psychoanalytical realm in order to decrypt and reveal the hidden. Although political and emotional differences could not/cannot be openly acknowledged without taking serious personal risk, Aretxaga refused to give in to emotional resistance that leads us to shun feelings and unconscious emotional states lying semidormant beneath the surface. Instead, resistance was harnessed to provide a much-needed exhaust valve to emotions and knowledge that, we have been told, should be endured quietly and privately, and not be unveiled.

24 Glendinning, "Derrida and the Problem of Consciousness," 6
25 Glendinning, "Derrida and the Problem of Consciousness," 6
26 Jagger in Woodward's Statistical Panic, 13.

As Aretxaga proceeds with her analysis, she tells us a story of her childhood that she links a posteriori to becoming conscious of the word terrorism by extension. That memory centers around a "terror mystery" television show, as she calls it, that she was allowed to watch in her parents' bedroom while convalescing from a foot injury. She metonymically connects the "bad guy" killing women in the show, his weapon concealed in the apparently innocuous umbrella, and his daily aspect of respectability, to the face of Franco's dictatorship and its functioning. The paradox of her remembrance of terror entering her consciousness while in her parents' bedroom is not lost on us. It is not lost on her either, of course, as "family" is supposed to keep us safe. The need to make that connection without analyzing it directly could bespeak her inability, at the time of the event, to articulate that the trauma that both my and Aretxaga's family structures imposed on us, reminiscent of the patriarchal forms of ruling that controlled/control our daily lives. It is, however, another moment during which, as a reader, I felt pulled into her intimate, subjective realm, particularly as a woman of her generation, via the overwhelmingly affecting space and psychoanalytically charged sphere that the parental bedroom represents. Aretxaga's framing of her emotions—clearly stemming from our cultural norms, practices, and interdicts—in an academic setting, provided tools and a space in which I could think of myself in solidarity at a time when feminist alliances were made invisible in the Basque Country. It showed that, contrary to what we have been told in general, and most particularly in the Basque Country, women's emotions "can be collective as well as personal, thus underscoring the mutually constitutive nature of subjectivity and sociality."[27]

27 Woodward, Statistical Panic, 21.

Of further interest is how, for Aretxaga, terror is learned "intuitively." As she puts it, "I intuitively learned that terror is not the effect of an outside source, like the violence perpetrated by a foreign agent radically different from one's own world, as with the subversive of the Francoist state."[28] Terror for her becomes "understood" after having been "learned intuitively" not as "the product of estrangement but of familiarity, not a force but a state of being, one deeply immersed in the everyday order of things." This intuition in the process of autobiographical memory where she "sees herself in the memory,"[29] is what confirms that Aretxaga "depicts herself, the remember in the memory, from a perspective she could not have possibly had at the time," as if the memory "had been worked over."[30] This process mirrors her use in the essay of the Lacanian Real to explain, through the analysis of a fictional apparatus, how this event for her is the Real because it works as "an irruption within the symbolic system that gives sense to our everyday world."[31] Her reliance in this introduction on fiction, theory, and psychoanalytical theory in particular, in conjunction with the kind of metaphorical memory that she describes regarding the consciousness of terror, may be the tools she needed to not only engage in academic writing but also to make sense of the fact that her anthropological approach to the terror embodied in Franco's definition of the Basque Country, is anchored in that of the silence or what is missing surrounding the Spanish Civil War. This link that she can only make by resisting symbolization of the Spanish Civil War's violence (since no one wanted or dared to remember it out loud around her) may be felt outside language, and anxiously so, as a "dispossession of experience."[32] This explains the Real's traumatic trait.

28 Aretxaga, States of Terror, 12
29 Conway, Martin A. "Memory and Desire - Reading Freud," in the Psychologist 19(9):(548-550) September 2006, 548
30 Conway, "Memory and Desire," 549).
31 Aretxaga, States of Terror, 128
32 Rob White, Freud's Memory: Psychoanalysis, Mourning, and the Foreign Body. London:

Rob White, in his work on Freud, posits that when "the individual's mind is preoccupied by the memory of incidents that are beyond the frame of its own experience, thinking can no longer travel back to the identity of personal experience."[33] The absence of reference to the Spanish Civil War in her daily life while growing up is what she sees as preventing this travelling back to pinpoint terror. That, in turn, may throw the self into crisis mode when intuitive knowledge of absence and silence, embodied in Franco's face or in that of those who remind her of him, has to make up or fill the gap for the memory of personal experience. Even the possibility of an intergenerational legacy of family experience is, as she emphasizes, denied to her and may be the source of a breach in the formation of subjectivity.[34] Aretxaga studied psychology and was well aware of Freud's and Lacan's works. The deliberate choice of words in her efforts to locate her becoming conscious of terror brings together intuition, reason through understanding, and memory, first through her inability to remember certain things—"I don't remember when I began to have the suspicion that there was more to the reality of terror"[35]—and then through the act of being able to remember "the day when the word terrorist printed on the front page of the local newspaper (...) struck me as a strange charade."[36] The knowledge attained as a result of the articulation of "herself in memory," carries, as Conway puts it, "negative emotions such as anxiety."[37] As she moves

Palgrave McMillan, 2008, 63.
33 White, Freud's Memory, 63.
34 Some of us whose Basque family members fled from Spain to other countries after Franco seized power, have been blessed with many stories about the Spanish Civil War. As I am getting older, I realize what an incredible privilege that was for me as, even though much was probably missing in these accounts, the Spanish Civil War was neither a censored subject nor a taboo topic of conversation in my family, for example, influencing in a less traumatic fashion the formation of parts of our subjectivities. This is the legacy of those who had to flee and who had to suffer the difficulties of political and social exile, but who, in so doing, could probably articulate more freely that trauma in the hopes of ensuring a better future for the new generations.
35 Aretxaga, States of Terror, 129
36 Aretxaga, States of Terror, 129
37 Conway, Memory and Desire, 549

from an earlier, somewhat nebulous, articulation of her apprehension of the word terrorism in the introductory sentence, and it "entering her consciousness as," to the use of much more specific words such as "suspicion," "reality of terror," and "strange charade," she directly points to troubled emotions such as anxiety and alarm, emotions that are exacerbated by a sense of distrust and awareness of the dystopia she lives in. On the one hand, she tries to mitigate this frightening awareness by using irony with her reference to a "strange charade," while on the other, this irony translates to a sharp ability to critique, becoming a tool of survival while also emphasizing her disconnect with the reality that surrounds her.

This is why, Conway explains, "negative emotions such as anxiety and hate (. . .) can also be a resource for the self that underpins current desirable self-images, and which motivate goal-completion in the present."[38] One such "goal-completion in [her] present" was, during her research trips back to the Basque Country, to provide, from an ex/patriate location that she believed gave her the privilege to do so, links to, or to be the embodiment of, a bridge between generations and people who, in the 1990s, used to be friends but that politics kept dividing. She emphasized the idea that her "insider/outsider" position placed her "in an undetermined location" that "despite its ambiguities (. . .) had at least one clear advantage in conducting [her] research in a deadlocked and polarized political culture."[39] Aretxaga defining her being in the USA as in an "undetermined location," allows her to avoid taking sides, she says, and to remain friends with people whose geographical position does not leave them any other option but to take a political position. However, as the essay progresses, she finds

38 Conway, Memory and Desire, 549
39 Aretxaga, States of Terror, 133

it necessary to also point out that her being back in Euskadi doing research could only yield results or information if she were perceived as "legitimate" by the new generation of radical nationalist activists involved. Her first collection of essays written while in Euskadi "on the political funerals of ETA members that the GAL (government organized death-squads) assassinated in the 1980s" (Aretxaga, States of Terror, 133) provided her with that legitimacy. In other words, it was a very "determinate" location—the "inside" location, the location of first-hand experience—that gave her rights, validity, and authority, as opposed to the undetermined location that she returned to time and again. As she puts it herself, "In coming back to the Basque Country, my person was often located within this political map of the past,"[40] and often mediated by her reliance on old friendships to give her access to the present that she could only experience vicariously. This is, in and of itself, everyone's condition, as no one can always be in full possession of experiences. However, her relationship with the Basque Country through her anthropological research, and from an "outsider" location as a resident of the USA, made her painfully aware, I believe, of yet another form of "dispossession of experience"[41] resulting from the fact of being Basque globally, but mostly diasporic. Of course, Aretxaga understood, as Carol Bardestein explains, that "the figures of diasporic cultural production (...) may be found in a wide range of realms of human perception and apprehension, in ways that ultimately chip away at the notion of diasporic cultural production as wholly distinct and distinctive."[42] Understanding this, however, probably did not prevent her from feeling, as a Basque from Donostia, that coming "back home,"

40 Aretxaga, States of Terror, 133
41 White, Memory and Desire, 62
42 Bardestein, Carol. "Figures of Diasporic Cultural Production: Some entries from the Palestinian Lexicon," in special volume of book series Thamyris/Intersecting: Place, Sex, and Race, eds. Marie-Aude Baronian, Stephan Besser, and Yolande Jansen. Amsterdam & New York: Rodopi Press, No.13, 2006, 31

on the one hand allowed her to see herself in memory, giving her possession of that experience through her very real political participation in the anti-Franco resistance, but that it has also "dispossessed" her of an experience that could have been different.

Another interesting example of a "dispossession of experience" can be found in Aretxaga's later discussion of the GAL (Grupos Antiterrorista de Liberación, Antiterrorist Liberation Groups) during her American academic production. Aretxaga dedicates her attention to the GAL in several chapters of States of Terror. For example, in order to delve into state terrorism, she brilliantly chose to focus on the 1994 confessions of two police officers working for the intelligence department of the Spanish police in 1987, who were "charged and convicted of organizing the GAL. Along with Amedo and Dominguez, a number of mercenaries were arrested in connection with the assassination of Basque activists."[43] Her aim was to show that "state officials become terrorists for the purpose of eliminating Basque terrorism, and to that end invent a terrorist organization called the GAL. It is a tale about the phantasmatic universe in which terror and desire are mutually constituted in acts of violence."[44] When analyzing the GAL, she clearly states that it was a dirty war and a "plan worked out by the security services of the Spanish state against Basque political refugees living in the French Basque Country (. . .) some of whom were ETA members."[45] Although in her book Aretxaga repeatedly mentions the issue of balkanization in Hegoalde (a division between Spanish Basques rooted in the disagreement regarding what course to follow at the end of the 1980s and during the 1990s, or whether to consider the Ertzaina[46] a cipayo or a police true to its

43 Aretxaga, States of Terror, 218
44 Aretxaga, States of Terror, 219
45 Aretxaga, States of Terror, 156
46 An ertzaina is a member of the Basque police force, called the Ertzaintza, which largely
 replaced the Spanish Policía Nacional during the "transition to democracy".

Basqueness),[47] she falls shy in her analysis, for example, when it comes to the impact of the GAL's dirty war on Basques living on the French side. The balkanization among Basques was not anything new for most Basques from the north side, and it was particularly painful for those who were first generation "French" Basques whose grandparents had come as refugees after the Spanish Civil War, and who were still mostly perceived by Basques from Hegoalde only as gabachos (in Spanish, a pejorative reference to French people). This oversight on her part could be read as a result of a "dispossession of experience" since it was probably, if not denied to her, at least part of another lived reality to which she, as a Basque activist from Hegoalde, may not have been privy. For Basque activists from Iparralde, the presence of refugees from the other side (ETA members and otherwise) reminded us that being Basque meant solidarity, and that as Basques we were also the object of the Spanish State's violence, often by just being in the wrong bar at the wrong time. Her analysis of the GAL, in these essays in particular, is the perfect opportunity to address this all-too-often-forgotten fact. Several people the GAL killed or injured were not ETA members, and several of these crimes were committed in my hometown or in very close vicinity, with impunity. Through the frequent omission of experiences such as those of Basques living on the "French" side who were also subjected to Spanish state terror, I realized how much of our respective Basqueness had been defined by the nation-state with which we had to institutionally identify—at least in terms of national citizenship. The fact is that, in many ways, the omission of a Basque experience due to one's own "dispossession of experience," is not that different from the one that Aretxaga sees at work when radical nationalists accused the

47 Aretxaga, States of Terror, 210

Ertzaintza, the newly formed Basque police force, of violent betrayal, calling them cipayos.[48] As she explains:

> Unlike the Spanish police forces, who often lived in separate compounds on the outskirts of the community, ertzainas lived among the local population, had families and friends within the Basque geography, and thought of themselves as part of the community. The image of the Ertzaintza was a metonymy of the imagined Basque nation-state. Yet as a police force, the Ertzaintza had to assume the task of enforcing the law, which was still Spanish law. The ambiguity of Basque police enforcing the (Spanish) law created distrust not only from radical nationalists but from the Spanish government as well.[49]

I assume that the reason why Aretxaga, in that description of who the ertzainas (members of the Basque police) are, does not refer to them as Basques, is because some of them did not identify as Basques. But then again, in those days, and still today, the right to identify as Basque is mediated by cultural, social, and political forces that greatly and gravely so deny many of us access to parts of our self that have been inscribed in generations of traditions, ways of being, and a language that our families legated to us.

This finally brings me to the sensitive subject of who holds the privilege to define herself and others as Basque. For example, being Basque

48 "I learned that (...) cipayos was the name given to the Ertzaintza by radical nationalists. Cipayo (...) was the name for the soldiers of Indian origin serving the British colonial army."(Aretxaga, States of Terror, 210). These radical nationalists, by using the term cipayos, explains Aretxaga, were equating ertzainas to native informants collaborating with the Spanish nation-state in their policing of Basque people's daily lives, and consequently traitors to their own people.
49 Aretxaga, States of Terror, 209

from the other side, the French one, often was—for Basques from the Spanish side—as suspicious as being an ertzaina. If the Ertzaintza, as Aretxaga explained, was "a metonymy of the Spanish state," Basques on the French side were/are a metonymy of the French state. If, as Aretxaga writes, "in acting as metonymy of the [Spanish] state, the Ertzaintza introduced a threatening shift in the culture of Basque nationalism which, as with other nationalism, rests on the fraternal unity of the imagined Basque people,"[50] then I would argue that this unbearable ambiguity at the core of the nation, this balkanization of the Basque Country, has existed for a long time, and way before the formation of the Ertzaintza. To be "divested" of Basque identity by placing the northern Basque firmly on the French side of the Basque/French continuum (I mimic Aretxaga's argumentation[51]) is further complicated by the ways in which the French government also distrusted/distrusts Basque people. Perhaps that "suspicion" is what colored her response to me during our encounter.

Iparralde writer Itxaro Borda, in her scathing critique of what being Basque should look like depending on ideological positions from both sides of the border, denounces Hegoalde's hegemonic hold on the Basque language and culture over Iparralde's. She also delivers a no less blistering assessment on how these restraining male- and normative-imposed codes of conduct followed by many, divide Basques and—worse yet—muzzle those of us on the northern side of the border:

> I was every time more ashamed, as I felt part of those submissive
> people. I could not do much else: I had inherited Euskera in
> obscurity, just like today, from my mother's breast and in my father's

50 Aretxaga, States of Terror, 213
51 Aretxaga, States of Terror, 213

barn. Joanes was envious of me because I had suckled Euskera together with the milk, naturally, which implied tremendous luck; but luck did not last long for me. When I went to school to internalize the pedagogical and universal model of Enlightenment and of suppression, I lost closeness with the language, and I bore punishments, marginalization, and slaps in the face that I undoubtedly deserved in my childhood. I remained in silence in the face of adults' violence, one that I immediately internalized, and that I still do, like Indians and aboriginal people. Joanes was right: I could not be an authentic militant because I had buried my ability to speak.[52]

Borda also brilliantly reminds us that "we have the referential system that we deserve, no more, no less."[53] Aretxaga's work—through the many paradoxes and contradictions that being from somewhere entail—pointed, already twenty some years ago, to the ever-pressing need to rethink our selves beyond the straightjacketing, elitist, exclusionary, autocratic, and outdated conceptual framework of nationhood. As Basques, we owe it to our ancestors, our children, and the world, to continue leading the way by imagining new modernities based on intersectional dialogues and community formation, while never giving up on our right to exist as Basques. I am hopeful that we are moving in that direction.

52 Itxaro Borda, 100% Basque. Translated by Bego Montorio. Donostia-San Sebastian: Meettok, 2012, 200; my translation from the Spanish translation of her original text in Basque.
53 Borda, 100% Basque, 205

Conclusion

After spending many years reading and re-reading Aretxaga's trailblazing writing and research on what Brow defines as "affect embodied through political economy and their imbrication with nationalisms, terrorisms, violence, gender and the state,"[54] I have come to understand "the complex of emotions" associated with my initial encounter with her as an "expression of reassurance"[55] and "affective memory as an emotional attachment"[56] that translates a difficult era and spaces that she and I embodied in different ways, although marked by a profound desire to engage in self-knowledge, rethinking what signs of identity mean, and how to approach "thought as felt and feeling as thought."[57]

WORKS CITED

"Anthropology." Definition. http://www.americananthro.org/ August 28, 2018.

Aretxaga, Begoña. States of Terror. Begoña Aretxaga's Essays. Reno: Center for Basque Studies, 2005.

Bardestein, Carol. "Figures of Diasporic Cultural Production: Some Entries from the Palestinian Lexicon." In special volume of book series Thamyris/Intersecting: Place, Sex, and Race, eds. Marie-Aude Baronian, Stephan Besser, and Yolande Jansen. Amsterdam & New York: Rodopi Press, No.13, 2006.

54 James Brow, "Dear Friends of Bego, Dear Colleagues," in Letter sent on Sunday, January 5, 2003
55 Woodward, "Psychoanalysis, Feminism, Ageism," in Images of Aging, 81
56 Woodward, "Psychoanalysis, Feminism, Ageism," in Images of Aging, 81
57 Raymond Williams in Woodward, Statistical Panic, 12

Borda, Itxaro, 100% Basque. Translated by Bego Montorio. Dono-stia-San Sebastian: Meettok, 2012.

Brow, James. "Dear Friends of Bego, Dear Colleagues," in Letter sent on Sunday, January 5, 2003.

http://h-net.msu.edu/cgi-bin/logbrowse.pl?trx=vx&list=h-sae&month=0301&week=a&msg=Pzteg%2B6%2BpByT2E24T6MgHg&user=&pw=

Conway, Martin A. "Memory and Desire - Reading Freud," in The Psychologist 19(9): (548-

550) September 2006.

Derrida, Jacques. "How to Avoid Speaking: Denials," in Languages of the Unsayable. The Play of Negativity and Literary Theory. Edited by Sanford Budick and Wolfgang Iser. Palo Alto: Stanford University Press, 1987).

———. Of Spirit. Heidegger and the Question. Chicago & London: University of Chicago Press, 1989.

Glendinning, Simon. "Derrida and the Problem of Consciousness: What Would They Have Said About our Mind-Body Problem," in Consciousness and the Great Philosopher. Edited by Stephen Leach and James Tartaglia. Oxford: Routledge, Taylor and Francis Group, 2016.

Stanford Encyclopedia of Philosophy. "Jacques Derrida. Basic Argumentation and its Implications," November 22, 2019. https://plato.stanford.edu/entries/derrida/

Warren, K.B. "Critical Voices and Representational Strategies from Begoña Aretxaga's Ethnography on Northern Ireland," in

Aretxaga, Begoña. States of Terror. Begoña Aretxaga's Essays. Reno: Center for Basque Studies, 2005.

White, Rob. Freud's Memory: Psychoanalysis, Mourning, and the Foreign Body. London: Palgrave McMillan, 2008.

Williams, Raymond. Marxism and Literature. Oxford: Oxford University Press, 1977.

Woodward, Kathleen. "Psychoanalysis, Feminism, Ageism," in Images of Aging. Cultural Representations of Later Life, eds. Mike Featherston and Andrew Wernick. London & New York: Routledge, 1995.

————. Statistical Panic. Cultural Politics and the Poetics of the Emotions. Durham: Duke University Press, 2008.

Liminal Spaces: Motherhood, Emotion, and Memory in Works by Alja Rachmanowa

Xenia Srebrianski Harwell

U.S. Military Academy, West Point

Alja Rachmanowa (1898-1991), known primarily for her work Milchfrau in Ottakring (Milkmaid in Ottakring),[1] was a prolific Russian-Austrian writer of semi-autobiographic texts and biographies of famous Russian women. Her semi-autobiographic works, four of which will be discussed here, drew on the rich materials of her turbulent and peripatetic life.[2] She was born in Perm, Russia, into an upper-class family, but with the Russian Revolution and ensuing Civil War, she was forced to flee her home city. She spent several years in Siberia, living in extreme hardship. There she met and married Arnulf von Hoyer, an Austrian who had been a prisoner of war in Russia. Their child Alexander was born in 1922. In 1925, after a few quiet years during the NEP (New Economic Policy) period, the family was forced to leave the Soviet Union, returning to von Hoyer's homeland of Austria. They spent two years in Vienna while von Hoyer trained to become a teacher and Rachmanowa struggled to run a small milk shop in a working-class neighborhood of Vienna. Eventually they settled in Salzburg, where they slowly established themselves, working and raising their son. The

1 Alja Rachmanowa, Milchfrau in Ottakring (Salzburg-Wien: A. Pustet, 1933). All translations are mine.
2 Alja Rachmanowa is the pen name of Galina Djurjagina.

rise of National Socialism and the events of World War II thrust the family once again into a critical state, culminating in the death of their son, Alexander, then a German soldier, in April 1945, at the Russian front. Rachmanowa and her husband moved to Switzerland after World War II and spent their remaining years there. It should be noted that Alja Rachmanowa wrote only in Russian, and her husband translated all her works into German for publication.[3]

The four works I will discuss in this article parallel the lives of Rachmanowa and her family during their long odyssey. The first book, Jurka: Tagebuch einer Mutter (Jurka: Diary of a Mother),[4] is situated in Russia during the Russian Civil War, and reflects the period when Rachmanowa's child Alexander, nicknamed Jurka, was in his first year of life. In the second work, Jurka erlebt Wien (Jurka experiences Vienna),[5] the exiled family had moved to Vienna and was adjusting to life there. The third work, Einer von Vielen: Das Leben Jurkas (One of Many: The Life of Jurka),[6] consists of two volumes, Der Aufstieg (The Rise) and Das Ende (The End), both of which are situated in Salzburg. The first volume recounts the family's relatively stable and increasingly prosperous life in Salzburg during Jurka's school years. The second volume covers the years of World War II, when the adult Jurka is a German soldier at the front.

The author Alja Rachmanowa was by inclination a memory-keeper, in that she recorded her life's events in diary form throughout her life, even under the most arduous conditions. These diaries were the basis for her semi-autobiographical literary works but were not identical

3 Rachmanowa's works have not been published in Russia or in Russian.
4 Alja Rachmanowa, Jurka: Tagebuch einer Mutter (Salzburg-Leipzig: Otto Müller Verlag, 1938).
5 Alja Rachmanowa, Jurka erlebt Wien (Zürich: Rascher Verlag, 1951).
6 Alja Rachmanowa, Einer von Vielen: Das Leben Jurkas, Erster Band: Der Aufstieg, Zweiter Band: Das Ende (Zürich: Rascher Verlag, 1946).

to them.[7] In fact, one of Rachmanowa's actual diaries was published in 2015 and bears little resemblance to her literary works. The author reworked her personal diaries into literary texts, using traditional literary devices and shaping the narrative with specifically selected themes, events, and characters. Thus, the four works may be considered representative of the genre of autofiction—a mixture of autobiography and fiction—and in her case, presented within a diary structure.[8] As Melissa Bokovoy and M. Jane Slaughter point out, in narration "what gets told, and how, is influenced by subsequent imprisonment, exile, and social ostracism."[9] Rachmanowa's selection of themes, in addition to developing a narrative that describes the ways in which a single family deals with the vagaries of fate and cataclysmic historical events in the twentieth century, has an additional purpose. In speaking of memory, Bokovoy and Slaughter note that "different groups contest and struggle over memories and how the 'memory' will be represented in the public domain."[10] Nations such as the new Soviet Union, in forging their own origin story, forget that which and those who they do not want to remember. In this case, a nation would prefer to discard the stories of those it disposed of through exile. Rachmanowa's semi-autobiographical works push back against this, claiming their right to exist. In resisting obliteration through memory-writing of an alternate story, Rachmanowa contests the nation-building narrative of the new

7 Rachmanowa's personal diaries were not neatly curated notebooks, but often scribbles on whatever slips of paper were available to her during her years of poverty. Despite this challenge, she did demonstrate a singularity of purpose in her writing.

8 See Alja Rachmanowa, Auch im Schnee und Nebel ist Salzburg schön: Tagebücher 1942 bis 1945. Translated and edited by Heinrich Riggenbach (Salzburg-Wien: Otto Müller Verlag, 2015). Felix Weyh, in reviewing this diary, deems it as low-key and mundane, with a chronological rather than literary structure. See Florian Felix Weyh, "Russische Schriftstellerin/Die Entzauberung der Alja Rachmanowa," Deutschlandfunkkultur.de/ http://www.deutschlandfunkkultur.de/russische-schriftstellerin-die-entzauberung-der-alja.1270.de.html?dram:article_id=323080/ Beitrag vom 20.06.2015. Most recently accessed on 6 September 2018.

9 Bokovoy and Slaughter, "Memory," 1029. See Melissa Bokovoy and Jane M. Slaughter, "Memory, Gender, and War," Choice (February, 2001: 1023-1031).

10 Bokovoy and Slaughter, "Memory," 1024.

202 | LIMINAL SPACES: MOTHERHOOD, EMOTION, AND MEMORY

Soviet regime.[11] At the same time, through memory, the author remains connected to the homeland. In these works, memory (and writing) also ties the author to her new, adopted nation in terms of the universality of her experience of losing a son to war. In other words, the sacrifice of her son is a sacrifice of motherhood, binding her to other mothers, as well as to her adopted homeland, and therefore merging personal memory with collective memory.

Liminal spaces, both physical and mental, are remembered well by individuals because of their traumatic nature resulting from acute discontinuities in life. As Patrick Troy Zimmerman notes, liminal space "refers to an intermediate state or condition in which the liminal entity has characteristics of what it is between, but at the same time is separate and distinct from those characteristics."[12] The liminal space is a space "which is essentially ambiguous and is, by definition, temporary; a transitional space or space between fixed constants."[13] It is also a state that is "transformative in nature."[14] The periods and locations in which the works are situated are distinctly representative of stressful junctures in the lives of the protagonists: moments that are transitional (though not necessarily brief) in nature, when major historical events intersect with their personal lives. These transitional periods represent the liminal spaces in which the family is repeatedly entangled. They are highly charged with emotional and psychological suffering, coupled with physical deprivation and the lack of surety about the future, and—for

11 For an earlier discussion of this, see Harwell, Xenia Srebrianski. "Repositioning the Exiled Body: Alja Rachmanowa's Trilogy My Russian Diaries" in German Woman Writers and the Spatial Turn. New Perspectives, edited by Carola Daffner and Beth Muellner (Berlin: DeGruyter Press, 2015, 101-120).
12 Zimmerman, "Liminal," 5. See Zimmerman, Patrick Troy. "Liminal Space in Architecture: Threshold and Transition." Master's Thesis (Knoxville: University of Tennessee, 2008). https://trace.tennessee.eduutk_gradthes/453
13 Zimmerman, "Liminal," 5.
14 Zimmerman, "Liminal," 6.

the mother—lack of control over the fate of the child.[15] Thus, the four works highlight the ways in which the mother/narrator negotiates motherhood through liminal space. All four works are written from the point of view of the mother, who focuses her gaze on her child. Moreover, even though the stated purpose of the works is to follow the child's development (which they do), they simultaneously highlight and amplify the convergence of stresses placed on the mother and, more universally, on mothering. Within the literary diaries, a discourse on writing and creativity is also at play, focusing on their function as a means of both memory retrieval and memory creation. In the introduction to Jurka: Tagebuch einer Mutter, the author notes that her son is now seventeen and that she derives great satisfaction from reading her old notes, which trace his development during his first year of life, and from recalling her own first year of motherhood. In this way, from the outset, Rachmanowa introduces and links motherhood, memory, and writing.

Jurka: Tagebuch einer Mutter describes Jurka's first year of life, when the family lives a life of subsistence and great deprivation in Siberia during the mid-1920s. The title of the work plays with the reader's expectation that the work will be the diary of the boy but flips our expectations with the subtitle of the work, which deems it the diary of a mother. By linking her son's name with the subtitle, the author suggests both the intimate link between mother and child as well as the fact that the narrative focus is directed not only at the child, but at the mother as well—and perhaps primarily at the mother, as the "mother-as-subject."[16] As Donna Bassin, Margaret Honey, and Meryle Mahrer

15 The narrator addresses this in Einer von vielen, Vol. 1 Das Ende (203) in comparing Jurka's struggle for life as an infant, when she could intervene to save his life, and Jurka as a soldier, when she is powerless to protect him.
16 The concept of the mother-as-subject is explored in Donna Bassin, Margaret Honey and Meryle Mahrer Kaplan, "Introduction" in Representations of Motherhood, edited by Donna,

Kaplan argue, looking at the mother as the subject involves viewing her as an individual with "her own needs, feelings, and interests," which is necessary in fighting the "devaluation of women."[17] While the needs of the woman is most definitely a theme in Rachmanowa's works, all roles are represented as subservient to that of motherhood. Motherhood is both traditional and idealized. In Jurka: Tagebuch einer Mutter, the narrator states:

Mein ganzes Leben habe ich mich danach geseht, Mutter zu werden. Als ich noch ein ganz kleines Ding war, gab es keine größere Freude für mich, als irgendein Kind, das noch kleiner war als ich, in meinen Armen halten zu dürfen. Und als ich dann älter wurde, kam es [...] vor, dass ich auf ein Picknick verzichtete, wenn man mir nur gestattete, bei meinen kleinen Vettern und Basen zu bleiben, ihnen ein Wiegenlied zu singen und sie schlafen zu legen. Wenn sie dann einschlummerten, während ich ihnen ein selbst ausgedachtes Märchen erzählte, dann glaubte ich, ich hätte den Gipfelpunkt jenes Glückes erreicht, das eine Frau überhaupt erreichen kann. (Jurka: Tagebuch einer Mutter, 42-3)

All my life, I have longed to be a mother. When I was still a tiny thing, there was no greater joy for me than to hold a child [...] in my arms. When I was older, I would give up a ballet, a theater show, or a picnic if I were promised that I could stay with my little cousins, sing them a lullaby, and put them to bed. When

Bassin, Margaret Honey, and Meryle Mahrer Kaplan, (New Haven: Yale University Press, 1994), 1-24.
17 Bassin, Honey, and Kaplan, "Introduction," 2.

they fell asleep as I told them a fairy tale I had made up, I thought
I had reached the peak of happiness that a woman can reach.

The narrator sees motherhood as the highest and most noble
calling a woman can expect, one that brings a happiness that supersedes
all the struggles, sacrifices, and traumas of life. To this end, she begins
her story with a flashback to her experience of giving birth. The birth
coincides with a time when Russian society was transitioning to the
Soviet way of life, and in Rachmanowa's view, was traumatic in nature—
impersonal, painful, and dangerous. The narrator's pleas to the midwife
that she was about to give birth were ignored, and she gave birth alone
in an icy-cold room of a maternity hospital, and almost died. This
birth scene is lifted verbatim from another of Rachmanowa's books,[18]
possibly to underscore its importance as a starting point for the liminal
experience of motherhood in a continually threatening and dangerous
transitional space.

The danger that was heralded at Jurka's birth continues for the
narrator and her child during the first year of Jurka's life. The demands
placed on the mother during this harsh period places mothering at the
forefront of her existence, and the narrator's efforts to keep her family
alive are presented as a strength of motherhood. Just as the narrator
tolerated and survived the maternity hospital as a new mother, she
continues to tolerate and accept everything in her life for the sake of
her child—bed bugs, sharing a room with other families, and the lack
of baby supplies and basic clothing. Considering her child to be a
blessing, even in the most difficult circumstances, she thinks to herself:

18 See my discussion of this scene in Harwell, Xenia Srebrianski, "Repositioning the Exiled
Body," 101-120.

Danke deinem Schöpfer dafür, daß er dir die Aufgabe auf deine Schultern gelegt hat, dieses junge Wesen aufzuziehen und zur Blüte zu bringen. Und um so wunderbarer muß mir diese Aufgabe erscheinen, als rings um mich her alles zerfällt, als ich nichts als magere, hungrige, blasse Menschen sehe, zu denen ich doch auch selbst gehöre. Auch ich werde von Tag zu Tag blasser und magerer, und dennoch hinder mich dies nicht, das Leben trotz allem wunderschön zu finden, denn ich weiß, daß ich meinem Kinde helfe zu leben [...]. (Jurka:Tagebuch einer Mutter, 63)

Thank your Creator, that he has laid this task upon your shoulders, to raise this little creature and to make him blossom. This task appears all the more wonderous to me when everything around me is falling apart, and I see nothing except thin, hungry, pale people, of whom I too am one. With each passing day I am getting thinner and paler, but in spite of everything this does not hinder me in finding life to be wonderful, because I am helping my child to live [...].

As the family's suffering accelerates, the mother is put to an even greater test when she faces the prospect of starvation for both herself and her child. The basic impulse to survive drives the mother's motivation when she loses her ability to produce breastmilk, and poor nutrition followed by near-starvation take their toll on both her and the baby. She views this as a twofold catastrophe. On the one hand, she feels that the emotional mother-child bond has been irretrievably severed and mourns its loss. On the other hand, she is in distress because she does not know where she will be able to find food that a seven-month-old

Jurka will be able to eat. Although the narrator feels despair, she does not succumb to it. She innately believes that she gains strength, though weak herself, by separating herself psychologically from the devastation in the world, and that by doing so, she is able to keep her child healthy. She struggles to accomplish this.

One day, during the narrator's daily search for food, she notices a starving woman standing on a hill, holding a child. This mother begs for food. When she is given a small potato, she feeds it to her child, although she herself is obviously also starving. The narrator reads in the mother's face the fierce desire for the child's survival and recognizes this same tenacity in herself. This elicits a sense of the universality of motherhood in the narrator. Moving beyond her own personal experience, she reflects on the common bond among women in their selfless efforts for their children. The liminal space of deprivation, then, highlights the shared experience of mothers. The narrator also notes another phenomenon at play in the mother-child relationship. True for her, as well as for other mothers, is the reciprocal interaction with the child, which she sees as potentiating the desire for survival: while a mother wants above all for her child to live, the fact that the child is alive gives the mother herself the determination to go on living in order to further protect her child. Moreover, as concerns memory, the narrator contrasts herself as the bearer of memories with her child, who is oblivious to the outside world and will not remember the struggle.

The description of the family's confinement within the small, enclosed space that is their living quarters, focuses on the window, which is the physical barrier between the inside and the outside. On the one hand, the inside is a safe place for Jurka to enjoy his daily activities of baby discoveries. On the other, it is the structure that beckons them

to the outside, into nature, when they do not own the clothes that would enable them to spend time outdoors. Here, as in other works, the author foregrounds the beneficial and life-giving benefits of nature, and nature counters the brutalities of daily life. One day, when the narrator is very ill, her husband brings her roses. Her first reaction is to wonder who would grow roses in a time of hunger. At the same time, she is mesmerized by the flowers and gains strength simply through their presence, in that she understands them to symbolize life, hope, and renewal. Moreover, seeing her child holding the roses causes the narrator to contemplate the promise of a normal life, i.e., a space beyond the liminal.

Ultimately, the narrator's idea of motherhood is severely tested in this work. But despite everything, at the end of the year of suffering, she confirms her devotion to the role as mother:

Es ist nun schon bald ein Jahr, daß ich meinen Jurka habe, und noch immer kann ich dieses Glück nicht ganz fassen. Es gibt keine größere Freude in meinem Leben, als neben ihm zu sitzen, für ihn zu sorgen, ihn zu beobachten, und vor allem, ihn lieb zu haben! Jedes Lächeln, jede Bewegung ist mir ein Teil meines eigenen Lebens [...]. (Jurka: Tagebuch einer Mutter, 379)

It is almost a year now that I have my Jurka, and I still cannot fathom this happiness. There is no greater joy in my life than to sit next to him, to take care of him, to observe him, and above all, to love him! Each smile, each movement is a part of my own life [...].

Despite the narrator's paean to motherhood, her actual position as mother and woman is more complex. Although she does inscribe herself in the traditional role of motherhood, the narrator does not do this to the exclusion of other roles. While caring for her child, she also simultaneously observes and writes when she is able—functions that are necessary to her own well-being. This is true not only in this work but in the subsequent works as well. In fact, these functions take on ever greater importance as the narrator's life progresses through the novels that follow.

The next book in the series, Jurka erlebt Wien, recounts the period from late December 1925 to the summer of 1927. The family is now in Vienna, having left the Soviet Union against their will. Their circumstances are still difficult. As in Russia, the family inhabits confining living quarters and longs for, but never has the opportunity, to access fresh air, sunlight, and a space where they can enjoy the natural world. In contrast to the first book, Jurka is now old enough to be aware of the family's situation, and to consciously share in their suffering. The work revolves around three primary themes that are in continual interplay with one another and point to the family's ongoing presence within a liminal space. These themes include Jurka's memory of Russia, his attempts to fit in within his new milieu, and his creation of an alternate universe.

Jurka erlebt Wien portrays Jurka as an extremely precocious child in intellect, creativity, and memory. The latter plays an important role in the work on several levels, particularly when it strains the credulity of the reader that such a young child can have such a prodigious memory, make certain pronouncements, and hold seemingly adult opinions of events based on this memory. To minimize the reader's suspicion that

the boy is the mouthpiece for his mother and that he could not possibly retain distinct memories of the Soviet Union for one and a half years when he departed at the age of three and a half, the author employs the technique of having the narrating mother herself feign surprise at the longevity of her child's memories.

Nevertheless, realistically speaking, some memories appear to be more plausible than others for a young child. Among those that stretch the reader's sense of the possible are the memories that are supposedly the basis for Jurka's criticism of the new Soviet regime. For example, Jurka tells his mother that since he was ejected from Russia as a child, he plans to write a letter to the GPU (State Political Directorate and secret police) to ask why, saying his goal is to shame the GPU men for having exiled a child. At another time, Jurka sketches a map of Europe and informs his mother that he has drawn a very tiny Russia because he is angry at it for expelling them. In a similar vein, but not overtly political, Jurka expresses ideas and emotions that appear to more readily mimic the experience of his mother rather than his own experience. Thus, when early in the diary, Jurka asks his mother, "Why can't people live where they choose?" the reader understands this question to be primarily rhetorical, expressing longing for the homeland, on the part of both mother and child. The narrator states that she cannot answer this question, leaving it simply a reflection of the disbelief and grief that the family can never return to Russia.

Memory is a prominent leitmotif in this work, as Jurka and his family try to deal with their memories of the past and make a place for themselves in their new home city. Michael Kammen suggests that "memory is, by definition, a term which directs our attention not to the past, but to the past-present relation. It is because 'the past' has this

living active existence in the present, that it matters so much [...]."[19] While this is true during all types of transitions, for those in exile it is particularly true as they adapt their past identity to the present. One example of this, tied to the notion of outsider versus insider, occurs when Jurka tells his parents that he has come to understand the concept of worthlessness:

> Das ist sehr unangenehm, wenn man 'nix wert' ist! In Rußland habe ich Wert gehabt, und jetzt habe ich ihn verloren! Warum? Ist das, weil wir das nicht haben, was die andern habend? (Jurka erlebt Wien, 35)

> It is very uncomfortable, when one is 'worth nothing'! In Russia I had value, and now I have lost it. Why? Is it because we do not have what the other people have?

The local boys regularly confirm Jurka's outsider status, as when one of them tells Jurka that if the family does not own a radio, it does not have a right to live in Vienna. Jurka tells his parents that the three of them are strangers in Vienna and that no one loves them there.

However, Jurka takes the initiative to fit in, and he not only survives, but eventually even thrives, within the community of Viennese street urchins. He does this by adapting himself to them. He learns street lingo in Viennese dialect. He masters properly intoned aggressive slang, accompanied by appropriately tough body language. He learns

19 Kammen, Mystic, 6. See Michael Kammen, Mystic Chords. The Transformation of Tradition in American Culture (New York: Vintage, 1991).

to fight and misbehave.[20] He learns to speak confidently about subjects that would normally be taboo at home, such as drunkenness, wife beatings, bullying, and theft—all subjects that Jurka's parents would normally have shielded him from, but which he now hears about from his young companions.

Language is one of the hallmarks of the liminal space, to the extent that identity is bound up with language. In the liminal space of exile, not only identity, but language as well, must be reconstituted, which may be a difficult and painful process, and one of long duration. For those in exile, language is a marker of both belonging and non-belonging. Through his mother tongue, Jurka still belongs to Russia, and his mother tongue is, importantly, also a vehicle for memory. Language is also a marker of difference, as it is in Vienna. Jurka recognizes that his knowledge of a second language, Russian, sets him apart, and he is also disturbed that the other boys demonstrate no interest in the process of language learning. "Das ist mein Kreuz, dass die Kinder hier sich für gar keine Sprachen interessieren,"[21] ["It is the cross I must bear, that the children here are not interested in any languages"] he comments.

While Jurka wishes to fit in, he also does not want to be completely subsumed by the culture of the street boys. Just as he uses language to be inside the group, he simultaneously employs it to demonstrate difference. Listening to the language of customers at the milk shop, he absorbs language quickly and learns to interweave "high" and "low" culture as manifested in language use. He is proud that he can read and write in two languages. With great facility, he works across the two languages he knows as he applies the principles of word creation and

20 Before misbehaving, he patiently explains to his parents why he must do this and apologizes in advance.

21 Rachmanowa, Jurka erlebt Wien, 113. In the utopian world Jurka later creates, all of the inhabitants speak many languages.

formation in Russian to construct words in German. In almost ritualistic fashion, he compiles his own German-Russian dictionary, an act which is perhaps meant to symbolize his process of merging the two cultures. Jurka's use of language, both Russian and German, demonstrates how he straddles the two worlds he inhabits, continuing to hold on to the old world through Russian, and embracing the new through German. As Judith M. Melton states:

> For exile autobiographers in particular, a life in a new language redefines the dislocated self, for the process of integrating into a new language and culture is time-consuming and overwhelmingly psychically uprooting. [...] Revealing a reconstructed identity in language, particularly if it is a new language, throws a psychological light on the theoretical supposition of the self as an 'intersection of discourses.'[22]

It appears that Jurka is at the intersection of just such a discourse.

The fact that the process of integration is incomplete and ongoing is manifested in the imaginary world Jurka creates for himself.[23] This world encompasses an alternate space and reality to which Jurka retreats regularly in his imagination. It is an outlet for his creativity through drawing and storytelling, and it sheds light on the things that Jurka feels are missing from his life in Vienna. As Philip W. Porter and Fred E. Lukermann point out, "much utopian literature reflects a deep sense of loss. We have been driven from the Garden and long to return. [...]

22 Melton, Face, 182. See Judith M. Melton, The Face of Exile: Autobiographical Journeys (Iowa City: University of Iowa Press, 1998).
23 The creative escape is a major way in which Jurka, like his mother, copes with exile. Jurka equates his need to draw with his mother's need to write, and he tells her that his soul is lost when he cannot draw.

Second, much modern utopian writing looks toward the realization of a better world."[24] Jurka's world, which he calls Küchleinland, or the Land of the Chicks, fulfills both of these criteria for a utopia. It is worth noting that there may be a reason why his utopia is inhabited specifically by chicks. Jurka's nickname for his mother is "Kura," which means 'chicken,' or 'hen,' and he refers to himself as "chick." It would not be a stretch to see that for Jurka, his mother's qualities and the qualities of his utopia are related.

Jurka's utopia incorporates positive aspects of both the Russian past and the Austrian present. Most importantly, it is a place where things are done right—better than they are done in Vienna or were done in Russia. Things are better in Küchleinland than in the Soviet Union because the family was expelled from there, for example, and better than in Austria, where the local people want to trick them, and kids steal his things. Küchleinland offers chicks the things that Jurka would like to have: access to free food and free transportation,[25] the freedom to be left-handed,[26] a bathroom in the apartment and the possibility of daily baths, and two pairs of shoes. Chicks also receive more sweets at Christmas, and an abundance of eggs.[27] Chicks are allowed to go to school from birth, they like to learn, and they like fresh air and lots of commotion.[28] In addition to abundance, the inhabitants of Küchleinland are ideal, as are their social structures and cultural practices. Chicks like to help each other, for example. They see what

24 Porter and Lukermann, "Geography," 199. See Philip W. Porter, and Fred E. Lukermann, "The Geography of Utopia," in Geographies of the Mind: Essays in Historical Geosophy (New York: Oxford UP, 1976), 197-223.
25 When they finally buy a little heater for their cold apartment, Jurka remarks that it is just like the one in Küchleinland.
26 During the 1920s and 1930s in Europe, children were generally discouraged from writing with their left hand, and often forced in school to use their right.
27 It is a costly rarity for Jurka to eat an egg at this time.
28 Jurka had expressed the desire to attend school and was told by his parents that he was too young to go to school. He transfers a feature of his own personality—his love of learning and commotion—to the chicks.

another chick needs and drop it on the ground for the needy chick to pick up. Best of all, when someone dies in Küchleinland, he or she is taken to the cemetery, and then brought back alive. Finally, in his construction of his chick nation, Jurka sees all chicks as soldiers who fight the Bolsheviks. Aware of the danger of the new regime, he says that if he ever travels to Küchleinland, he will use a pseudonym on his passport and visa to ensure that the GPU does not kill the chicks.

Playing with the idea of national belonging, one day Jurka tells his parents that he has now wholly rejected Russia since it rejected him, and that he is considering whether to direct his allegiance toward Austria or Küchleinland. This remains an open question for him for a long time. Prior to this, Jurka's memories of Russia were at the forefront and his homesickness was clear. He missed the people and things left behind. What he recalled were his toys and pets, the airy rooms of their house, delicious food, and the lovely fragrances of their garden. Most of all, however, Jurka remembers his grandparents. He equated them with home and feels that Vienna would be more like home if they were there. In his strong attachment to his grandparents, he dreams of them and is eager to go to sleep each night in order to dream of them again.

As time goes on, Jurka's ever-changing renditions of Küchleinland begin to incorporate more and more positive aspects of Austria—fresh air, heat, an artist population, and sidewalks like the Mariahilfer Strasse.[29] One might presuppose that Jurka has worked through his memories of Russia and his struggles with the liminal milieu and has accepted his new homeland and identity. However, this turns out not to be the case. One day, Jurka erupts in bitter crying when he suddenly realizes,

29 Mariahilfer Strasse is a main shopping street in Vienna.

for the first time, that he will never again see his grandparents, nor his old home and animals:

> Jurka hörte gespannt zu, dann schluchzte er plötzlich auf und sagte, während ihm die Tränen in Bächen aus den Augen stürzten: 'Dürfen wir nie mehr in unsere Stadt fahren? Niemals mehr? Und werden wir den Großvater and die Großmutter niemals mehr sehen? Und unsere Zimmer? Und unsere Betten? Und Tomka wird sich sicher sehr nach mir sehnen, und Wassjka auch!' (Jurka erlebt Wien, 228-9)

> Jurka listened intently, then suddenly broke out in sobs, and said, with tears streaming from his eyes like a brook: 'We are not allowed to travel back to our city? Never again? And we will never see Grandfather and Grandmother again? And our rooms? And our beds? And Tomka will certainly long for me, and Wassjka too.'[30]

This is a crisis moment in Jurka's maturation—his move away from the fantasy world of Küchleinland to the reality of exile and to the fact that his is a one-way journey. His gesture of holding fast to an old envelope sent long ago from Russia by his grandfather to him materializes the notion of holding on to memory. It also demonstrates that the tensions of identity and memory, and thereby of the liminal space, remain unresolved as this work concludes.

Jurka's Küchleinland is a simulation of his ideal place. He characterizes the country according to the values he believes in, creating

30 Tomka and Wassjka were his dog and cat respectively.

what Henri Lefebvre would refer to as a meaningful social space,[31] or what Yi-Fu Tuan would call "place," i.e., a space with value.[32] As Tuan theorizes, place is a common social space where people interact.[33] This type of social caring is manifest in the social treatment of the chicks for each other.

During the time period covered in Jurka erlebt Wien, the longed-for utopia is not achieved. However, during the next stage of their lives, some of the conditions for a utopia, as expressed in Jurka's Küchleinland, are actually achieved. In Einer von vielen, the family now lives in Salzburg, and the two volumes that comprise the work follow the rising and falling fortunes of the family. In volume one, Der Aufstieg, the narrator and her son both exit the liminal space for a time and gain respite from its trauma, as there is an eventual upward spiral of happiness and contentment for the family. The city of Salzburg is magical, nature is readily accessible, and the father has a steady job as a teacher. The successes of the narrator's writing career and of Jurka's intellectual achievements are at the forefront of this work. In addition, the narrator continues to engage in her role as mother. She states:

> Daß ich es mit erlebe und mit daran arbeiten darf, wie Jurka zu einem Menschen wird, das erscheint mir manchmal als das Größte in meinem Leben, und ich danke Gott jeden Tag dafür, daß er mir dieses Wunder geschenkt hat. (Der Aufstieg, 62)

31 Cresswell, Place, 12. See Tim Cresswell, Place: An Introduction. (London: Blackwell Publishing, 2004).
32 Cresswell, Place, 8.
33 Cresswell, Place, 20.

Sometimes I feel that the greatest thing in my life is that I can
share in and work together on how Jurka develops into a person,
and I thank God every day for the fact that he has bestowed this
miracle upon me.

The narrator is also pleased to see Jurka become completely
integrated into school, both socially and academically. In addition to
the obvious importance that this has for her son, it is important to her
as well:

Das Heimweh, das mich so oft fast zur Verzweiflung getrieben
hat, verliert nach und nach seine unerträgliche Gestalt, und mit
jeder der tausend Wurzeln und Würzelchen, mit denen mein
Kind in Salzburg, das nun zu seiner Heimat geworden ist, täglich
und stündlich fester Bodon faßt, wird auch für mich Österrich
langsam, aber sicher das Land, in dem ich mich zu Hause fühle.
Ich weiß es, daß ich meine erste Heimat nie werde vergessen
können; aber ich bin glücklich, daß ich nun, das ich sie verloren
habe, in der Heimat meines Mannes und meines Kindes eine
zweite Heimat finden kann. (Der Aufstieg, 62)

The homesickness that so often pushed me to despair is gradually
losing its unbearable shape, and with each of the thousand roots
and rootlets with which my child becomes more at home in
Salzburg, which has now become his homeland, Austria is slowly
but surely becoming the country in which I feel at home. I know
that I will never be able to forget my first homeland, but I am

happy that now that I have lost it, I can find a second home in the homeland of my husband and son.

A sign of their full incorporation into Salzburg as their home is their purchase of a house, a singularly important event in the arc of their lives, symbolizing homeland and belonging. The house signifies the pinnacle of their successful, reclaimed, normal life—comfortable, peaceful, friendly, and most importantly, a life in harmony with the outside world of Salzburg. The narrator describes in great detail the peaceful routine of their daily lives, illustrating its importance by devoting an entire chapter to the description of the house and how they live in it. She focuses especially on Jurka's room and his new life in that room with friends and pets. Peter Blickle, in his discussion of the notion of homeland (Heimat) in Germany, states that "Heimat is constructed not outside of, but around, bourgeois ideals of family, class, gender roles, history, and politics."[34] The narrator's descriptions of the family's life and home clearly transmit a comfortable, bourgeois sense of well-being and of being "at ease"[35] in their environment, both in the house and within the community.

Helping the narrator find her place in the new homeland are the advances she makes in her writing career. No longer focused on sheer survival, the narrator can now explore the significance of writing in her life, and her commitment to it. She reflects that the process of writing is a vehicle for accessing the past and reconstituting old memories.

34 Blickle, Heimat, 20. See Peter Blickle, Heimat: A Critical Theory of the German Idea of Homeland (New York: Camden House, 2002).

35 Blickle states that "Heimat provides on a social level that which a self at ease with itself is supposed to provide on a personal level" (77). I would argue that for the narrator, homeland provides the sense of ease on both social and personal levels.

Upon receiving a book contract to write her second book, the narrator thinks:

> Ich stelle mir währenddem schon vor, wie ich wieder meine Tagebücher zur Hand nehme, wie die Vergangenheit langsam vor meinen Augen neu ersteht, mit ihr die Menschen wieder
>
> lebendig werden, die um mich herum und mit mir gelitten und sich gefreut haben, und wie ich immer wieder in den Menschen das Gute gesucht—und gefunden habe. Während wir heimgehen, befinde ich mich schon mehr in der versunkenen Welt des Gestern als in der Wirklichkeit des Heute. (Der Aufstieg, 167)

> Meanwhile, I imagine how I once again place my diaries in my hand, how the past comes to life again before my eyes, and with it, how the people begin to live again, those people who surrounded me and who suffered and rejoiced with me, and how I have always sought the
>
> good in people and have found it. As we go home, I find myself more in the world of yesterday, which has disappeared, than in the reality of today.

As the narrator relates in this volume, she does not reach the decision to write easily, concerned about revealing to the public the innermost recesses of her life and emotions. Ultimately, she reconciles her inner conflict by embracing writing as a means of helping others—in particular, women. This mission bears fruit as fans shower her with letters or visit her, seeking advice. She earnestly responds to all requests,

creating a circle of women around her and helping them deal with issues that women face on a daily basis.[36] Later, in the second volume of Einer von vielen, Das Ende, the narrator takes her role to another level, devoting an entire chapter to the common suffering of mothers left at home while their sons and husbands are at war.

In the end, the idyllic life that the narrator feels the family finally has earned comes to an abrupt end, and the narrator is unceremoniously and suddenly cast back into the liminal space of uncertainty, fear, loss of identity, and the historical events soon to come. This occurs in the late 1930s, when the narrator is on a book tour in Germany. She senses that something is wrong, and eventually learns that the Nazis have deemed her books "undesirable," and that her tour venues have been warned about this. She also understands that the small number of people who nevertheless come to her readings and who stand and applaud, are there as much to quietly demonstrate against the regime as to honor her. Filled with anxiety and disbelief, she rushes home.[37] David Seamon argues that home is the private place where people "can withdraw from the hustle of the world outside and have some degree of control over what happens within a limited space."[38] It is evident that the narrator feels that home is the only place where she can experience a sense of control within this new, developing liminal configuration. Despite seeking refuge at home, however, the narrator is overcome by the unexpected realization that part of her idyllic and normal life—her writing life, and therefore in part, her identity—has been negated. Moreover, she feels she may be in danger because she realizes that as a writer, she is visible to the authorities. In response to these emotions,

36 It should be noted that the author Alja Rachmanowa studied psychology in Russia.
37 The representation in Einer von vielen of the growing presence of National Socialism in the lives of the people of Salzburg, is a subject that, though beyond the scope of this paper, demands further research.
38 Creswell, Place, 24.

too difficult to bear, she retreats into illness and unconsciousness. This is not resolved in her mind until she realizes that although writing is important, Jurka is the most important thing to her. Thus, again, motherhood is her salvation, as it was when Jurka was an infant, and the narrator confirms the ascendancy of her role as mother.

The second volume of Einer von vielen, Das Ende, begins with a memory from the narrator's childhood. The narrator recalls a scene in which she and other children sit at a lake, launching paper ships into quiet waters:

> Aber diese Ruhe war nur eine scheinbare, und wir wußten, was dahintersteckte. Wir machten kleine Schifflein aus Papier und setzten sie durch den Zaun hindurch auf das Wasser. Langsam, ganz langsam bewegten sie sich diesem Orte zu, dann trieben sie schneller und immer schneller vorwärts, bis die sich mit einem Male wild um ihre eigene Achse drehte und dann, mit dem Schnabel nach vorne, in der Tiefe verschwanden. [...] Es faszinierte uns und erregte in uns gleichzeitig ein Gefühl des Unheimlichen, des Grauens. (Das Ende, 1)

> But this calm was only an appearance, and we knew what lay underneath. We made little ships out of paper and put them in the water, reaching through the fence. Slowly, very slowly the ships made their way to this spot. Then they sailed forward faster and faster, until all at once they started turning on their axis, and then, bow-first, disappeared into the deep. This fascinated us and at the same time gave us a feeling of the uncanny, a sense of horror.

Thus, the last book in the series that is being discussed here begins with a foreshadowing of the terrible events to come. The calm waters that represent the family's quiet life in Der Aufstieg were only the lull before the storm. The image of the vortex, in contrast, foreshadows the events that initiate the family's descent into a new and more dangerous liminal space. Despite the fact that friends give the narrator advice to go underground to protect herself, she chooses to remain in Salzburg and in her house. With her new status as forbidden writer, and as the Nazis begin their takeover of Austria and Salzburg, the once-harmonious landscape becomes hostile. The narrator's house as the only place of refuge suggests that now the meaning of 'homeland' has shrunk from the country of Austria and the city of Salzburg to just the house itself.

In Das Ende, the house becomes emblematic as the site of refuge for Jurka as well, as a place to which to retreat from war. During each of the four times he comes home on leave, Jurka embraces the homecoming and the experience of being in the house and in his room. Each time her son returns, the narrator is able to relax and to find respite from her perpetual anxiety about Jurka's safety. Immersing herself in the familiar traditional functions of motherhood, such as cooking and ironing for her child, the narrator feels a temporary peace through the process of mothering. In doing this, she is possibly re-enacting the idea of homeland. As Blickle states, "Heimat is often associated with innocence and childhood, a state usually linked to a mother figure. Notions of an idealized mother and an idealized feminine are constitutive in expressions of Heimat."[39]

39 Blickle, Heimat, 17.

In this last book, the house takes on the additional meaning of site of memory. Jurka reminisces about the past whenever he is home from the front. During frightening bombing raids, the narrator remembers the quiet, peaceful life with her son as a child. Her thoughts turn to memories of her own childhood as well, as she recalls Christmases in Russia at her father's and grandfather's houses, and then in Vienna, and in Salzburg—a long chain of remembered safe and cozy family nests, like their Salzburg house was before the war.

Ultimately, however, the narrator realizes that the house cannot truly be a refuge from reality. During one of Jurka's visits home from the front, she states her awareness of how things really are:

> Jurka und Omar und ich mit ihm, haben uns jetzt mitten im Krieg, mitten unter Tod und Verderben, ein Luftschloß gebaut und wohnen darin, als ob es ein wirkliches Haus mit festgefügten Fundamenten wäre. Und doch, ich danke Gott, daß er uns wenigstens die Möglichkeit einer solchen seligen Täuschung gegeben hat! Wir wollen sie genießen, bis zum letzten auskosten [...]. (Das Ende, 218)

> In the midst of war, amid death and destruction, Jurka, Omar, and I have built ourselves a castle of air and we live in it as if it were a real house with a firm foundation. And yet, thank God, that he at least gave us the opportunity for such a blessed illusion! We want to enjoy it, to savor it to the last drop [...].

The narrator knows that the dream world she speaks of is intangible, easily dissipated, and only a temporary reprieve from fate. When Jurka is away at war, memory is the narrator's coping mechanism. The tactile pleasure of holding Jurka's toys and childhood notebooks often initiate her memories, reconnecting her to Jurka's childhood self. She remembers Jurka's construction of Küchleinland and poignantly recalls that Jurka once told her that in Küchleinland there were no wars. She remembers that as a child Jurka called her "Hen" and himself "Chick," signifying the close and protective mother-child relationship. Her memory reaches back further, to Russia, as she recalls a Russian saying, that "a mother's prayer keeps her son safe,"[40] and a poem that she recited as a child of ten, which included the lines that a mother's true tear and nothing else is all that remains of a son's death.[41]

In this last book, as the denouement—Jurka's death—approaches, death imagery, nature imagery, and the theme of beauty converge, and are represented in both the present time of the narrative, as well as in memory. The narrator remembers writing a poem as a child, in response to the drowning of a little boy. At that time, she wrote: "Rose, wundervolle Rose, du blühst, Und der arme Waβja starb. Warum?"[42] [Rose, wonderous rose, you are blooming, and poor Wasja died. Why?] The question the narrator poses as a child, juxtaposing death and the continuing beauty of nature, is relevant in the present. Whenever Jurka returns from the front, he notices anew the beauty of Salzburg. When he leaves for the last time, the narrator notes that birds are chirping. When spring comes in 1945, the narrator feels nature coming back to life but senses with foreboding the coming of Jurka's death. When Jurka is away, she looks up at the night sky, recognizing its beauty and

40 Rachmanowa, Das Ende, 359.
41 Rachmanowa, Das Ende, 210-11.
42 Rachmanowa, Das Ende, 132.

stillness, but when—in her mind's eye—her gaze moves downward to the earth, she sees a battlefield. Finally, bringing the imagery of death and nature full circle, after Jurka has died, she thinks of him lying on a battlefield that is blooming with flowers and teeming with the life of small creatures.

This volume in particular reflects its title of Einer von vielen.[43] Jurka is one of many who became soldiers and died. His final farewell is emblematic of all the farewells endured universally by parents of soldiers at war. The narrator speaks of the uniqueness of the final farewell as compared to those that came before: "es ist so ganz anders heute, es ist als ob sich in dieser einen Minute das Leid, die Tragik der ganzen Menschheit in diesem Raume zusammengeballt hätte."[44] [It is so totally different today; it is as if in this single minute, the pain and tragedy of all mankind had concentrated itself in this room.]

In the end, the narrator weaves together the themes of loss, war, emotion, motherhood, and memory in one simple gesture. A soldier who had fought side by side with Jurka comes to see the narrator and her husband to tell them about Jurka's last hours. To thank him for his visit, the narrator presents him with a copy of her book Jurka erlebt Wien, which, she recalls, she once wrote "with so much love and so much hope," and which she now inscribes "in the most beautiful handwriting [she] is capable of 'in memory of Jurka.'"[45]

43 Rachmanowa's two volumes that treat the Nazi period could be said to belong to the category of works that view Austria as a victim of Nazi Germany. For a discussion of this category of works, see Jacqueline Vansant, "Challenging Austria's Victim Status: National Socialism and Austrian Personal Narratives," The German Quarterly, Vol. 67:1, Modern Austrian and (Erstwhile) GDR Literature (Winter, 1994), 38-57. For a discussion of Alja Rachmanowa's relationship to the Nazi regime, see Heinrich Riggenbach, "Nachwort," in Alja Rachmanowa, Auch im Schnee und Nebel ist Salzburg schön: Tagebücher 1942 bis 1945. Translated and edited by Heinrich Riggenbach (Salzburg-Wien: Otto Müller Verlag, 2015), 271-300.
44 Rachmanowa, Das Ende, 333.
45 Rachmanowa, Das Ende, 373. This gesture is also significant in that it conflates the narrator and the author.

Two of the four works I have discussed here have what I would term companion pieces. These encompass the same periods but focus more on the mother and less on the mother-child relationship. Jurka's birth and babyhood are treated briefly in the first two volumes of the trilogy Meine russischen Tagebücher.[46] The third volume in the trilogy, Milchfrau in Ottakring—which focuses on the mother's efforts to create the milk shop in Vienna, to begin her writing career, and to overcome the challenges of exile—can be considered a parallel text to Jurka erlebt Wien.[47] The fact that author Alja Rachmanowa chose to rework the materials of her diaries not once, but twice, from different points of view, underscores the truly catastrophic impact on her of the events she experienced. It appears from her works that the liminal period, although supposedly transitional in nature, can actually be of long duration, possibly lasting a lifetime, and that memory must be relied on to provide relief.

WORKS CITED

Bassin, Donna, Margaret Honey and Meryle Mahrer Kaplan, "Introduction." In Representations of Motherhood, edited by Donna Bassin, Margaret Honey, and Meryle Mahrer Kaplan, 1-24. New Haven: Yale University Press, 1994.

Blickle, Peter. Heimat: A Critical Theory of the German Idea of Homeland. New York: Camden House, 2002.

46 Rachmanowa, Meine russischen Tagebücher (Graz: Verlag Styria, 1968).
47 For a discussion of this trilogy, see Harwell, Xenia Srebrianski, "Repositioning the Exiled Body," 101-120.

Bokovoy, Melissa, and Slaughter, M. Jane. "Memory, Gender, and War," Choice (February, 2001): 1023-1031.

Creswell, Tim. Place: An Introduction. London: Blackwell Publishing, 2004.

Harwell, Xenia Srebrianski. "Repositioning the Exiled Body: Alja Rachmanowa's Trilogy My Russian Diaries." In German Woman Writers and the Spatial Turn. New Perspectives, edited by Carola Daffner and Beth Muellner, 101-120. Berlin: DeGruyter Press, 2015.

Kammen, Michael. Mystic Chords. The Transformation of Tradition in American Culture. New York: Vintage, 1991.

Kurz, Nina Ladina. Die Milchfrau von Ottakring. Tagblatt.ch/ http://www.tagblatt.ch/ostschweiz/Die-Milchfrau-von-Ottakring;art120094,3775198/ Last accessed 15 September 2018.

Melton, Judith M. The Face of Exile: Autobiographical Journeys. Iowa City: University of Iowa Press, 1998.

Porter, Philip W. and Fred E. Lukermann. "The Geography of Utopia." In Geographies of the Mind: Essays in Historical Geosophy. 197-223. New York: Oxford UP, 1976.

Rachmanowa, Alja. Auch im Schnee und Nebel ist Salzburg schön: Tagebücher 1942 bis 1945. Translated and edited by Heinrich Riggenbach. Salzburg-Wien: Otto Müller Verlag, 2015.

———. Die Milchfrau von Ottakring: Tagebuch einer russischen Frau. Salzburg: A. Pustet, 1933.

———. Einer von vielen: Das Leben Jurkas. (Erster Band: Der Aufstieg, Zweiter Band: Das Ende). Zürich: Rascher Verlag, 1946.

————. Jurka erlebt Wien. Zürich: Rascher Verlag, 1951.

————. Jurka: Tagebuch einer Mutter. Salzburg-Leipzig: Otto Müller Verlag, 1938.

————. Meine russischen Tagebücher. Graz: Verlag Styria, 1968.

Riggenbach, Heinrich, Nachwort. In Auch im Schnee und Nebel ist Salzburg schön: Tagebücher 1942 bis 1945. Translated and edited by Heinrich Riggenbach. 271-300. Salzburg-Wien: Otto Müller Verlag, 2015.

Vansant, Jacqueline. "Challenging Austria's Victim Status: National Socialism and Austrian Personal Narratives." The German Quarterly, Vol. 67:1, Modern Austrian and (Erstwhile) GDR Literature (Winter, 1994), 38-57.

Weyh, Florian Felix, Russische Schriftstellerin / Die Entzauberung der Alja Rachmanowa. Deutschlandfunkkultur.de/ http:// www.deutschlandfunkkultur.de/russische-schriftstellerin-die-entzauberung-der-alja.1270.de.html?dram:article_id=323080/.

Zimmerman, Patrick Troy. "Liminal Space in Architecture: Threshold and Transition." Master's Thesis, University of Tennessee, 2008. https://trace.tennessee.eduutk_gradthes/453

Mothers, emotions, and memory transmission in spaces of conflict: some cases of literary mothers by Herta Müller, Brigitte Burmeister, and Arantxa Urretabizkaia

Garbiñe Iztueta

Euskal Herriko Unibertsitatea-Universidad del País Vasco

Introduction[1]

The Romanian Nobel Prize author Herta Müller (1953), born to a Romanian-German family in the Romanian Banat and exiled in Germany in the 1980s; the East-German author Brigitte Burmeister (1940), a novelist who grew up and began her career in the extinct German Democratic Republic; and the Basque author Arantxa Urretabizkaia (1947) problematize the transmission of cultural memory in the 1990s by approaching it with a significant emotional component and by focusing on experiences of loss in intimate spaces of motherhood during situations of political and social conflicts and/or violence. Müller, Burmeister, and Urretabizkaia can be interpreted as authors aiming at non-hegemonic memory, trying thus to break away from the repetition of structures of dominance and oppression that occur when a subject is

1 This work was supported by the University of the Basque Country (research project EHU15/09) and the Spanish Ministry of Economy (research project FFI2017-84342-P).

not aware of mechanisms of hegemonic memory.[2] Daring to remember from a non-hegemonic position is a common topic in their narratives.

In the first place, I will define some key concepts related to memory that are pertinent to this article. Second, I will contextualize my contribution in the current theoretical and literary studies on memory and exile at the intersection with emotions in German and Basque literature, and on memory transmission at the intersection with emotions in mother-daughter relationships. The third part will focus on an analysis of the literary approach that Herta Müller, Brigitte Burmeister, and Arantxa Urretabizkaia employ to address the subject of constructing non-hegemonic cultural memory in spaces of trauma/taboo by exposing difficulties of memory transmission related to motherhood. The analytical basis will be the representation of the mother and her relationship to the conflict, trauma, and/or exile. Common aesthetic and ethical aspects to all three authors will be tackled and interpreted from a feminist perspective. Finally, general conclusions will be drawn and open questions for further research will be pointed out.

Concepts

Memory is—according to consolidated research such as the theoretical work of Maurice Halbwachs and more current research by Aleida and Jan Assmann, for example, and Astrid Erll—a subjective and individual process intertwined with a cultural and collective dimension. Memory is a process of meaning-making from past experiences, knowledge, and

2 Kathrin Schödel, "Kulturwissenschaftliche Gedächnisstheorien," in Rumäniendeutsche Erinnerungskulturen: Formen und Funktionen des Vergangenheitsbezuges in der rumäniendeutschen Historiografie und Literatur, ed. Gerald Volkmer and Jürgen Lehmann (Regensburg: Verlag Friedrich Pustet, 2015), 27.

identity, in which individuality intersects with a dominant collective process. According to Émile Durkheim, images of memory as well as memory practices are formed by society.[3] Meanwhile, Maurice Halbwachs affirms that memories are not only acquired and given a meaning in society.[4] Moreover, he contends that memory is configured by each individual from his or her distinctive position as a unique group/society/culture member,[5] resulting thus in multiplicity of memory. Therefore, subjectivity, multiplicity, process, and transference are inherent categories of memory.

Aleida and Jan Assmann complete this understanding of memory by adding three important components. In the first place, they point out that memory can be communicative or cultural, depending on the temporal and spatial atmosphere. Communicative memory is limited to a maximum of three generations and to daily-life communication—in short, to a family transmission. Cultural memory, on the other hand, is the result of an institutional communication, distanced from daily life, surviving throughout many generations in a society, in the form of rites, monuments, and texts intended to transfer meaning from past experiences, knowledge, and identity. In the second place, emotions gain relevance as meaning-making components. In the case of communicative memory, these take the form of emotional attachment, while in the realm of cultural memory, emotions have a counterpart of reflectiveness and critical observation in the approach to knowledge, experiences, and identity transferred from a past that one has not witnessed directly or indirectly. In the third place, Aleida and Jan Assmann find both

3 Emile Durkheim, The Elementary Forms of Religious Life, trans. Joseph Ward Swain (Mineola, New York: Dover Publications, 2008), 10.
4 Maurice Halbwachs, On Collective Memory, ed., intro., and trans. L.A. Coser (Chicago: University of Chicago Press, 1992), 38.
5 Maurice Halbwachs, The Collective Memory, trans. Francis J. Ditter and Vida Yazdi Ditter (New York: Harper Colophon, 1980), 48.

in communicative and cultural memory the central function of "the concretion of identity."[6] This is because, as Jan Assmann contends in the case of cultural memory, it "preserves the store of knowledge from which a group derives an awareness of its unity and peculiarity. The objective manifestations of cultural memory are defined through a kind of identificatory determination in a positive ('We are this') or in a negative ('That's our opposite') sense."[7]

Memory has been further examined as to its linguistic component and is considered consequently a discursive construct.[8] This textual and discursive dimension of memory reinforces the idea of the need for meaning-making: transference of memory needs the process of meaning-making from past experiences, knowledge, and identities in search of the basis for present identity. It is the topos of the mother-daughter transference of memory that offers an opportunity to reflect on important issues of memory.

Concepts such as meaning-making from past experiences, knowledge, and past identities in search of a basis for a present identity, and the role of emotions in this meaning-making process, are important in two ways: on the one hand, they are central categories of cultural memory and, on the other, they help interpret the selected works by Müller, Burmeister, and Urretabizkaia from a comparative and transnational dimension. These authors are dealing with these concepts in the interplay between the problematic, emotional mother-daughter communication and the contexts of exile and violence.

6 Jan Assmann, and John Czaplika, "Collective Memory and Cultural Identity," in New German Critique 65 (1995), 130.
7 Ibid.
8 Maurice Halbwachs, On Collective Memory; Nicholas Pethes and Jens Ruchatz, Gedächtnis und Erinnerung: Ein interdisziplinäres Lexikon (Hamburg: Rowohlt, 2001), 13.

1 Theoretical and literary studies on memory and mother-daughter transmission

Astrid Erll's Memory in Culture takes as its subject matter the connection between culture and memory, and its final aim is to present a proposal for theorizing and working with "cultural memory," by presenting concepts and methods for the study of memory in culture from a transdisciplinary and international dimension of memory research.[9] Furthermore, Astrid Erll and Ansgar Nünning's Gedächtniskonzepte der Literaturwissenschaft is one of the most important studies to offer a theoretical and methodological basis for studies of cultural memory in literary texts.[10]

The key role of emotions as a reinforcing factor in the process of generating and consolidating memory was already mentioned by ancient mnemotechnics and is also pointed out by Aleida Assmann.[11] Furthermore, emotions are described by Harald Welzer as operators that help us evaluate and classify our experiences according to their emotional impact and keep them in our memory.[12] In particular, research on generational novels written by women authors points out that these novels offer a new perspective by focusing on an alternative memory, or the "hidden history of women's experiences of war and political turmoil."[13] Marianne Hirsch has focused her conception of

9 Astrid Erll, Memory in Culture, trans. Sara B. Young (Houndmills, Basingstoke, Hampshire: Palgrave: Macmillan, 2011), 10.
10 Astrid Erll and Ansgar Nünning, Gedächtniskonzepte der Literaturwissenschaft: Theoretische Grundlagen und Anwendungsperspektiven (Berlin; New York: De Gruyter, 2005), 2.
11 Aleida Assmann, Cultural Memory and Western Civilization: Functions, Media, Archives (Cambridge: Cambridge University Press 2011).
12 Harald Welzer, Das kommunikative Gedächtnis: implizites Gedächtnis. Eine Theorie der Erinnerung (München: Beck, 2008), 150.
13 Valerie Heffeman and Gillian Pye, eds., Transitions: Emerging Women Writers in German Language Literature (New York: Rodopi, 2015), 8. Further studies on memory in German literature by women authors include Friederike Eigler, Gedächtnis und Geschichte in

memory on the affective link generated toward the remembered past, referring especially to postmemory.[14] Her most important contributions to memory studies are her conclusions about memory transmission in the aftermath of the Holocaust and the concept of postmemory as a strong emotional experience, as well as her focus on feminism and mother-daughter plots in German literature.[15]

Regarding relevant areas of research on Basque literature, motherhood related to memory transmission and nation-making in Basque literature is addressed by Gema Lasarte in her PhD dissertation "Pertsonaia protagonista femeninoen ezaugarriak eta bilakaera euskal narratiba garaikidean" (Characteristics and evolution of female protagonists in contemporary Basque narrative).[16] Moreover, Mari Jose Olaziregi and Mikel Ayerbe focus on the literary treatment of the Basque conflict and violence, history, and motherhood from the perspective of gender politics.[17]

Generationenromanen seit der Wende (Berlin: Erich Schmidt, 2005); Caroline Schaumann, Memory Matters: Generational Responses to Germany's Nazi Past in Recent Women's Literature (Berlin: Walter de Gruyter, 2008); Katharina Gerstenberger, "Fictionalizations: Holocaust Memory and the Generational Construct in the Works of Contemporary Women Writers," in Generational Shifts in Contemporary German Culture, ed. Laurel Cohen-Pfister and Susanne Vees-Gulani (Rochester, NY: Camden House, 2010), 95–114.

14 Marianne Hirsch, The Generation of Postmemory: Writing and Visual Culture After the Holocaust (New York: Columbia University Press, 2012), 33.

15 Marianne Hirsch, The Mother/Daughter Plot, Narrative, Psychoanalysis, Feminism (Bloomington: Indiana University Press 1989).

16 Gema Lasarte, "Pertsonaia protagonista femeninoen ezaugarriak eta bilakaera euskal narratiba garaikidean," PhD diss., University of the Basque Country 2011, at https://addi.ehu.es/bitstream/handle/10810/7847/Pertsonaia%20protagonista%20femeninoen%20ezaugarriak%20eta%20bilakaera%20euskal%20narrativa%20garaikidean.pdf?sequence=9&isAllowed=y (last accessed September 15, 2018). In English, see Gema Lasarte, ed., Ultrasounds: Basque Women Writers on Motherhood (Reno: Center for Basque Studies, University of Nevada, Reno, 2015).

17 Mari Jose Olaziregi, "Literatura vasca y conflicto político," in Diablotexto Digital 2 (2017), 22-25, doi: 10.7203/diablotexto.2.10144 (last accessed September 15, 2018); for a further recent contribution see also Mari Jose Olaziregi and Mikel Ayerbe, "El conflicto de la escritura y la escritura de la identidad: análisis de la narrativa de escritoras vascas que abordan el conflicto vasco," in Identidad, género y nuevas subjetividades en las literaturas Hispánicas, ed. Katarzyna Moszczynska-Dúrst et al. (Varsovia: Universidad de Varsovia, 2016), 45–66. In English, see Mikel Ayerbe, ed., Our Wars: Short Fiction on Basque Conflicts (Reno: Center for Basque Studies, University of Nevada, Reno, 2012).

This work seeks to focus on an analysis of the literary motif of mother-daughter relationships in connection with either individual or collective memory in the narratives by Herta Müller, Brigitte Burmeister, and Arantxa Urretabizkaia, in the form of a contribution from a comparative and transnational perspective to the research carried out so far. It will allow us to gain insight into these narratives' impact on cultural memory in their respective societies at a historical point when each social system was forced to look back on its collective near past. Furthermore, this transnational perspective creates new possibilities for future studies on the role of contemporary literature in the raising of critical awareness through cultural memory.

2 Memory transmission in narratives by Herta Müller, Brigitte Burmeister, and Arantxa Urretabizkaia

Herta Müller, Brigitte Burmeister, and Arantxa Urretabizkaia offer an innovative perspective on the topic of memory related to taboo areas in their respective societies. Eva Hoffman and Marianne Hirsch have theorized about rupture in memory transmission as a direct consequence of traumas, the Holocaust, exile, and diaspora.[18] The literary motif of rupture in memory transmission is used by all three selected authors as a chance to raise awareness about the emotional process of cultural memory-making and concurrently advocate for multiple and non-hegemonic memories in line with new narratological perspectives on memory.

It is significant that in different cultural contexts of conflict, violence, and exile, specifically in the Romanian-German, post-unification

18 Eva Hoffman, After Such Knowledge: Memory, History, and the Legacy of the Holocaust

German, and Basque cases, respectively, common topics, strategies, and aesthetic patterns play determinant roles when envisaging memory configuration. In the 1990s, Romania, Germany, and the Basque Country witnessed major political, social, historical, and literary change. In Herta Müller's case, the 1990s meant that Ceausescu had been deposed, executed, and officially the post-communist era had started. Moreover, it meant that she could approach, from her position in her German exile, the Romanian reality from a new, albeit still problematic, setting when it came to dealing with the Romanian past.[19] That same decade, meanwhile, Brigitte Burmeister faced the problem of confronting, like many other citizens of the extinct German Democratic Republic (GDR), her personal memory up to 1989 and the cultural memory of the former GDR, condemned by West Germany after the Berlin Wall came down in 1989 and Germany was reunified in 1990.[20] At the same time, Basque society was also experiencing a new era. Specifically, it was experiencing political and sociological changes related to violence and terrorism, with a more open pronouncement of public opinion against the massive and bloody attacks of the violent separatist organization ETA (Basque Homeland and Freedom), a social pact (termed the Lizarra Pact) among different Basque civil and political organizations designed to put pressure on the Spanish government to engage in a peace process, and a temporary ceasefire by ETA.[21] In this new framework, Basque society became more open to discussing the problem of terrorism and violence, a topic that started to be central

(London: Vintage, 2005); Hirsch, The Generation of Postmemory.

19 Simona Mitroiu, "Recuperative memory in Romanian post-Communist society," in Nationalities Papers 44, no. 5 (2016): 751, 771, DOI: 10.1080/00905992.2016.1182144 (last accessed September 15, 2018).

20 Wolfgang Emmerich, "Wendezeit (1989-95)," in Kleine Literaturgeschichte der DDR (Berlin: Aufbau, 2000), 435–526.

21 See William Douglass and Joseba Zulaika, "Basque Political Violence and the International Discourse of Terrorism," in Basque Culture: Anthropological Perspectives (Reno: Center for Basque Studies, University of Nevada, Reno, 2007), 139–142.

in many narrative works as a means of deconstructing the myth and taboos about the terrorist underworld.[22] Thus, all three selected authors are female novelists who write in their respective social and literary contexts and deal with memory and memory transmission in situations of exile and/or conflict and violence. Their literary approach to the subject works by exposing the difficulties of memory transmission related to problematic emotional communication and motherhood in spaces of conflict, exile, and/or violence.

The starting point in Müller's Herztier (1994)—published in English as The Land of Green Plums in 1998—is the suicide of a young student, Lola, in Ceausescu's Romania. Thereafter, it addresses the efforts of the first narrator (Lola's college roommate) to investigate this taboo case and the motives for the suicide, in order to construct her roommate's silenced memory. In this construction process of Lola's memory, the first-person narrator's research on Lola's life will trigger her own metatextual process of memory construction, a self-exploring process concerning her own memory construction; her own identity; her intimate sphere of closest friendship with Edgar, Georg, and Kurt; and her own conflicts with her mother, her family, her village, and the abusive Romanian secret police, the Securitate.

The main topic in Burmeister's Unter dem Namen Norma (1994) is the loss of identity on the part of the protagonist Marianne after the extinction of the GDR—specifically, the loss of legitimation for the existential social values of her former existence and the loss of her Heimat (cultural, social, and private Homeland) as a consequence of the fall of the GDR. Feelings of exile in her own city, Berlin; disorientation in the new social, economic, political, and cultural coordinates of the Reunified

22　Olaziregi and Ayerbe, "El conflicto de la escritura y la escritura de la identidad," 45.

Germany; uncertainty about the future and feeling torn between, on the one hand, staying in East Berlin, following a life path more in line with her past and inner essence and, on the other, joining her husband Johannes who has opted for a new life in West Germany: these are all emotions associated with the main protagonist, Marianne. It is in this context that Marianne's imaginary dialogues with her imaginary daughter, Emilia, play an important role as an analytical and emotional process of restoring the self-censored emotional memory of the GDR.

Urretabizkaia's Koaderno Gorria (1998)—or, in English, The Red Notebook (2008)—deals with a mother's desperate attempt to recover contact with her children: a thirteen-year-old girl, Miren, and a ten-year-old boy, Beñat, abducted seven years before and taken to Venezuela by their father while she was hiding in the French Basque Country as a consequence of her underground activity in ETA. The situation of the mother's forced separation from her children and, as a result, the children's tragedy of having been deprived of their memory, are the direct consequence of the mother's political and underground military activism. In these circumstances, her red notebook—which she writes with the aim of having it delivered to her children—is to be interpreted as an act of restoring her own memory and that of her children of their early years, a truth silenced by the father during those seven years in Venezuela.

In all three cases, then, the emotional dimension linked to the rupture of mother-daughter memory transmission is offered as a key realm in which conflicts considered to be "external" (that is, social, political, and cultural) can be approached, analyzed, and reflected on from an alternative and holistic perspective, in order to create spaces for non-hegemonic and multiple memories Their arguments for rethinking

cultural memory, its formation, and its transmission, by focusing on the very intimate sphere of a ruptured mother-daughter communication and memory transmission, underlines the predominant role of emotions not only in memory formation but also in coming to terms with traumatic and conflictive experiences of the past.

Furthermore, by connecting the public and the intimate spheres, and by underlining the problem of a rupture of memory transmission and of mother-daughter communication, Müller's, Burmeister's, and Urretabizkaia's contributions are to be interpreted as a conscious and conscientious practice of so-called "soft memory." Alexander Etkind coined this term, in opposition to "hard memory," for a compendium of primarily texts (literary, historical, and narrative texts that contribute to society's debate on memory sites in each culture. In democratic societies, consensus needs to be reached for soft memory to become hard memory.[23] In this context, all three authors understand their task as writers as making their readership especially aware of the determinant role of reflection on the formation and configuration of communicative memory, on that very stage of soft memory that will lead to a certain cultural memory in the future. Through their work in the aftermath of major social transformation, they offer literary instruments to open up a social debate on memory. As a literary strategy to acknowledge several layers of painful experiences in the past, all three authors use intimate spheres to approach the construction (and deconstruction) of memory related to experiences of loss in mother-daughter relationships.

23 Alexander Etkind, "Hard and Soft in Cultural Memory: Political Mourning in Russia and Germany," in "Memory/History/Democracy," special issue, Grey Room 16 (Summer 2004), 36–59.

2.1 Memory transmission and motherhood

Opting not to follow the Victorian pattern of motherhood in traditional Western European societies and conveying on their mothers the social function of perpetuating traditional values and hierarchical structures (both considered key elements of memory transmission), Müller, Burmeister, and Urretabizkaia are clearly in line with a feminist agenda. Their mother-figures are in conflict. On the one hand, they are powerless figures, overwhelmed by external settings, in exile, and finding it hard to communicate with their daughters. Yet, on the other hand, Müller, Burmeister, and Urretabizkaia present the mother-daughter relationships as challenging spheres to develop transgressive perspectives not only on motherhood, but also on silenced memories.[24]

In Herta Müller's Herztier/The Land of Green Plums, the narrator and her closest friends, Edgar, Kurt, and Georg, find a very significant feature in common among their mothers, in contrast to their SS fathers. They are sick women in pain, and they communicate emotionally with their children by verbalizing their symptoms.

> When we talked about our mothers, rather than our SS fathers, who had come back from the war, we were amazed that our mothers, who had never met in their lives, all sent us the same letters, full of their illnesses. . . . All these illnesses had been lifted out of our mothers' bodies and lay inside the letters like the stolen organ meats of slaughtered beasts inside the compartment of the fridge.

24 Karin Bauer, "Körper und Geschlecht," in Herta Müller. Ein Handbuch, ed. Norbert Otto Eke (Stuttgart: Metzler, 2017), 208; Olaziregi, "Literatura vasca y conflicto político," 23–24.

Our illnesses, our mothers thought to themselves, are a knot
with which to tie our children (LGP 45–46).[25]

As a sick body with strong connotations of death in life and an incapacity
for emotional bonds, the mother figure is very often silent, presented
as torn between the violence inherited from and impregnated by the
male, reactionary, and violent Romanian-German enclave in Banat, and
the instinctive silenced love for her daughter. This image is central in
several passages of the novel in which the narrator is not the daughter
herself, but an omniscient narrator who portrays scenes between "the
child" and "the mother." In fact, it is this omniscient external narrator
who first offers the reader an image of the protagonist's mother, tying
her daughter to a chair to violently cut her nails:

A child refuses to let her nails be cut. That hurts, says the child.
The mother ties the child to a chair with the belts from her
dresses. The child's eyes cloud over, and she starts to scream.
The mother keeps dropping the nails-clippers onto the floor.

Blood drips onto one of the belts, the grass-green one. The
child knows: if you bleed, you die. The child's eyes are wet;
they see the mother through a blur. The mother loves the child.
She loves it [sic] like crazy, and she can't stop herself, because
her reason is as tightly tied to love as her child is to the chair.
The child knows: the mother in her tightly tied love is going
to cut up my hands (LGP 6–7).

25 References to quotes from Herta Müller's Herztier/The Land of Green Plums will be
indicated with RN and the page number in the text.

In this surrealistic and repeated scene (also in LGP 32, 117) of the mother-daughter relationship, with special focus on body parts such as fingers, nails, and eyes, the mother figure is enigmatic and polyhedral. A powerful contrast is generated in the scene between the imposing image of the mother and the narrator's reference to her crazy love, in which she is presented as a mother irrationally and inevitably subject to a violent love.

Violence is also present in the mother's discourse, which will, however, undergo an evolution toward emotionalization. Her reproaches and accusations against her daughter for leading an immoral life in the city and for having rebelled against the Ceausescu apparatus (LGP 177), hers is the voice of collective oppression and the silencing of her own voice and pain, just as Herta Müller recalls the unwillingness of her own mother to talk about her traumatic past as a deportee for several years in Ukraine after World War II.[26] After the death of the narrator's father in the novel, the mother-figure gains in presence and importance. However, she is characterized as a traumatized figure with an obsessive act of winding alarm clocks in a desperate search for reassurance. Moreover, the remarkable presence of her voice in the form of passages from letters to her daughter in the city with daily news from the village (LGP 68–69, 128) is perceived by the narrator as linked to an oppressive collective voice expressed through meaningless, emotionless letters. The mother remains silent about her own emotions, only very rarely and indirectly expresses pain,[27] and lacks any emotional proximity to her daughter. This generates a metaphorically, psychologically, and affectively absent mother, which only underlines an ineffectual emotional communication

26 Hirsch, The Generation of Postmemory, 117.
27 The mother's repeated formula of referring to her back pain at the beginning of every letter conveys the idea that the sentence has lost its semantic content, that the roen relationship with her body and her pain is not spontaneously transmitted.

with her daughter,[28] and is also a key feature of Müller's "poetic of the gap," namely her aesthetic challenge to grasp in written language what cannot be pronounced. It is only at a later stage, when in The Land of Green Plums both mother and daughter are about to leave Romania for Germany, that the mother is able to emotionally open up and describe the spontaneous reactions of her body to external stimuli: "my heart was racing" (LGP 231).

Later on, once mother and daughter have settled separately in Germany, it is in their epistolary communication in exile that the silenced part of the mother-figure comes to light. This opens an option for emotional communication between mother and daughter, and the former, rather than being a voice of the Banat's collective memory, starts to construct her own memory through discourse:

> I [Mother] am not used to asphalt. It makes my feet hurt, and my brain. I get as tired here in a day as I do back home in a year.
>
> It is not home, other people live there now, I [narrator] wrote to Mother. Home is where you are now (LGP 235).

Thus, it is once the mother is in exile—when she constructs and verbalizes a more authentic connection to her own body and puts into words her new location far from Banat in Romania—that the most direct and clear dialogue between mother and daughter is possible, interestingly enough on the concept of "home" in relation to the past and the present.

28 Adriana Raducanu, "Herta Müller and Undoing the Trauma in Ceauşescu's Romania," in Episodes from a History of Undoing: The Heritage of Female Subversiveness, ed. Reghina Dascal (Newcastle upon Tyne, UK: Cambridge Scholars, 2012), 94.

Their epistolary communication in exile in Germany is, for the first time, based on empathy, emotional proximity, and reciprocity, which leads to a free exchange of different perspectives on memory and thus co-construction of memory.

The Red Notebook presents the story of an absent mother too, in this case an imposed physical absence. It is initially a temporary absence, caused by the mother's need to hide in the French Basque Country, leaving her husband and two children behind; thereafter, it becomes permanent and completely out of her control, when her husband suddenly disappears with their children Miren and Beñat. The title of the novel alludes to the red notebook in which the protagonist, referred to only as Mother, and prey to complete uncertainty about the current life of her children in Venezuela, writes a long letter. As Mother explains in the notebook to Miren and Beñat,

> I know only one thing for sure, and it is enough to make me write this lengthy work: if you call the woman who lives with you mamá, it is because your memory of me has been stolen from you, and with it your childhood and maybe even the Basque language itself (RN 9–10).[29]

It is remarkable that in Mother's discourse memory, childhood and mother tongue belong together and represent her children's most basic identity rights.[30] Thus, Miren and Beñat, having been robbed of their early memories, represent a much more general dimension in

29 References to quotes from Arantxa Urretabizkaia, The Red Notebook, trans. Kristin Addis (Reno: Center for Basque Studies, University of Nevada, Reno, 2008) will be indicated with RN and the page number in the text.
30 "That's why I started writing this, to protect your rights, not mine" (10).

that they are deprived of their identity and of their basic rights, which the protagonist aims to restore. Because the deprival of her children's identity is the direct consequence of Mother's political destiny, the protagonist is represented as a woman experiencing a strong conflict between political commitment and motherhood. This collision occurs to the detriment of motherhood and of memory transmission in this very emotional mother-children communication. The motherhood experience of the protagonist is represented as a fight with powerlessness, as a collision between the physical and forced absence imposed on her by the father figure and her impulse to reach her children emotionally again by means of her red notebook and with the help of L.

Memory restoration can be understood in Mother's case as a double subversion. The denial of any private and emotional dimension to a political female fighter, in the eyes of many people a "person of great renown, a woman of wider authority" (RN 120), comes not only from the father-figure, but also from the other main female adult figure in the novel.[31] Though the father-figure has inflicted the physical absence between Mother and her children, it is a female gaze that will often judge Mother's notebook harshly. L. appears torn between empathy for Mother[32] and a recurring skepticism about the content of the red notebook: while L. reads it, her reactions range from questioning the veracity of the facts presented by Mother in the notebook and casting the shadow of obsessiveness on Mother's testimony (RN 27), to judging Mother's dramatic tone and expression of deep motherly love and feeling shame for judging Mother (RN 29). While the father-figure incarnates

31 In opposition to L.'s external empowered characterization as a free, liberated woman with a solid professional career as lawyer, the general third-person narrative frame of the novel nevertheless shows L. as a figure frequently dependent on the male gaze, fantasizing about her lover as Superman rescuing her in Venezuela (RN 27).
32 "she [L.] no longer has enough light. Her eyes feel swollen and she has a lump in her throat. ... L. shakes her head because she doesn't want to cry" (RN 14–15).

rupturing the transmission of family memory by abducting the children, L. represents the questioning of the authenticity of the non-hegemonic memory claimed by Mother, an apparently spontaneous reaction while reading the Notebook that derives from the hegemony of the public image constructed around the woman fighter for the freedom of her country. The condemning gaze on Mother's self-representation and memory is also a consequence of the fear of acknowledging a completely new dimension of Mother's identity—her powerless motherly side in pain—as the third-person omniscient narrator concludes: "This is why the notebook scares her [L.], because it is showing her a hidden side of someone she thought she knew well" (RN 38).[33]

The endangered transmission of contested memory is also problematized in The Red Notebook through the loss of the mother tongue: the communication between mother-children, originally in Basque, is ruptured not only as a consequence of physical separation, but also because once in Venezuela the father has no longer transmitted the Basque language to Miren and Beñat (RN 35, 73). Mother verbalizes her concern about the red notebook, written in Basque, becoming a mere hieroglyphic for her own children. The metaphor illustrates the incarnation of memory transmission as a communicative situation between two divergent universes, eventually with background references and memory sites that are just too different. The narrative offers two possible solutions for that problem. On one hand, the notebook could be translated into Spanish, which puts at risk the potential success of the contested memory because L. often has an impulse to adjust, in

33 Interestingly, L.'s reading the notebook triggers not only her struggle to acknowledge her friend's emotional motherly side in pain, but also L.'s own self-exploration and construction of her own family memory: reflections about her parents and the communication with them (RN 31, 64), about her own perspective on motherhood (RN 31, 64), and about her last failed relationship. L. undergoes a farewell process, accepting it as part of her memory, feeling free rather than lonely, and hoping for the past to come back (RN 54).

that process, certain expressions about the public image of the powerful woman fighter to "the person she [L.] knew before reading the notebook" (RN 124). On the other hand, there is the endeavor of recovering the mother tongue, as represented by the daughter Miren's position. Her awareness of having lost her mother tongue due to the father's decision, and her willingness to recover it as part of her individual and collective memory, is illustrated in her insistence on reading the notebook in the original form and her refusal to receive any additional explanations from L. about the personality of Mother (RN 119). In that way, there is a successful transmission of Mother's memory, which is paradoxically reinforced by the circumstances of the rupture, as Mother reflects: "A mother who has not known the hiatus that we have suffered surely would not remember her children's early childhood as well as I do. Perhaps when what happens in later years becomes a memory, other memories get displaced, like how a drop falling into a full bucket pushes out another" (RN 73).

The novel is thus a very clear example of the confrontation of Mother's memory transmission with the hegemonic, patriarchal discourse and gaze. Her red notebook is a transgressive instrument to restore her children's authentic memory and to create a personal space in order to build her own voice as a mother, to explore and re-explore herself on all levels (woman, lover, mother, fighter), and evaluate and reevaluate her past both as a fighter and as a mother for the next generation.

The transgression of Brigitte Burmeister's mother-figure in Unter dem Namen Norma (Under the Name of Norma) lies in the subversion of the traditional mother-daughter relationship and of the conventional truth-rationality correlation in mother-daughter communication. In the first place, Marianne (the mother-narrator) represents a disoriented

person in the context of a new beginning in German reunification (UNN 8–9).[34] She is consequently processing the conflict of coming to terms between her past existence in the former GDR and her present in the East Berlin of the 1990s. Rather than being a woman according to the traditional pattern of motherhood, ready to transmit the cultural memory of her ancestors to the next generation, she is unprepared for memory transmission, as she is herself in a process of problematic memory construction, and is finding it difficult to make sense of the recent past in Germany:

> dachte ich so, wie soll ich mich genau erinnern, wenn in meinem Gedächtnis nur Anhaltspunkte aufbewahrt, alle Verbindungsstücke verloren sind, auch der Aufenthalt an Ort und Stelle sie nicht wiederbringen, nichts uns zurückführen würde zu unserer damaligen Wirklichkeit, so daß wir mit ihr konfrontiert wären (UNN 109).[35]

The city is plunged into constant change after reunification; street names are changed overnight back to the old names from before the time of GDR, neighborhoods witness a constant flow of newcomers, and the vast majority of Marianne's environment has begun to follow the (professional) Western model. As a contrast, Marianne seems to be one of the few people to raise questions about the relationship between past and present in the reunified Germany. In her introspective process

34 References to quotes from Brigitte Burmeister's Unter dem Namen Norma (Under the Name of Norma) will be indicated with UNN and the page number in the text.
35 "So, I thought, how can I remember exactly, if only the reference points are stored in my memory and all connections are lost. Not even staying at the place and spot would restore them, nothing would lead us back to the reality of that time, so that we could confront it." (Translation Garbiñe Iztueta)

of analyzing remembered and forgotten memories, as well as the limits and fragmentariness of her own memories, Marianne discovers the uniqueness and fragmentariness of memories in general. The divergence of her own memories with those her husband Johannes has of the same shared moments (UNN 104–105) shows her that filtering and letting remembrances disappear belongs to memory configuration and is determined by unconscious emotional forces.

In the second place, we are confronted with an imaginary motherhood, even though the imaginary nature of the daughter is not clear at the beginning. Truth and irrational fantasy are connected concepts in the mother-daughter relationship in Unter dem Namen Norma, as it is by means of the fantasized daughter, Emilia, that protagonist Marianne discovers the deepest truths about herself. The daughter Emilia is presented as the abrupt voice that makes the protagonist and narrator Marianne wince, and further as the squeaky hoarse voice that does not talk much (UNN 116), though it does reveal the most important truths for Marianne. It is this imaginary daughter-figure Emilia, and not the mother, who acts as a trigger of memory in a context of historical and cultural forgetfulness about the GDR, in a context of forgetfulness about its sites of memory. As possible proactive solutions to Marianne's context of disorientation, forgetfulness, and loss, Emilia encourages her to write a chronicle of her neighborhood, to create an office of coordination for nostalgic Germans and those denying their past; a lost and found office of memories, a kind of counselling office to help with "where to get out of Germany and how" (UNN 123).

In the mother-daughter imaginary dialogues, Emilia represents Marianne's inner voice trying to awaken the paralyzed Marianne in the aftermath of reunification and encourage her to focus on the future. These

dialogues thus construct an intimate space for a dialogical opinion-forming on the extinct GDR and on the concept of memory, and a questioning of the so-called Ostalgic vision: Emilia expresses her disagreement with the constant discussion and stories about the past, with the constant comparison between past and present (UNN 121–122). The imaginary daughter offers a critical diagnosis of Marianne's paralyzed existence as well, identifying a lack of projects and hopelessness in her mother. In addition, this very intimate context of fantasized dialogues creates the necessary space for freeing strong feelings (feelings of frustration, weakness, and failure, as well as a feeling of inadequacy for her past, present, and future), and the emotional memory of the GDR, which is usually silenced in the social, cultural, and professional daily life of the Reunified Germany of the 1990s. Thanks to this imagined mother-daughter relationship and the communication between the two, a transformation of the mother-figure from object into subject is possible. This begins to take place after Marianne becomes aware of and expresses verbally her own emotions about the historical and existential change. A further signal of this transformation is her confidence in the legitimacy of setting free all kinds of emotions aroused by the past and the present in order to build a balanced memory.

Finally, in the closing passage of the novel, the mother Marianne wants to hear her imaginary daughter's certainties about Marianne's future: "[ich] wünschte dabei, dass zuguterletzt Emilia käme, mir im Mondlicht die neuesten Figuren vorführen und mit ihrer unmöglichen Stimme verkünden würde, anscheinend sei mir doch noch zu helfen" (UNN 286).[36] The imaginary daughter guides the disoriented mother, thereby subverting the traditional mother-role as a guide for her daughter.

36 "[I] wished that Emilia finally came, made an exhibition of the newest pirouettes in the moonlight, and announced with her impossible voice that apparently there was still hope for me" (Translation Garbiñe Iztueta)

2.2 Embodiment and discursiveness of memory transmission

The special focus on body parts in the mother-daughter communication is present in all three novels. It is interesting to recall that Jan and Aleida Assmann draw attention to the relevance of body representations in communicative memory, because adults in a family pass on the bodily and affective connection to determinant events of the past to their descendants.[37]

Herta Müller's main body metaphors related to the mother-daughter relationship are the eye, the finger/nail, and the back in pain in The Land of Green Plums. Müller's use of the eye and the gaze as a symbol of power and social control is recurrent in her narrative.[38] The surrealistic and cannibalistic image of the mother violently cutting the fingers and nails of her daughter and eating them (LGP 8) offers an image of destructive and amputating motherhood alongside the powerlessness of the young generation in the suffocating universe of the Romanian-German rural enclave of the Banat. In addition, the recurrent symptomatic image of the mother's back pain serves to confer the idea of illness and suffering directly related to guilt, as a consequence of the burden carried out by mothers as messengers of a corrupt memory.

Urretabizkaia's The Red Notebook character, L., embodies Mother's eyes and voice in Caracas, with Mother being represented in her exile as blind and mute (RN 21–22). According to Mother's entries in her red notebook and the dialogues remembered by L., Mother considers the

37 Aleida Assmann, "Memory, Individual and Collective," in The Oxford Handbook to Contextual Political Analysis, ed. Robert E. Goodin and Charles Tilly (Oxford: Oxford University Press, 2006), 213–214.
38 Morwenna Symons refers to the use of the symbol in Niederungen (Nadir) in Room for Manœuvre: The Role of Intertext in Elfriede Jelinek's Die Klavierspielerin, Günter Grass's Ein weites Feld and Herta Müller's Niederungen (London: Maney, 2005), 123–125.

lawyer her voice in Venezuela in order to reestablish communication with her children, and the ambassador of her love (RN 15). The metaphor of needing "different eyes" in order to "rebuild the broken bridge" (RN 21) between Mother and her children illustrates the idea that restoration of ruptured memory, and the further working on the consensus of cultural memory, needs several non-hegemonic gazes.

In Unter dem Namen Norma, Emilia is constantly represented as an unexpected voice, which very often gives Marianne a start, as well as an elegant ballet-dancing, pirouetting figure (UNN 119–121), contrasting with the paralyzed mother figure who moves clumsily in the new German context of unification (UNN 109, 119). Marianne's tearful eyes in her dialogues with Emilia are a symbol of her accepting her own negative feelings at an apparently booming, optimistic time, that is, a symbol of her confronting the self-censored emotional memory of the GDR.

In addition to the strong bodily dimension of memory, a multidimensional and multiperspective textual nature of memory is stressed. Memory is constructed in all three cases as an intricate temporal and textual composition, in which different types of texts and discourses are employed and no lineal discourse is possible.

Müller's narrative plays with different unidentified narrative voices, which makes the reading process a challenging task. The distant and ruptured mother-daughter communications are compensated by the narratological proximity effect of several diaries, letters, and long telephone conversations. These very textual instruments are also recurrent in Unter dem Namen Norma, in addition to the book Marianne is translating, her chronicle, and the fantasized dialogues with Emilia that are presented as real. This variety of textual types can be seen as a

gesture of reconciling a wide range of different meanings, from the most factual to the most irrational. The Red Notebook also presents different levels of communication, different voices and points of view on the story by means of various textual forms and by including the topic of translated texts. In addition to Mother's discourse in her red notebook addressed to her children, the novel consists of a heterodiegetic narrator relating L.'s experience in Caracas, her process of reading the notebook, her reactions to it (questioning Mother's interpretation of facts, judging Mother's emotions), L.'s diary-like notes in a black notebook, and her translation of the red notebook into a brown notebook.

The meta-textual play is significant also as a means of underlining the complexity of memory as a deciphering and constructing process based on many subjective discourses: reading intimate documents such as diaries and letters written by others but also by themselves, reflecting on the read texts, and translating and transmitting them for others. These are the meta-textual tasks that belong to memory construction and processes of self-exploration in Müller's, Burmeister's, and Urretabizkaia's novels. Marianne in Unter dem Namen Norma and the anonymous protagonist of The Land of Green Plums are professional translators, and L. in The Red Notebook is at one point involved in translating the notebook. An interaction between, on one hand, real, and on the other, unreal, surrealistic, and imagined scenes, especially in Müller's and Burmeister's novels, challenges the idea of the existence of a unique rational, memory and a, exclusively fact-based construction of cultural memory. All these components in Müller's, Burmeister's, and Urretabizkaia's novels indicate their contribution to giving voice to an alternative, questioning memory in post-communist Romania, Reunified Germany, and Basque society in the 1990s.

3 Conclusion

The Land of Green Plums, Unter dem Namen Norma, and The Red Notebook invite the reader to remember the past of communist Romania, the GDR, and the Basque Country from a non-hegemonic position. This non-hegemonic position is expressed through the perspectives of mothers and daughters in problematic relationships in direct correlation with a context of sociopolitical conflict, trauma, and/or exile.

Hirsch affirms that "the break in memory transmission resulting from traumatic historical events necessitates forms of remembrances that reconnect and re-embody an intergenerational memorial fabric that is severed by catastrophe."[39] These three authors show the exploration of the necessary new forms of remembrance. They create spaces of intimacy in which traditional patterns of mother-daughter relationships are subverted, mothers are demystified, difficulties of emotional communication are linked to the silenced pain of situations of conflict, and the reader is invited to a meta-reflection on memory transmission. Cultural memory is represented at an early stage as a communicative process in which meaning is created on the basis of very diverse discourse types and perspectives, with a special emphasis on the emotional, bodily, and discursive dimensions. Müller focuses on the need to maintain some distance in order to reach a sincere, open, and empathic intergenerational communication, and it is no coincidence that only when both mother and daughter have left Romania do they reach such a stage in their relationship. Burmeister suggests irrational and emotional mechanisms

39 Hirsch, The Generation of Postmemory, 32.

of memory as an alternative form of processing the cultural memory of the extinct GDR, represented in the figure of the imaginary daughter. And Urretabizkaia offers the chance to debate about the merits of a society that mutilates cultural memory by silencing challenging female memories.

Based on the conclusions of the present work, it would be interesting to analyze other narrative works by Müller, Burmeister, and Urretabizkaia in order to identify further narrative strategies that problematize non-hegemonic memory. Moreover, the comparative analysis of other forms of embodiment and discursivity of memory in the works of these three authors would complete the initial approach of this study. Last but not least, comparing the contributions of Müller, Burmeister, and Urretabizkaia to works by younger women authors could help to clarify, somewhat, the debate on Etkind's "soft memory" as regards communist and post-communist Romania, the GDR, and the recent violent past of the Basque society.

WORKS CITED

Assmann, Aleida. Cultural Memory and Western Civilization: Functions, Media, Archives. Cambridge. Cambridge University Press, 2011

———. "Memory, Individual and Collective." In The Oxford Handbook to Contextual Political Analysis, edited by Robert E. Goodin and Charles Tilly, 210-224. Oxford. Oxford University Press, 2006.

Assmann, Jan and John Czaplika, John. "Collective Memory and Cultural Identity." New German Critique 65 (1995): 125-133.

Ayerbe, Mikel, ed. Our Wars: Short Fiction on Basque Conflicts. Reno. Center for Basque Studies, University of Nevada, Reno, 2012.

Bauer, Karin. "Körper und Geschlecht." In Herta Müller. Ein Handbuch, edited by Norbert Otto Eke, 205–213. Stuttgart. Metzler, 2017.

Burmeister, Brigitte. Unter dem Namen Norma. Stuttgart. Klett-Cotta, 1994.

Douglass, William and Joseba Zulaika. "Basque Political Violence and the International Discourse of Terrorism." In Basque Culture: Anthropological Perspectives. 131–149. Reno. Center for Basque Studies, University of Nevada, Reno, 2007.

Durkheim Emile. The Elementary Forms of Religious Life. Translated by Joseph Ward Swain. Mineola, New York. Dover Publications, 2008.

Eigler, Friederike. Gedächtnis und Geschichte in Generationenromanen seit der Wende. Berlin. Erich Schmidt, 2005.

Eke, Norbert Otto, ed. Herta Müller. Ein Handbuch. Stuttgart. Metzler, 2017.

Emmerich, Wolfgang. "Wendezeit (1989-95)." In Kleine Literaturgeschichte der DDR, 435–525. Berlin. Aufbau, 2000.

Erll, Astrid. Memory in Culture, Translated by Sara B. Young. Houndmills, Basingstoke, Hampshire. Palgrave-Macmillan, 2011.

Erll, Astrid and Ansgar Nünning. Gedächtniskonzepte der Literaturwissenschaft: Theoretische Grundlagen und Anwendungsperspektiven. Berlin; New York. De Gruyter, 2005.

Etkind, Alexander. "Hard and Soft in Cultural Memory: Political Mourning in Russia and Germany." Memory/History/

Democracy, special issue. Grey Room 16 (Summer 2004): 36–59.

Gerstenberger, Katharina. "Fictionalizations: Holocaust Memory and the Generational Construct in the Works of Contemporary Women Writers." In Generational Shifts in Contemporary German Culture, edited by Laurel Cohen-fister and Susanne Vees-Gulani, 95– 114. Rochester, NY. Camden House, 2010.

Halbwachs, Maurice. The Collective Memory. Translated by Francis J Ditter; Vida Yazdi Ditter New York. Harper Colophon, 1980.

———. On Collective Memory, Edited, introduced, and translated by L.A. Coser. Chicago. University of Chicago Press, 1992.

Heffeman, Valerie, and Gillian Pye, eds. Transitions: Emerging Women Writers in German-language Literature. New York. Rodopi, 2015.

Hirsch, Marianne. The Generation of Postmemory: Writing and Visual Culture After the Holocaust. New York. Columbia University Press, 2012.

———. The Mother/Daughter Plot, Narrative, Psychoanalysis, Feminism. Bloomington. Indiana University Press, 1989.

Hoffman, Eva. After Such Knowledge: Memory, History, and the Legacy of the Holocaust. London. Vintage, 2005.

Lasarte, Gema. Pertsonaia protagonista femeninoen ezaugarriak eta bilakaera euskal narratiba garaikidean (Characteristics and evolution of female protagonists in contemporary Basque narrative). PhD Diss., University of the Basque Country, 2011, https://addi.ehu.es/bitstream/handle/10810/7847/

Pertsonaia%20protagonista%20femeninoen%20 ezaugarriak%20eta%20bilakaera%20euskal%20narrativa%20 garaikidean.pdf?sequence=9&isAllowed=y (15/9/2018)

————, ed. Ultrasounds: Basque Women Writers on Motherhood. Reno. Center for Basque Studies, University of Nevada, Reno, 2015.

Mitroiu, Simona. "Recuperative memory in Romanian post-Communist society." Nationalities Papers 44 no. 5 (2016): 751–771. DOI: 10.1080/00905992.2016.1182144.

Müller, Herta. Herztier. Frankfurt a.M. Fischer Verlag, 2010.

————. The Land of Green Plums. Translated by Michael Hofmann. Evanston. Hydra Books, 1998.

Olaziregi, Mari Jose. "Literatura vasca y conflicto político." Diablotexto Digital 2 (2017): 6–29. DOI: 10.7203/diablotexto.2.10144 (last accessed September 15, 2018).

Olaziregi, Mari Jose, and Mikel Ayerbe. "El conflicto de la escritura y la escritura de la identidad: análisis de la narrativa de escritoras vascas que abordan el conflicto vasco." In Identidad, género y nuevas subjetividades en las literaturas Hispánicas, edited by Katarzyna Dúrst, Moszczynska et al. 45–66. Varsovia: Universidad de Varsovia, 2016.

Pethes, Nicholas and Jens Ruchatz. Gedächtnis und Erinnerung: Ein interdisziplinäres Lexikon. Hamburg. Rowohlt, 2001.

Raducanu, Adriana. "Herta Müller and undoing the Trauma in Ceauşescu's Romania." In Episodes from a History of Undoing: The Heritage of Female Subversiveness, edited by Reghina Dascal. 83--134. Newcastle upon Tyne. UK Cambridge Scholars, 2012.

Schaumann, Caroline. Memory Matters: Generational Responses to Germany's Nazi Past in Recent Women's Literature. Berlin. Walter de Gruyter, 2008.

Schödel, Kathrin. "Kulturwissenschaftliche Gedächnisstheorien." In Rumäniendeutsche Erinnerungskulturen: Formen und FunktionendesVergangenheitsbezugesinderrumäniendeutschen Historiografie und Literatur, edited by Gerald Volkmer and Jürgen Lehmann, 11–28. Regensburg. Verlag Friedrich Pustet, 2015.

Symons. Morwenna. "Herta Müller." In Room for Manœuvre: The role of Intertext in Elfriede Jelinek's "Die Klavierspielerin," Günter Grass's "Ein weites Feld" and Herta Müller's "Niederungen." 106–155. London. Maney, 2005.

Urretabizkaia, Arantxa. Koaderno Gorria. Donostia. Erein, 1994.

———. The Red Notebook. Translated by Kristin Addis. Reno. Center for Basque Studies, University of Nevada, Reno, 2008.

Welzer, Harald. Das kommunikative Gedächtnis: implizites Gedächtnis. Eine Theorie der Erinnerung. München. Beck, 2008.

Beyond the Motherland: Memory and Emotion in Contemporary Basque Women's Fiction[1]

Mari Jose Olaziregi

Euskal Herriko Unibertsitatea-Universidad del País Vasco

This work presents a brief analysis of a selection of narratives in Basque literature authored by women. In these narratives, a transnational journey becomes the basis of a reflection on a problematic relationship that often subverts the gender roles sustained by Basque nationalism, whether in its traditional or radical form. In the novel which will be addressed in most detail, The Red Notebook by Arantxa Urretabizkaia, it is maternity (and its deconstruction) that channels this questioning of gender roles. My commentary will begin with a short overview of the current panorama of memory narratives by women authors in the Basque context. The specific discursive recourses of those narratives will be analyzed in the context of the memory boom that Basque literature is undergoing.

1 This article has been written as a part of the MHLI Research Group IT 1047-16 project, financed by the Basque Government, and the FFI2017-84342-P project, financed by the Spanish Ministry of Science and Innovation. It was previously published in Spanish as "Narrativas vascas actuales, filiaciones y afectos a flor de piel" (in González Fernández, H. et al. (eds.), Género y silencios en España y América Latina. Siglo XXI. Sevilla: Padilla Editores-Instituto de Estudios Ibéricos e Iberoamericanos de la Universidad de Varsovia, pp. 49-74). Translated by Cameron Watson.

A short introduction to Basque women's historical memory narratives

Recent research confirms that Basque literature, and especially that written in Euskara, or the Basque language, came late to representations of the Spanish Civil War and Basque terrorism. Avoiding a more detailed description of the evolution of diverse poetics, I would defend that it was in the 1990s when the evoking of the Basques' recent troubled past most notably emerged in literary form.

The narrative texts that first recreated the harsh politico-cultural repression that Francoism unleashed in the Basque Country, as well as the beginning of ETA's terrorist activity in 1959, were recreated in literary form as a means to embrace the desire of the grandchildren of the war, of the so-called postmemory generation. Hence, literature took on the moral and ethical duty of giving voice to the vanquished. My claim here is in line with the argument of Marianne Hirsch, and critics like Sebastian Faber[2] in the Iberian setting, when they refer to a postmemory of affiliative characteristics in which literature plays an important role. According to both Hirsch and Faber, the socialization of the duty to honor the memory of all the victims greatly influences the political environment in which the writer creates. In recent decades, Basque novels about the Civil War have raised such questions as: the importance of communicative memory in the family transmission of Basque nationalist ideology; the processes of victimization on the part of members of both factions in the war; and the appearance of sites of memory that present a sedimented past that encourage consensus and debate beyond the omnipresent Gernika. This paper hardly allows for a detailed illustration of all those questions; however, interested readers

2 (2014)

can readily dive into the abundant critical discourses generated by current memory studies in the Basque context.

Regarding narratives that tackle representation of ETA's terrorism, one could note that the emergence in the 1990s of Basque novels addressing terrorism coincided with a parallel tendency in English-language novels.[3] There were, however, particularities that clearly differentiated them. While Basque narratives also demonstrated a diversity of perspectives and significant novelesque qualities, they did not appear to offer, at least until quite recently, such a predominant tendency to focus on events narrated from the victim's point of view as in their English-language counterparts. Instead, Basque novels dealing with ETA's terrorism concentrated on the perspective of the perpetrators of violence: the terrorists. As Blessington[4] contends, any novel that addresses terrorism seeks to understand and experience why someone chooses terror: what the terrorist's mindset is. Remarkably enough, that has been the aim of most of the nearly seventy novels in the Basque language that have explored the subject. In this regard, in line with anthropologists Joseba Zulaika and William Douglass,[5] I would argue that such a focus has sought, above all, to make known and remove the taboo from terrorism's fetishized and ritualized elements.

It is interesting to note that, whereas the centrality of the perpetrator has only emerged within the last decade in Western literature—such as that of Central Europe and the United States[6]—in the Basque case, it is precisely that centrality that has been constructed as a core

3 Robert Appelbaum and Robert Paknadel, "Terrorism and the novel: 1970-2001", Poetics Today, 29; no. 3, (2008), 387-436.
4 Francis Blessington, "Politics in the terrorist novel," Sewanee Review 116, vol. 1, 117.
5 Joseba Zulaika and William Douglass, Terror and Taboo: The Follies, Fables, and Faces of Terrorism (New York: Routledge, 1996).
6 Richard Crownshaw, "Perpetrator Fictions and Transcultural Memory," Parallax, 17:4, (2011), 75-89. Robert Eaglestone, "Avoiding Evil in Perpetrator Fiction", Holocaust Studies, 17:2-3, (2011): 13-26.

critical argument in current debates on terrorism. Different victims' associations and transnational legislation have supported that demand of centrality for the victims. Acclaimed novels like Tigre ehizan (Chasing Tigers, 1996) by Aingeru Epaltza, Twist (2011) by Harkaitz Cano, and Mussche by Kirmen Uribe (2011) are examples of the growing importance that the victims in involving the Basque people have acquired. These novels are also paradigmatic of a multidirectional memory that draws on not only Basque, but also international conflicts such as twentieth-century Latin American dictatorships or the Nazi occupation of France and Belgium.

Novels by women authors

The boom in Basque novels dealing with recent Basque conflicts has also unavoidably taken on those by women authors. In fact, one could argue, it has done so in singular ways. One is struck by the formal differences between the literary production of men and women. When the author is a woman, narratives on the conflict do not fictionalize their protagonists as "women writers" on the conflict, but rather include characters that maintain an epistolary relationship with a textual recipient that does not transcend the private intimate sphere (the nucleus of the protagonist's friends or family). Put another way, novels written by men demonstrate metafictional structures that denote the active role male writers want to play in the face of the conflict, while women's narratives illustrate the Basque conflict through alternative autobiographical structures.

Recent novels written by women about Basque historical memory is told via diverse forms of the autobiographical genre, as is the case in novels about the Civil War. Some examples are Urtebete itsas argian (A

year in the lighthouse, 2006) by Miren Agur Meabe; Aulki jokoa (The game of chairs, 2009) by Uxue Alberdi; Txartel bat (des)herrira (A ticket to exile, 2013) by Garazi Goia; and Zuri-beltzeko argazkiak (Portraits in black and white, 2014) by Arantxa Urretabizkaia. All of these tell stories set in the Civil War or during the postwar era and deal with aspects such as the sexualization of Francoist repression and misogynist stereotypes, paternity conflicts, the exiles of thousands of children during the conflict and their alienation in England, and so on. One could say that the novels attempt to give visibility and voice to many women who experienced the war in the domestic rearguard—women who often had direct experience of the Francoist repression and persecution due to the mere fact that they had taken on a supportive role as mothers, sisters, or wives of the combatants. Some of the novels, such as Miren Agur Meabe's Urtebete itsas argian—winner of the Euskadi Prize for Children's and Young Adult Literature in 2007—attempt to write a story of counter-memory, concentrating especially on the repression and erasure suffered by Basque culture and its protagonists during and after the conflict. Given the limited corpus and noting the dates of publication, one could say the incorporation of Basque women writers into the narration of the Civil War has been, in truth, quite recent.

I would like to highlight Hobe isilik (Better off silent, 2013), the first novel by journalist Garbiñe Ubeda. The argument is, in some ways, typical of narratives in which filial relationships encourage the search for a missing family member—a search that, according to political scientist Judith Shklar, is governed by a feeling of family loyalty.[7] Bakartxo is the female narrator of this story whose textual recipient from the start is Bakartxo's grandfather, José Bermejo Zabaleta, an

7 Cited in Sebastiaan Faber, "La literatura como acto afiliativo" in Contornos de la narrativa española actual (2000-2010). Un diálogo entre creadores y críticos, María del Palmar Álvarez Blanco & Toni Dorca coords., (Madrid / Frankfurt: Iberoamericana / Vervuert): 103.

anarchist Navarrese railroad worker who had gone missing after World War II. It is a case of clearing up a big family mystery, one that has been accepted by different generations of the family who continue to admire old family photos in which José appears as the revolutionary anarchist he was, but also whose presence and look constitute that punctum, as Roland Barthes would say, which, like a burning arrow, continues to remind the family members of his fatal end: "he is going to disappear."[8] What is really unsettling about the novel, however, is the spectral presence of the grandfather: that ghost that appears before his granddaughter and reminds us of the mystery, the moral crime perpetrated in the past which remains unpunished. In the same way as in other contemporary Basque novels like Twist (2011) by Harkaitz Cano—an example of transnational memory through the link that the novel establishes between the missing in Spain's Dirty War and those in different twentieth-century dictatorships in Latin America— Ubeda's novel uses that ghostly appearance to embody the resistance to forgetting the past crime. "One has to speak about the ghost, even to or with the ghost," states Jacques Derrida in Specters of Marx, and that is precisely what the protagonist does in the novel. This is a story of great affective density and ethical evaluation in which sweats, chills, and emotions like hatred, rage, or pain get mixed up in a dreamlike atmosphere that underscores the fact that: "Dena da normaltasunetik kanpokoa, dena fikzioa, antzerkia, itxura" (66) [Everything is out of the ordinary, everything is fiction, theater, appearance]. The discovery of the grandfather's double life—of his conscious abandoning of his Basque family in order to start a new life with his French family—reveals an unanticipated and painful reality to Bakartxo.

8 Roland Barthes, La cámara lucida. Nota sobre fotografía (Barcelona: Paidós, 1989): 52.

One could argue much the same with regard to Basque women's narratives about the so-called Basque conflict—that is, the terrorism of ETA—have also surfaced relatively recently.. (and delete one of the 2 To the hailed novels Nerea eta biok (Nerea and I, 1994) by Laura Mintegi and Koaderno Gorria (The Red Notebook, 1998) by Arantxa Urretabizkaia—both using the epistolary genre to narrate stories about the conflict—one could add the autobiographical Esan gabe neukana (What I had to say, 2003) by Agurtzane Juanena (a heart-rending story about the torture suffered by the author); Boga Boga (2012) by Itxaro Borda (a deconstruction of gender roles in the classic detective novel); and short stories like "Gehienez bost hilabete" (Five months at most, 2005) by Arantxa Iturbe, or "Politika Albisteak" (Current politics, 2004) by Eider Rodriguez (a text that we already analyzed in another article[9] and that describes, like few others, the claustrophobia and downward spiral of a political reality whose most silent and invisible dimension can be found in the domestic terrain of the women who inhabit it). The protagonists of these works are women who, as in the story by Rodriguez, no longer produce life or dreams, but who are trapped in a role (that of self-sacrificing mothers and girlfriends) and in a language (that of the media and the military) whose phallocentrism and nationalist misogyny destroy them. Among those Basque women writers who write in Spanish, we should mention two works dealing with the grief resulting from the violent loss of loved ones. Both of these were winners of the Euskadi Prize for Literature in Spanish in 2009 and 2016 respectively. El ángulo ciego (The blind angle, 2008) by Luisa Etxenike is narrated by a child whose parents have been assassinated by terrorists, while El comensal (The dinner guest, 2015) by Gabriela Ibarra narrates, from

9 Mari Jose Olaziregi and Mikel Ayerbe, "El conflicto de la escritura y la rescritura de la identidad: análisis de la narrativa de escritoras vascas que abordan el conflicto vasco." In Identidad, género y nuevas subjetividades en las literaturas hispánicas, Kasia Moszczynska-Dúrst et al. eds. (Varsovia: University of Varsovia-Institute of Iberian Studies, 2016).

the perspective of a granddaughter, the assassination of her grandfather by ETA.

Raw emotions: Maternity and Basque literature written by women

Maternity is, without doubt, one of the most recurring themes in current Basque literature by women authors. This is so much the case that in dissertations like those by Professor Gema Lasarte on female protagonists in Basque novels written by women,[10] it is argued that ninety percent of the novels analyzed took maternity as their central theme—and highlighted its negative aspects on most occasions. This centrality has also been exemplified in Basque short-story anthologies such as Ultrasounds, published in 2014 by the CBS. It could well be argued that the negative representation of maternity in many female-authored Basque narratives, has its counterpart in the low birth rate and progressive aging of the population in the Basque Country—a reality that constitutes one of the major preoccupations for Basque institutions at present. In fact, the Basque Country has one of the lowest birth rates in Europe. As a result of their concern, the Basque government introduced a Plan of Support for Families in January 2018, a scheme which aims to, among other things, encourage more than 18,000 births in the Basque Country annually.

Regarding whether maternity as a literary motif is more prevalent in literature written in Basque than in other cultures' literature, we can confidently state that in the global world today—as is the case with other matters—Basques are not blatantly original with regards

10 Gema Lasarte, Pertsonaia femenino protagonisten ezaugarriak eta bilakaera euskal narratiba garaikidean, University of the Basque Country. PhD Dissertation. (http://www.euskara.eu-skadi.net/appcont/tesisDoctoral/PDFak/Gema_Lasarte_TESIA.pdf.Accessed:8/11/2018)

to the prevalent theme of maternity. The obvious questions are, then: what objectives do the representations of maternity meet? And are these objectives unique to Basques? There does seem to be a certain singularity when it comes to the possible objectives of the Basque female author's representation of maternity: namely, the overt criticism of the gender roles and categories that Basque society in general, and Basque nationalism in particular, have traditionally projected of Basque women; and, therein, the social functions women have conventionally been assigned—the role of mothers. Again, Basques are not so unusual with regards to the recurrent presence of maternity in our literature. On the contrary, the re-examining of the maternity role has become one of the central themes in contemporary feminist studies. This ubiquitous presence is correlated with the motif's growing presence in fiction and contemporary theory. Indeed, as Elizabeth Podnieks and Andrea O'Reilly argue, "[the] daughter-centricity has been countered and corrected in both fiction and theory"[11]—namely, matrifocal narratives that aim "to unmask and to redefine maternal roles and subjectivities."[12] In the case of the closest cultural tradition to authors in the Basque language (that of the Iberian Peninsula), it is noticeable that the growing reflections on maternity since the 1990s[13] are, in fact, a novelty. Such novelty has found inspiration in the well-known works of Adrienne Rich (born 1979)—who distinguished between maternity and the maternal institution—and Sara Rudick (1995), the author of systematic analyses of different aspects of behavior and maternal thought. As Rich states, "We do not think of the power stolen from us and the power withheld from us in the name

11 Elizabeth Podnieks and Andrea O'Reilly, eds., Textual Mothers/ Maternal Texts (Ontario: Wilfrid Laurier U. Press, 2010), 2.
12 Textual Mothers/ Maternal Texts, 5.
13 See "Introduction" in María Cinta Ramblado Minero, Construcciones culturales de la maternidad en España (Alicante: Universidad de Alicante, 2006). See also: Sarah Leggot, Memory, War and Dictatorship in Recent Spanish Fiction by Women (Lanhan, Mariland: Bucknell U. Press, 2015).

of the institution of motherhood."[14] Rich is referring to the concept of motherhood that narratives in Basque literature attempt to deconstruct: a patriarchal motherhood that "in transfiguring and enslaving woman, the womb—the ultimate source of the power—has historically been turned against us and itself made into a source of powerlessness."[15]

Yet another purported objective that could be met by the wide-ranging representation and demonstration of maternity in contemporary Basque literature is that of re-memorizing our most troubled past. Let us examine this possibility from the basis of cultural studies and the contributions made on violence in the Basque Country by Joseba Zulaika (1982). Zulaika highlights the fact that mothers make up the core image of women as projected by Basque nationalism, and that the ultimate expression of the Basque nationalist mother is found in the Amabirjina (the Virgin Mother), whose representations indicate qualities projected in turn onto Basque women: determination, strength, serenity, simplicity, and contingency.[16] In nationalist texts, women are associated with images of the mother, the land, and the homeland. Thus, in addition to the ama (mother) and Amabirjina, the Basques also relate the traditional idea of a woman with Ama Aberria (motherland) and Ama Lur (mother earth).[17] If literature is, as Elizabeth Jelin[18] contends, "shared cultural knowledge" in which episodes of suffering or personal pain become public, it is logical that Basque-language fiction would address the subject of the Basque conflict in its desire to contribute to a cultural memory that incorporates different versions and victimizations

14 Adrienne Rich, Of Woman Born: Motherhood as Experience and Institution. 2nd ed. (New York: Norton, 1986)
15 Rich, Of Woman Born, 68.
16 Teresa del Valle, Mujer vasca, imagen y realidad (Barcelona: Anthropos, 1985), 227.
17 Mujer vasca, imagen y realidad, 229.
18 Elizabeth Jelin, "Lecturas y relecturas de pasados conflictivos en América del Sur." In Construyendo memorias. Relatos históricos para Euskadi después del terrorismo, J.M. Ortiz de Orruño & J.A. Pérez eds., (Madrid: Los libros de la catarata, 2013): 91.

generated by this conflict, together with a critique of the gender politics that have governed it. In this sense, Basque literature on the subject would be contributing—in its capacity to constitute itself as cultural memory based on Basque collective identity—to dialogue and understanding, which precede the recognition of the hurt caused.

Koaderno gorria by Arantxa Urretabizkaia

A cult author within the panorama of contemporary Basque literature, Arantxa Urretabizkaia (Donostia, 1947), emerged on the scene of fiction written in Basque with her novel Zergatik Panpox (Why Little Darling 1979)—a long monologue carried out by an abandoned mother—which adopted the approach of difference feminism and the narrative techniques of writers like Annie Lecrerc.[19] The author's later narratives, with standout works like the recent Bidean ikasia (Learned along the way, 2016, and winner of the Euskadi Prize for an Essay in Basque), have also been marked by a critical perspective on and denunciation of popular Basque traditions such as the Alarde parade in Hondarribia.

For its part, Koaderno gorria (1998)[20] has been translated into Spanish, English, Italian, Russian, and German. A two-level composition, the novel first includes a long letter that the main character, the Mother (capitalized in the novel), writes in a red notebook for her children, of whom she has had no news since, seven years prior, their father fled with them to Venezuela. We know that the writing of this letter begins on October 5, 1990, and that it is continued for three hurried days

19 Mari Jose Olaziregi, "Worlds of fiction: An Introduction to Basque Narrative." In Basque Literary History, Mari Jose Olaziregi ed. (Reno: Center for Basque Studies, University of Nevada, 2012): 177-178.
20 Arantxa Urretabizkaia, Koaderno gorria (Donostia:Erein, 1998). English: The Red Notebook, translated by Kristin Addis (Reno: Center for Basque Studies, 2008).

by the Mother. The letter is, in reality, a personal diary that—through telling the story of the first years of her children's lives (six years in the case of her daughter, Miren, and three in that of her son, Beñat)—seeks to recover, and demand, the maternity robbed of her by the father. The letter, written in Basque—even when the Mother does not know if her children have held onto their (maternal) language—is an attempt to defend a linguistic and national identity that has possibly been maimed by the father.

In the second level, an extradiegetic narrator in the third person narrates the journey of a lawyer, Laura Garate, sent by the Mother to Venezuela to find her children and give them the notebook, so that they may realize she is still alive and wants to see them. What little we know about the lawyer is she is fifteen years younger than the Mother, slim, curly haired, single, and from a dysfunctional family background with obvious emotional deficiencies. As for the Mother, we know that her clandestine political activism led her into exile, an exile that silenced her voice (including any verbal communication with her family or writing a diary); concealed her face (photographs were banned for questions of security); and condemned her to live in a location that was unknown even to her. Shut away in a room, with only one external window in a quasi-heterotopic space, this is the environment in which the troubled character attempts to re-establish the contact she lost with her children seven years before.

Although the structure of the novel is not complicated, what stands out is the profusion of narratees. Besides the direct textual recipients of the red notebook written by the Mother, her children Miren and Beñat, we can add Laura herself, who also reads the notebook—becoming, in this way, the second recipient of the manuscript. For her part, the

Mother is the textual recipient of a letter Laura writes from Venezuela, a letter in which she comments on how the search for her children is going. This literary device is what Susan Lanser[21] has classified as a private narration: a narration that uses a diegetic textual recipient to mediate between the reader and the work, which is a typical characteristic of so-called women's literature according to Lanser. Intradiegetic reading and women readers establish a collusion of experiences that turns them into avid readers of these shared intimacies between women. Moreover, the subject matter addressed by the novel—that of both the voluntary and involuntary absence of the Mother—is one of the themes that, according to critics, allows contemporary fiction to reflect on how women negotiate the patriarchal imperative of being a "good mother" and their desire for autonomy or personal self-realization.[22]

Narrative Construction of Maternity

What follows is a consideration of the emotions that the novel The Red Notebook reveals. I will analyze these emotions "not as interior psychological states, but as social and cultural practices."[23] In effect, I will embrace the consequences of what has been termed the "cultural turn" that affected the social sciences and humanities starting in the 1980s, and which has encouraged a revision of the role of emotions at the heart of social movements and their politics. Furthermore, in the case of cultural studies, the affective turn allows us to think about and analyze cultural texts beyond the problem of representation, and

21 Susan Lanser, "Toward a Feminist Narratology", Style, 20, vol. 3, 341-363.
22 Elizabeth Podnieks and Andrea O'Reilly, eds., Textual Mothers/ Maternal Texts (Ontario: Wilfrid Laurier University Press, 2010), 13.
23 Sara Ahmed, "Home and Away: Narratives of Migration and Estrangement", International Journal of Cultural Studies, Vol. 2, issue 3 (1999), 9.

understand them, as Jo Labanyi contends, from a performative point of view—that is, as "things that do things,"[24] as creations that have the capacity to affect us. I will not delve into the debates surrounding the distinctions between affections and emotions contemplated at the root of works on Massumi's neurological experiments; instead, I will adopt the approaches of recent publications in the field of Iberian studies that follow the arguments of Sara Ahmed and Teresa Brennan, who choose not to do so.[25] My opening hypothesis is clear: if we begin with the idea that maternity is a function constructed as natural and necessary by a contingent cultural order,[26] the concept of maternity revealed in The Red Notebook demonstrates—through the emotions that bring the characters in the novel together—the socio-cultural limits of the function that Basque nationalism, whether in its traditional or radical form, has attributed to women as mothers. In order to do so, the novel presents the affective mechanisms by which that function is constructed through the two narrative levels: the mother's story in the notebook and Laura's journey. In this way, the novel suggests a similarly performative definition of the concept of maternity.

> I am your mother and I love you, inescapably, more than I love myself. That's how things are now, in these seven years I have spent far away from you, and that's how things were before, when your father stole you [...] it seemed to me that you were pieces of my body, that you and I could not leave apart from each other. Obviously, I was wrong [...]. (120)

24 Jo Labanyi, "Doing things: emotion, affect, and materiality", Journal of Spanish Cultural Studies 11, 3-4, 232.

25 Elena Delgado, Pura Fernandez and Jo Labanyi, eds., Engaging the Emotions in Spanish Culture and History (Nashville: Vanderbilt University Press, 2016), 6-7.

26 Silvia Tubert, ed., Figuras de la madre (Madrid: Cátedra, 1996), 36.

By means of the mother's story, the novel perfectly exemplifies the phases her maternity goes through. Her characterization fits that of a clandestine activist: we do not know her real name, or her nom de guerre; all we know of her is that she is at an unknown location, that she has no personal photos or documents that could reveal her identity because the organization forbids them, and that writing in her red notebook (illicitly) allows her, for the first time, to recover her stolen maternity. As if giving birth for the second time, the mother's story—with the word "Mother" capitalized in Laura's story— lets us witness the evolution of a maternity that is not easily compatible with one's love of homeland in the form of an armed struggle. Likewise, the notebook accounts for a long-awaited maternity, in which her love for her children has pushed her love for her homeland into the background:

The aim of the Mother's story is obvious: to construct a familial memory that has been denied to her. "What I have told you will become a memory for you—not a complete one, I'm not that ambitious, but at least a sliver, a spark, a familiar tune" (72). This familial memory, due to obvious impediments, has not been transmitted orally (communicative memory) and must be passed on in writing via the letter. The letter attempts—in the same way as the cases described by Marianne Hirsch regarding the postmemory generation—to mediate in that transmission. Moreover, the narrator of the letter is conscious of the fact that all memory is created and constructed and, therefore, capricious and subject to the conditioning of the moment: "Do not worry, I do know the danger of recounting things by memory, I know the tricks memory can play" (36).

The timing of the mother's previous family life and her two maternity spells were conditioned by her political activism. We know

that the couple married after the death of dictator Franco and that, following marriage, her activism did not wane. On the contrary, she took part in activities like the pro-freedom march and the general amnesty movement in 1977. Most significantly, the narration begins by stating the emptiness and loneliness and fear she has been condemned to in being separated from her children (11). According to Nussbaum,[27] these are emotions (especially fear) which, although primal, are still vital to the present day, insofar as they keep us out of danger. Remarkably, though, fear was not an emotion that characterized this woman when she was an activist:

> Your father told me that the most difficult aspect of all our issues was my lack of fear, that hominids would never become humans if they had had no fear. I have not forgotten those discussions, because we had long arguments about risk, and the upshot was that I had to promise him that I would not take on too much that summer. (50-51)

Thanks to the notebook, we are aware that the Mother was admired by her husband precisely for that lack of fear (44). In contrast to her, the husband "wasn't brave enough" (44). It is the female character, then, who ultimately states, "I have always liked more action than contemplation" (82)—an attitude that led her to put her love for her homeland ahead of her love for her family, and made her a woman who "followed orders without hesitation" (86). This sturdiness drives her to

27 Martha C. Nussbaum, Political Emotions. Why Love Matters for Justice (Cambridge: Harvard University Press, 2013): 320.

act when she receives a call from the Organization and allows her to accept a life of exile in the French Basque Country later in life (87).

Martha Nussbaum[28] underlines the emotional component of patriotism, which could be described as a form of love that considers the nation as one's own. It is that love of homeland that conditions the mother's life, a love that does not exclude the other great love of her life: the love she feels for her children. Indeed, the mother's narration constantly reveals her resistance to following the script that was written for her in the Basque heteropatriarchal society—a society in which her ascribed role was to become a mother and, hence, to prioritize the care of her children alongside that of her husband. Marriage, subsequent pregnancies, and celebrations like Christmas (67-68) are all concessions to the demands of a husband and the pressure of a grandmother, who does not hesitate to replace the Mother by raising her children during the harsh years of the young woman's activism. She is a mother whose narration stresses the corporeal part of maternity, contemplating it as something natural by use of metaphors that allude to trees that grow within the maternal belly—"[you grew] like the beech trees in front of the window that only need time to grow" (26)—and totally take over the mother's body, especially in the case of the second pregnancy: "I was not the owner of my own body" (62). The physical and emotional separation from her children, and their kidnapping by their father, imply the emotional death of the Mother: "Here am I, a wilting plant that for too long has not known the sweet sun" (120). She is turned into an amputated body, a body that has been deprived of its most sacred fruit: the children. From that perspective, the metaphor of the withered flower serves as a reflection on a powerless mother nature. Only at the end of her narration will she declare, and for the first time,

28 Political Emotions. Why Love Matters for Justice, 208.

her unswerving love for her children: "I am your mother and I love you, inescapably, more than I love myself" (120).

Laura's Journey

The journey narrated in the novel, as one would expect, will transform Laura. From the mistrust and perplexity she feels on arriving in a foreign land, to the loss of her suitcase, everything makes her feel like she is in a threatening place. She describes the place as full of thieves (7) and a place in which her sweaty skin reveals the exhaustion and stimulation of being far away from home: "She sniffs her armpits with a sigh" (6). Despite the heavy sweltering heat (11), she shivers at the sight of a setting (the tonality of red, purple, and dark blue the sky acquires) (14) and a people. There is mention of the attractive, colorful nature of women's clothes (16) that seem strange and that betray her as foreign—a symptom, Kristeva would posit, of the identity conflicts her (foreign) presence generates among the locals.[29] Along the lines of Ahmed's argument,[30] we observe that the experience of moving to a new place/home, even if only temporarily, is experienced as a cumulus of sensations: sensations of fear before which her body reacts with a lump in her throat (14), or with an incontrollable urge to cry (15). She feels awkward and strange among well-dressed women (31), under a sun she feels is "extravagant" (32), and as the hours go by, she does not hesitate to state "how much more difficult everything is in a foreign country" (39). Indeed, she does not feel comfortable in Caracas (31). Transformed into a foreigner, her body literally shivers as a result of

29 Julia Kristeva, Strangers to Ourselves (New York: Columbia University Press, 1991).
30 "Home and Away," 342.

the trauma and the pain she feels through not being "at home."[31] Laura's journey to Caracas—a city that feels to her labyrinthine and jungle-like, and in which the vehicles that traverse it in search of the elevated neighborhoods huff and puff like tired elephants—highlights her dislocation and estrangement.

This exoticism of space, this sentiment that one is in alien terrain, is heightened by the another estrangement the protagonist experiences—the one that comes from discovering her body as a result of the journey to Caracas and of reading the red notebook, that notebook whose leitmotif is the discursive construction of maternity on the part of the Mother. Through her reading of the notebook, Laura relives the physical sensations of the Mother's pregnancies, sensations which, little by little, also take control of her, putting down roots inside her and showing her a reality and a corporality that she was unaware of and that she ends up obsessed with and consumed by. "Surrounded by children, fenced in, besieged" (76), she states, in the face of the mother's story that has sown a net with which to trap her (79). For the fact is that maternity does not enter into the plans of this lawyer who experienced a traumatic childhood, and for whom children have just been—following De Beauvoir's argument—a way toward slavery (38); The mother's maternity tale is, above all, a corporal experience that allows for the discovery and awakening of a body that she inhabits but does not know. The corporeal awakening is illustrated through the repeated references to the reflection of her body in mirrors. Laura, while still feeling herself a non-mother, cannot help acting as one with Miren and Beñat.

31 "Home and Away," 92.

Maternity and Homeland

Urretabizkaia's novel, thus, suggests a reflection on the compatibility between political commitment and maternity. It is obvious that this mother—who is reclaiming her stolen maternity by means of memories—had not been proffered the option of juggling her activism and maternity. She could not balance her political commitment with the duties assigned to a "good" mother. According to Rudick, such duties correspond to the demands imposed on a mother by her child: preservation, growth, and development (the mother-child emotional link) and social learning (the need for acceptance on the part of the child within the social group the mother belongs to).[32]

The narration of Laura's journey describes the social image of the Mother with precision. She describes her as a woman surrounded by men, treated by them as "normal" and "complete" (85); a woman, in sum, "without any family"—a true miracle, in Laura's eyes (85). As Zuriñe Rodríguez and Oihana Etxebarrieta contend, gender differences are polarized in armed conflicts:

> Men will be universal activist people; we women, on the other hand, will be everything that men are not. Thus, men will be public, productive, subjects, rational, and masculine; women, however, will be private, reproductive, objects, irrational, and feminine.[33]

32 Sara Rudick, Maternal Thinking. Towards a Politics of Peace (Boston: Beacon Press, 1989): 17.
33 Zuriñe Rodriguez and Oihana Etxebarrieta, Lisipe. Borroka armatua eta Kartzelak (Zarautz: Susa, 2016): 30.

The Mother fulfilled, at least until she decided to be a mother, the prototypical ETA member: a male prototype that mythologized virility[34] and whose strength, indarra in Basque, was related—as Begoña Aretxaga demonstrates—to the strength of action, as in the case of men, and not to the strength of affective support, as in the case of women.[35] The Mother owed loyalty, as did all ETA members, to her "true" family: the Organization; and not to her own family, despite her husband's attempts to involve her in domestic duties (61).

I would argue that The Red Notebook points to a reconstruction of gender within Basque nationalism, a creed that at its very foundation by Sabino Arana designed a role that women were expected to fulfill: the role of selfless mother who raises her children and transmits the language and the Catholic faith to them. As Leyre Arrieta contends,[36] in the same way as other late nineteenth-century Catholic conservative parties, the Basque Nationalist Party (PNV) embraced the dichotomous concept that Sabino Arana had about women: he considered them biologically inferior to men, but, at the same time, he valued their symbolic-maternal function very positively. It was precisely as compensation for this secondary role, that Basque nationalism extolled maternity and allocated women, as Arana had done, the very of symbol of the Homeland.[37] Maternity was converted, therefore, into a weapon of power for women, and praised by cultural creations of the time as absolute power. In this regard, Miren Llona has rightly pointed out the symbolic limitations that Basque artists had when representing gender roles during the

34 Miren Alcedo Moreno, Militar en ETA. Historias de vida y muerte (Donostia: Haranburu, 1996): 353.
35 Cited in Alcedo, 353.
36 Leyre Arrieta, "Desde las cunas y los fogones:'Emakume'y emociones en el nacionalismo vasco". In Emoción e identidad nacional: Cataluña y el País Vasco en perspectiva comparada, Geraldine Galeote, María LLombart Huesca y Maitane Ostolaza, eds. (Paris: Éditions Hispaniques. U. Sorbonne: 2015): 199.
37 Leyre Arrieta, "Desde las cunas y los fogones:'Emakume'y emociones en el nacionalismo vasco", 205.

Civil War. Paintings like Aurelio Arteta's Tríptico de la Guerra (1937) sacralized the figures of the mother and the soldier and became good examples of the prescriptive gender codes during the conflict.[38] Although the role of women did evolve and ascended to the same level as that of men within the PNV, it is clear that Basque nationalism, including its radical variant, has perpetuated and continued to extoll the work of women's moral and logistical support—their function as "guardians of the home"—even in the case of women in ETA.[39] This is demonstrated in the aforementioned study edited by Teresa del Valle:

> The role of wife, companion, both in early nationalism and in radical nationalism, became blurred with the image of the mother, which was associated with the most sacred values, aberria, lurra, birjiña [homeland, land, the Virgin]. (…) In its "Letter to Basque intellectuals," published by ETA in 1965, it is possible to establish a continuous line with early nationalism insofar as a perspective of the mother is concerned.[40]

The protagonist of The Red Notebook is an ETA member, ideologically distant from Arana's traditional nationalism but someone who still appears to have been assigned the role that Basque nationalism in general (even its radical variant) allotted to women. As Begoña Aretxaga points out, "the ethics of the redeeming hero proposed as a form of activism imply problems in terms of female identification, because the martyr hero is a son and a brother. (…) The activist woman

38 Miren Llona, "From Militia Woman to Emakume: Myths regarding femininity during the Civil War in the Basque Country", in Memory and Cultural History of the Spanish Civil War. Worlds of Oblivion, ed. by Aurora G. Morcillo, Boston: Brill, 2014, 179-212.
39 Leyre Arrieta, 210.
40 Mujer Vasca, Imagen y Realidad, 253.

can only identify with this model of active warrior by rejecting herself as a woman, or as the possessor of that which defines the essence of masculinity. The other possibility for women is to identify themselves with the image of the mother, taking on the role of mediator".[41]

In sum, one could say that Arantxa Urretabizkaia's novel points to a political commitment that flees the masculinizing ethics of a radical Basque nationalism in which, as Cameron Watson posits, "men are the gudariak (warriors) and initiators of the radical discourse, women are the strong and supportive wives and mothers."[42] According to Carrie Hamilton,[43] it was not just ETA that influenced this assignation of roles. There were also recurring representations in the media: images of mothers and widows of ETA members, as well as those of its victims. They were images that idealized the strength of these women in the face of suffering—images, in sum, which spoke of women's maternal sacrifice.[44] Indeed, Basque literature has extolled this sacrifice and pain of mothers with well-known poems such as "Joxepa Mendizabal Zaldibian" (Joxepa Mendizabal in Zaldibia) by Gabriel Aresti. The poem, dedicated to the mother of ETA member Txikia (one of the last activists to be executed by Franco), regards women as "compassionate mothers," never as active members of the Organization: "The compassionate ETA mothers / deserve some peace / for their hearts beat frantically. / The ETA mothers suffer greatly. / Within the hearts of these women / fits / the whole world's pain (…) The ETA mothers / suffer greatly, / when their sons are killed / and above all / when their sons kill."

41 Begoña Aretxaga, "The death of Yoyes: cultural discourses of gender and politics in the Basque Country", Critical Matrix: the Princeton Journal of Women, Gender and Culture 1 (1988): 9.
42 Cameron Watson, "The Tragedy of Yoyes". In: Amatxu, Amuma, Amona: Writing in Honor of Basque Women, edited by Cameron Watson and Linda White (Reno: Center for Basque Studies, 2003): 151.
43 Carrie Hamilton, Women and ETA (Manchester: Manchester University Press, 2003), chapter 4.
44 Women and ETA, 102.

Patriotic or politicized motherhood (…) existed in relation to, but outside ETA. In the majority of cases women either had to sacrifice motherhood in order to become ETA activists, or to sacrifice activism once they became mothers.[45]

"Bakeroak etorri dira pistolekin eta ama hil egin dute"

"The cowboys came with their pistols and killed mom." These were the words with which the son of María Dolores González Catarain, known as Yoyes, testified to the murder of his mother on September 10, 1986, when, at the age of three, he was strolling with her in the main square of Ordizia. Yoyes was one of the few women to be involved in the ETA leadership. But after abandoning the Organization and going into exile, she eventually decided to return to the Basque Country—an act that was deemed unacceptable for ETA, who killed her. Indeed, Yoyes herself had stated, two years prior to her murder, that her life was in the hands of ETA—an organization resentful of her desertion "as if it were a husband whom the wife had left, but as long as not everyone knows, holds on to the hope that she will return."[46] The large number of critical studies that have analyzed and interpreted Yoyes' life[47]—together with several narratives, both in literature and film, based on the former ETA activist (such as Helena Taberna's movie Yoyes and Bernardo Atxaga's The Lone Woman)—demonstrate her importance. One could argue that Arantxa Urretabizkaia's The Red Notebook, insofar as it addresses the relationship between maternity and political activism, could well have been influenced by the life of Yoyes. Subverting the symbolic order of

45 Women and ETA, 103.
46 Women and ETA, 168.
47 Aretxaga, 1988; Watson, 2003; Zulaika, 2006; Ortiz de Zeberio, 2015; and so forth.

the Organization meant for Yoyes an acceptance of her wish to become a mother, and an escape from the "male equals activist" role that the Organization had assigned her. "I don't want to be a woman who is accepted because she's 'macho,'" she noted in her diaries.[48]

Sort of conclusion

After commenting on the significance that remembering our troubled past has in current Basque narratives written by women, I have attempted to focus on the affective and emotional implications in stories such as The Red Notebook by Arantxa Urretabizkaia—stories in which the protagonist's transnational journey give cause to reflect on, or question, gender identities and roles nurtured by Basque nationalism. As has been highlighted, the redeeming hero ethic has raised issues for women ETA activists, insofar that the martyr hero is always a son or brother. It is only when women have relinquished themselves—and renounced to maternity—that they have been able to take on an active role within radical nationalism. As we have illustrated through texts that turn to our most troubled recent past, contemporary Basque women writers are contributing to a collective memory that incorporates a reflection about the gender politics that have governed the conflict, as well as the traumas that it has generated. Arantxa Urretabizkaia's The Red Notebook is, without a doubt, a novel that denounces the sexist gender politics promoted by Basque nationalism and seeks for a maternal empowerment in tune with a twenty-first century vision of motherhood—an empowered vision that aligns with Andrea O'Reilly's plea to confer on mothers

48 Cited in Ortiz Ceberio 2015: 148.

"the agency, authority, authenticity and autonomy denied to them in patriarchal motherhood."[49]

WORKS CITED

Ahmed, Sara. "Home and Away: Narratives of Migration and Estrangement". International Journal of Cultural Studies. Volume: 2, no.3 (1999): 329-347.

Alberdi, Uxue. Aulki jokoa. Donostia: Elkar, 2009. Spanish: El juego de las sillas. Translated by Miren Agur Meabe. Irun: Alberdania, 2012.

Alcedo Moreno, Miren. Militar en ETA. Historias de Vida y muerte. Donostia: Haranburu, 1996.

Appelbaum, Robert & Paknadel, Alexis. "Terrorism and the novel: 1970-2001". Poetics Today, 29, no. 3 (2008): 387-436.

Aretxaga, Begoña. "The death of Yoyes: cultural discourses of gender and politics in the Basque Country". Critical Matrix: the Princeton Journal of Women, Gender and Culture 1 (1988): 1-10.

Arrieta, Leyre. "Desde las cunas y los fogones: "Emakume" y emociones en el nacionalismo vasco". In: Emoción e identidad nacional: Cataluña y el País Vasco en perspectiva comparada, edited by Geraldine Galeote, María LLombart Huesca and Maitane Ostolaza, 197-201. Paris: Editions Hispaniques. U. Sorbonne, 2015.

Atxaga, Bernardo. Zeru horiek. Donostia: Erein, 1995. English: The Lone Woman. Translated by Margaret Jull Costa. London: Harvill, 1999.

49 Andrea O'Reilly, "Outlaw(ing) Motherhood. A Theory and Politic of Maternal Empowerment for the Twenty-first Century", in Twenty-first Century Motherhood: Experience, Identity, Policy, Agency, edited by Andrea O'Reilly, (NY: University of Columbia Press, 2010): 370.

Barthes, Roland. La cámara lucida. Nota sobre fotografía. Barcelona: Paidós, 1989.

Blessington, Francis. "Politics in the terrorist novel", Sewanee Review 116, vol. 1, (2007): 116-124.

Borda, Itxaro. Boga Boga. Zarautz: Susa, 2012.

Cano, Harkaitz. Twist. Zarautz: Susa, 2011. English: Twist. Translated by Amaia Gabantxo. NYC: Archipelago books, 2018.

Crownshaw, Richard. "Perpetrator Fictions and Transcultural Memory". Parallax 17:4, (2011): 75-89.

Del Valle, Teresa, ed. Mujer vasca, imagen y realidad. Barcelona: Anthropos, 1985.

Delgado, Elena; Fernández, Pura and Labanyi, Jo (eds.). Engaging the Emotions in Spanish culture and History. Nashville: Vanderbilt University Press, 2016.

Eaglestone, Robert. "Avoiding Evil in Perpetrator Fiction". Holocaust Studies, 17:2-3 (2011): 13-26.

Etxenike, Luisa. El ángulo muerto. Barcelona: Bruguera, 2008.

Faber, Sebastiaan. "La literatura como acto afiliativo". In: Contornos de la narrativa española actual (2000-2010). Un diálogo entre creadores y críticos, edited by María del Palmar Álvarez Blanco & Toni Dorca. 101-110. Madrid / Frankfurt: Iberoamericana / Vervuert, 2011.

———. "Actos afiliativos y postmemoria". Pasavento. Revista de Estudios Hispánicos. Vol 2 (1) (2014): 137-156.

Goia, Garazi. Txartel bat (des)herrira. Donostia: Elkar, 2013.

Hamilton, Carrie. Women and ETA. Manchester: Manchester University Press, 2007.

Iturbe, Arantxa. "Gehienez bost hilabete". in Adiskide maitea. Tafalla: Txalaparta, 2005.

Jelin, Elizabeth. "Lecturas y relecturas de pasados conflictivos en América del Sur". In Construyendo memorias. Relatos históricos para Euskadi después del terrorismo, edited by Ortiz de Orruño, J.M. & Pérez, J.A. 45-67. Madrid: Los libros de la catarata, 2013.

Juanena, Agurtzane. Esan gabe neukana. Donostia: Elkar, 2013.

Kristeva, Julia. Strangers to Ourselves. New York: Columbia University Press, 1991.

Labanyi, Jo, "Doing things: emotion, affect, and materiality". Journal of Spanish Cultural Studies 11, 3-4 (2010): 223-233.

Lanser, Susan. "Toward a Feminist Narratology". Style. 20, vol. 3 (1986): 341-363.

Lasarte, Gema. Pertsonaia femenino protagonistenez augarriak eta bilakaera euskal narratiba garaikidean. University of the Basque Country. PhD Dissertation. (http://www.euskara.euskadi.net/appcont/tesisDoctoral/PDFak/Gema_Lasarte_TESIA.pdf.

———. Ed. Ultrasounds Translated by Nere Lete. Reno: Center for Basque Studies, UNR, 2014.

Leggot, Sarah. Memory, War and Dictatorship in Recent Spanish Fiction by Women. Lanhan, Maryland: Bucknell U. Press, 2015.

Llona, Miren. "From Militia Woman to Emakume: Myths regarding femininity during the Civil War in the Basque Country", in Memory and Cultural History of the Spanish Civil War. Worlds of Oblivion, edited by Aurora G. Morcillo. 179-212. Boston: Brill, 2014.

Meabe, Miren Agur. Urtebete itsasargian. Donostia: Elkar, 2006. Spanish: Un año en el faro. Salamanca: Loguez, 2008.

Mintegi, Laura. Nerea eta biok. Zarautz: Susa, 1994. English: Nerea and I, translated by Linda White. New York: Peter Lang, 2005.

Nussbaum, Martha C. Political Emotions. Why Love Matters for Justice. Cambridge: Harvard University Press, 2013.

Olaziregi, Mari Jose, "Worlds of Fiction. An Introduction to Basque Narrative". In Basque Literary History, edited by Mari Jose Olaziregi. Reno: Center for Basque Studies. University of Nevada, (2012): 137-200.

———. "Literature and Political Conflict: the Basque Case". In The International Legacy of Jose Antonio Agirre's Government, edited by Xabier Irujo and Mari Jose Olaziregi. Reno: Center for Basque Studies. University of Nevada, (2017): 251-278.

Olaziregi, Mari Jose & Ayerbe, Mikel. "El conflicto de la escritura y la rescritura de la identidad: análisis de la narrativa de escritoras vascas que abordan el conflicto vasco". In: Identidad, género y nuevas subjetividades en las literaturas hispánicas, edited by Kasia Moszczynska-Dúrst et al... Warsaw: University of Warsaw-Institute of Iberian Studies, (2016): 45-66.

O´Reilly, Andrea. "Outlaw(ing) Motherhood. A Theory and Politic of Maternal Empowerment for the Twenty-first Century", in Twenty-First Century Motherhood: Experience, Identity, Policy, Agency, edited by Andrea O'Reilly. NY: University of Columbia Press, (2010): 366-380.

Podnieks, Elizabeth and O'Reilly, Andrea, eds. Textual Mothers/ Maternal Texts. Ontario: Wilfrid Laurier University Press, 2010.

Ortiz Ceberio, Cristina. "Paradigmas éticos-políticos en los diarios Yoyes desde su ventana". In: Imágenes de la memoria. Víctimas del dolor y la violencia terrorista, edited by Pilar Rodríguez. Madrid: Biblioteca Nueva, (2015): 139-154.

Ramblado Minero, María Cinta. Construcciones culturales de la maternidad en España. Alicante: Universidad de Alicante, 2006.

Rich, Adrienne. Of Woman Born. Motherhood as Experience and Institution. 2nd. Edition. NY: Norton and Company, 1986.

Rodríguez, Eider. "Politika albisteak". In: Eta handik gutxira gaur. Zarautz: Susa, 2004. Spanish: "Actualidad política". In: Y poco después ahora. Donostia: Ttarttalo, 2007.

Rodriguez, Zuriñe and Oihana Etxebarrieta. Lisipe. Borroka armatua eta kartzelak. Zarautz: Susa, 2016.

Rudick, Sara. Maternal Thinking. Towards a Politics of Peace. Boston: Beacon Press, 1989.

Ubeda, Garbiñe. Hobe isilik! Donostia: Elkar, 2013. Spanish: Mejor me callo. Donostia: Ttarttalo, 2017.

Urretabizkaia, Arantxa. Koaderno gorria. Donostia: Erein, 1998. English: The Red Notebook. Translated by Kristin Addis. Reno: Center for Basque Studies, 2008.

———. Zuri-beltzeko argazkiak. Iruña: Pamiela, 2014. Spanish: Retratos en blanco y negro. Translated by Fernando Rey and Arantxa Urretabizkaia. Iruña: Pamiela, 2015.

Ybarra, Gabriela. El comensal. Madrid: Caballo de Troya, 2015.

Watson, Cameron. "The Tragedy of Yoyes". In: Amatxu, Amuma, Amona: Writing in Honor of Basque Women, edited by Cameron Watson and Linda White. Reno: Center for Basque Studies, (2003): 134-156.

Zulaika, Joseba. Basque Violence: Metaphor and Sacrament. PhD Dissertation. University of Princeton, 1982.

———. ETAren hautsa. Irun: Alberdania, 2006. Spanish: Polvo de ETA. Translated by Gerardo Markuleta. Irun: Alberdania, 2007.

Zulaika, Joseba & Douglass, William. Terror and Taboo: The Follies, Fables, and Faces of Terrorism. New York: Routledge, 1996.

About the Authors

Marina Arizmendi Pérez de Mendiola is Richard Armour Professor of Modern Languages in the Department of Spanish, Latin American, and Caribbean Literatures and Cultures, & Humanities at Scripps College. She has published on Latin American, Transatlantic, and Basque cultures and literature. Her current research focuses mostly on Basque studies.

Larraitz Ariznabarreta is an assistant professor at the Center for Basque Studies (University of Nevada, Reno). Her fields of research deal with the analysis of various expressions of Basque culture and their relations with power. She published Notes on Basque Culture: The Aftermath of Epics in 2019.

Edurne Arostegui is a PhD candidate and Bilinski Fellow in Basque Studies (History) at the University of Nevada, Reno, and at the University of the Basque Country. Her dissertation analyzes Basque women's migration to the American West with an intersectional approach to gender, labor, and ethnicity within migration experiences. Arostegui has written on Basque stereotypes in American fiction, gendering the Basque diaspora, Basque collectivities in the Americas, and on Basque Radical Rock.

Margaret Bullen (Nedging, Suffolk, UK, 1964) is a feminist anthropologist who holds a BA in modern languages (Bristol, 1987) and a PhD in social anthropology (Liverpool, 1991). She has been lecturing at the University

of the Basque Country since 2005 and is currently subdean of the Faculty of Education, Philosophy and Anthropology. She previously taught with USAC (University Studies Abroad Consortium), while authoring Basque Gender Studies (2003). In 2018, she held the Eloise Garmendia Bieter Chair in Basque Studies at Boise State University. Research interests in migration, identity, and social change are strengthened by a gendered perspective and a focus on symbolic systems, particularly in relation to the defence of equality and participation of women in festive rituals, in the co-authoring of Tristes espectáculos: las mujeres y los Alardes de Irun y Hondarribia (2003). As a member of AFIT (Feminist Anthropology Research Group), she collaborated on Continuidades, conflictos y rupturas frente a la desigualdad (2016) which looked at gender relations, and corporal and emotional practices, of Basque youth. She is presently working on networks among emergent social movements.

Ziortza Gandarias Beldarrain is an assistant professor at Boise State University's Department of World Languages. She completed her PhD in Basque studies at the University of Nevada, Reno with a cotutelle agreement with the University of the Basque Country. Her area of research and specialization is focused on Euzko-Gogoa, the emblematic Basque cultural magazine published in the Basque diaspora during the Franco dictatorship. Her research has been presented at multiple national and international conferences. Outside of her academic research and course offerings, she is also actively involved in the Basque community in Boise, Idaho. She enjoys spending time with her family and friends and sharing her passion for Basque culture over a nice cup of coffee.

Garbiñe Iztueta is an associate professor in the German Department of the University of the Basque Country and the director for the Promotion of Basque Language at the Etxepare Basque Institute. Her main research areas are comparative literature and representations of the body and memory in post-unification German literature, Heimat/Homeland, and memory in recent German and Basque literature. She is currently a member of the research project "Contested Memories" (FFI2017-84342-P). Recently published books in co-edition with Bescansa, Saalbach, and Talavera are Unheimliche Heimaträume: Repräsentationen von Heimat in der deutschsprachigen Literatur seit 1918 (2020) and Raum-Gefühl-Heimat. Literarische Repräsentationen nach 1945 (2017). Recent articles are: "Clemens Meyer und das Unheimliche als Nachwendebild" in Unheimliche Heimaträume (2020); "Die Wassermetaphorik als Grenzraumgestaltung in Uwe Tellkamps 'Der Turm'" in Sarmatien – Germania – Mitteleuropa (2020), eds. Egger/Hajduk/Jung; and "Transiträume und Heimatlosigkeit als Grunderlebnis bei Herta Müller" in Transiträume und transitorische Begegnungen in Literatur, Theater und Film (2017), eds. Hess-Lüttich et al.

Nere Lete is a professor of Basque and the director of the Basque studies minor at Boise State University in Boise, Idaho. She holds a bachelor's degree in Basque philology from the University of Deusto and a master of fine arts in literary translation from the University of Iowa. She has published her translations in various American literary venues. Nere Lete's grassroots work was instrumental in the creation of a Basque language preschool in Boise, Idaho, where she loves to perform puppet shows in Basque.

Monika Madinabeitia is an associate professor at the Faculty of Humanities and Education Sciences (Mondragon University). She published the illustrated book Petra, My Basque Grandmother in 2018. She is currently the co-coordinator of the recently launched degree Global Digital Humanities (MU–Bilbao). Her main research areas are identity and migration, with an emphasis on the Basque-American diaspora in the US West.

Mari Jose Olaziregi holds a PhD in Basque literature. She is an associate professor at the University of the Basque Country (Spain) and has taught at the University of Nevada, Reno; the University of Konstanz; the University of Chicago, CUNY; and others. She holds an MA in studies in fiction (University of East Anglia, UK) and since 2003 has been the editor of the Basque Literature in Translation Series (CBS, UNR). She specializes in contemporary Basque and Iberian literature, and Basque cultural studies, and has published widely as a scholar. Among her publications, the book Waking the Hedgehog. The Literary Universe of Bernardo Atxaga (2005), or the anthologies Six Basque Poets (2006) and Basque Literary History (2012), could be mentioned. She served as the director of the language and universities division at the Etxepare Basque Institute (Basque Government) and, since 2013, has been the director of the MHLI (Historical Memory in Iberian Literatures) consolidated research group at the University of the Basque Country (www.mhli.net).

David Río is a professor of American literature at the University of the Basque Country (UPV/EHU) in Vitoria-Gasteiz. His research interests center in the field of American studies, with an emphasis on diaspora

studies, regional literatures, and especially western-American writing and Basque-American literature. He is the author of El proceso de la violencia en la narrativa de Robert Penn Warren (1995), Robert Laxalt: The Voice of the Basques in American Literature (2007), and New Literary Portraits of the American West: Contemporary Nevada Fiction (2014). He has also co-edited five volumes on the literature of the American West and the special issue of the journal Western American Literature on "Writing the Global Western" (2019). David Río coordinates an international research group (REWEST) specialized in the literature and culture of the American West.

Xenia Srebrianski Harwell received her PhD from the University of Tennessee and has been a Fulbright (University of Vienna), Fascell (St. Petersburg, Russia), and NEH (Vienna) Fellow. She has taught all levels of both Russian and German language, literature, and culture at several universities, including most recently at the US Military Academy, West Point, where she was program director for the German section of the Department of Foreign Languages in 2017–2018. Her publications encompass a wide range of scholarly interests, including the representation of exile in works by Russian and German women writers, the Russian émigré community of New York City, the war memoir, spatial theory, and language pedagogy. Her forthcoming publications discuss a classroom project that synthesizes language, art, and history in the German classroom (co-authored), and the reflections of a Russian field chaplain on the Russo-Japanese War. Her current project is the translation of a manuscript within the field of Russian history.